LIFE
on
INSTAGRAM

2017

PARTICULAR
BOOKS

FOREWORD

This book is a celebration of life, in all its different guises, all over the world.

There are many, many photographic books that beautifully or artistically present the human experience, usually projects by just one, or a few, prominent photographers. But *Life on Instagram* is a unique anthology. It's about you and me recording the spectacle and nuance of our own lives and sharing what excites us personally – imparting our experiences, joys, and sometimes our sorrows as they happen. This very immediate, visual way of communicating has become a defining component of our culture. Before Instagram, it was virtually impossible to access anything close to this breadth and quality of photography. And it is regularly breathtaking.

Life on Instagram offers a printed focus that embraces this sense of limitlessness. There are so many million images uploaded every day that there is no way to see – let alone appreciate – all the content on Instagram (though we did try). Yet each one selected here is captivating, chosen for its inimitable qualities, for having something idiosyncratic, something that might make you look again.

What research for this book has shown is that all around the world there are millions of talented photographers taking superb and inspiring photographs. With an amazingly international and inter-cultural span, Instagram encourages anyone with a cameraphone and a sharp eye to capture and share the vibrancy of a single moment. And the random upload nature of the platform is something we have enjoyed emulating in the book. Side-by-side images complement and juxtapose from one moment to the next, driving an unexpected narrative.

We have tried not to overdose on selfies, sunsets, cappuccinos and cute pets (unless they're completely irresistible). Our aim has been to select real-life images. Even when taken by experienced photographers, these are images that anyone could potentially capture, in the right circumstances, on the right day. We'd like to believe that everything here was achieved in-camera and through the Instagram app, leaving special effects and post-production to other collections.

Many of these photographs have an extra dimension, achieved either carefully and deliberately, or fortuitously in a fleeting moment. At times there is a sentimental magic that's hard to define, an intangibility that can't be ignored. This sense of mystery reinforces just how distinctively every individual views the world around them. This is surely the pleasure of *Life on Instagram*.

Jim Stoddart

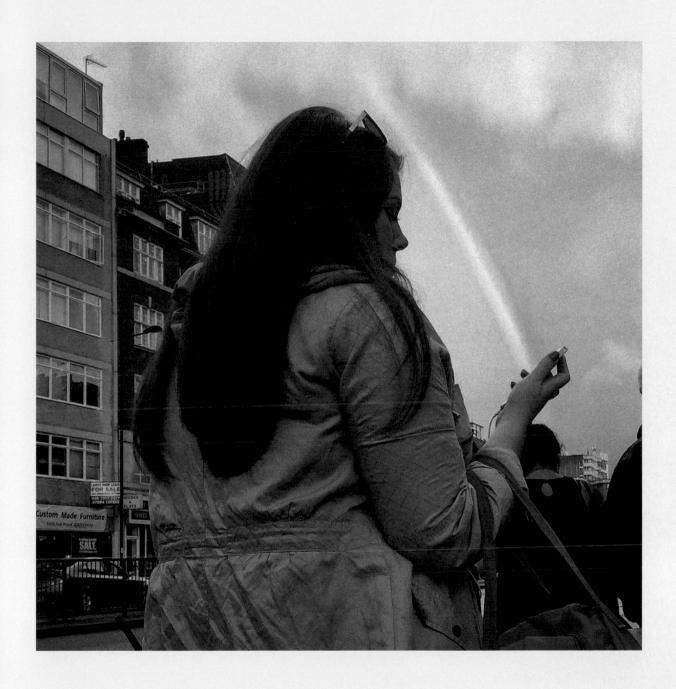

oggsie
London right now on Instagram...

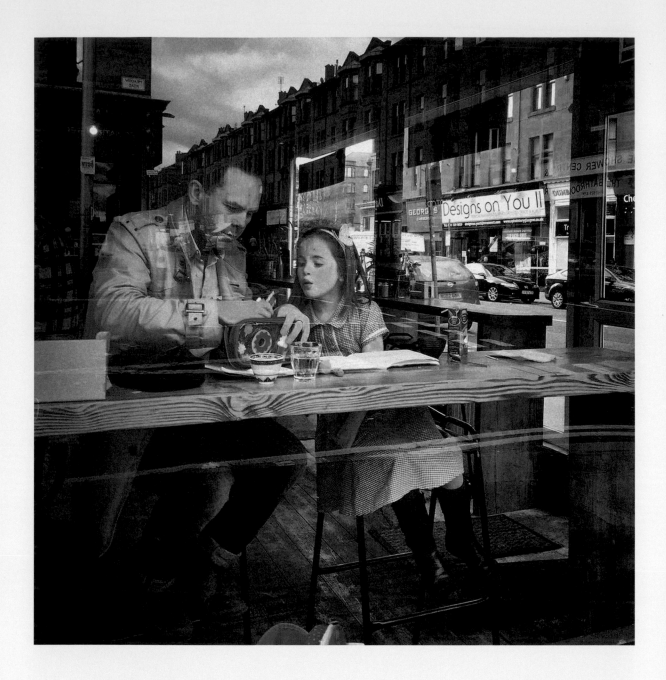

kierandodds
I am taking over the @burndiary feed this week
sharing new moments from Scotland. I will keep
posting alternative shots here.

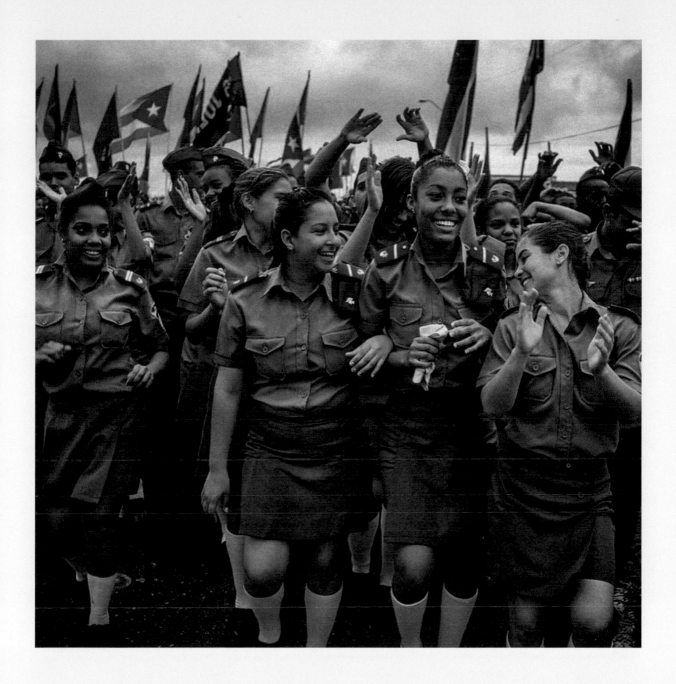

dianazeynebalhindawi
Plaza De La Revolution, Ciudad De La Habana
Yesterday's march in #Havana for '#DiaDeLosTraba-
jadores' (International Workers Day). I left confused...
not sure if it was a political march or a massive
#dance party down one particular grand avenue...

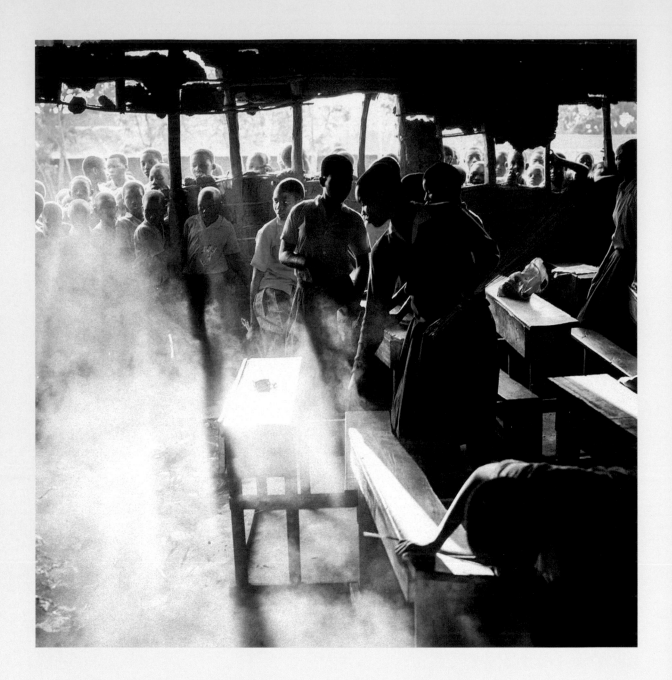

jaydabliu
Arabuko-Sokoke Forest, Malindi, Kenya.
It's back to school week in Kilifi. That means
shaking off last year's dust and gearing up
for a new one.
#Kenya #WorldVision

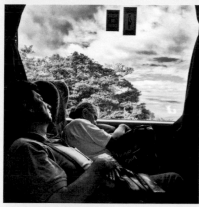
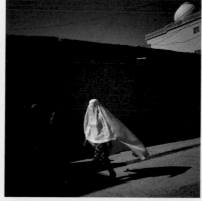
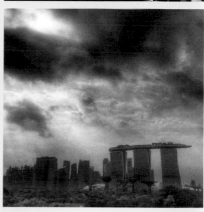
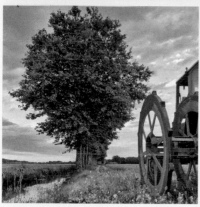
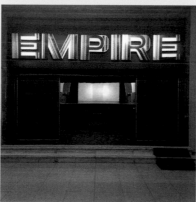
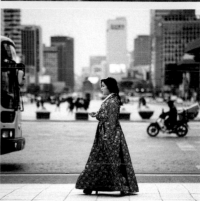

jacobjonasthecompany
Yucca Valley, California
Women are so powerful and have strengths that
are needed and valued. Work hard and don't let
anyone take credit for your talents. Props to
@taylorswift for speaking up!

mishavallejo
Bus dreaming – a scene on the road between
Lago Agrio and #Quito for my ongoing mobile
phone project #TomandoElBus in #Ecuador
#EverydayEcuador @runa_photos

tonipascualcuenca
Basses D'en Coll
Les Basses d'en Coll-Pals/Girona
Els meus llocs per compartir! Gaudint de la natura
i les vacances !!
Mis lugares para compartir ! ...

saunakspace
Manhattan Bridge
The struggle on the street is real.
#moodygrams #500lnaynays

f64s125
An alley in central #kabul #afghanistan

cremedelacremeba
Buenos Aires, Argentina
Hidden Buenos Aires : The amazing Art Deco
theatre Teatro Empire – I was given a behind the
scenes by the owners today. Literally I died and
went to heaven. It's in very original condition,
hardly touched since it was built in 1934 ...

kevindliles
People wait, some since 5 a.m., I get inside TD
Arena in #Charleston for the funeral of Clementa
#Pinckney. President Obama will give the eulogy.
Photographed for UPI. #photojournalism #on-
assignment #Charleston9 #Charlestonshooting ...

iphoneishootipost
Marina Bay, Marina Barrage
After the rain! – It was raining heavily but I was
in the mood for photography. Undeterred by the
weather I went photo hunting at Marina Barrage
Singapore. Just when I reached, the rain stops ...

reycanlasjr
Seoul, South Korea
Seoul Strutting.

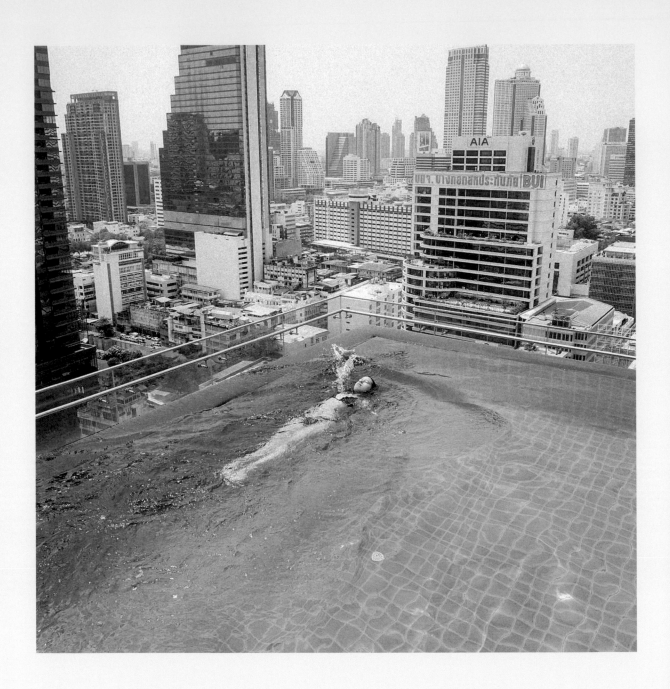

piergiuliocaivano
Amara Bangkok
{ bye } • it's time to say goodbye Thailand, I hope
to see you again very soon •

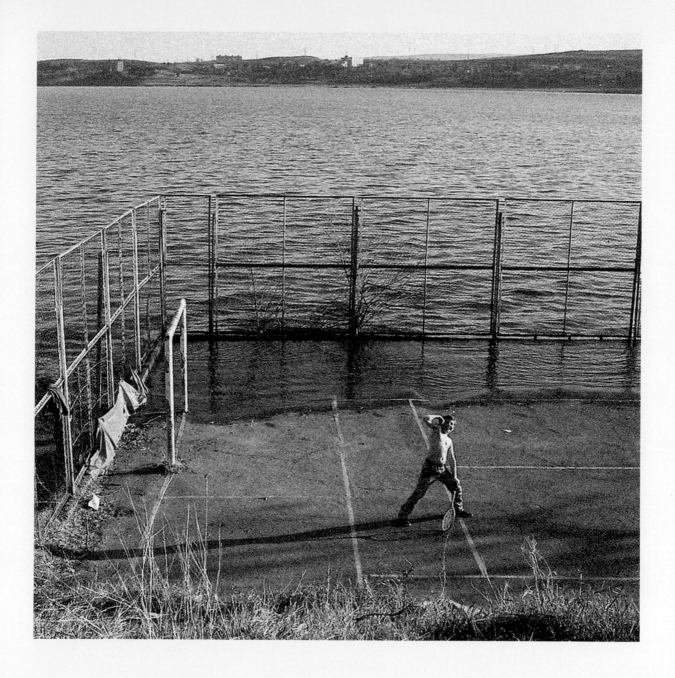

darosulakauri
A boy showing off his muscles, while playing
on a half drowned tennis court. #filmkodak
#tbilisisea #halfdrowned #tennis #tenniscourt
#boy #showingoff #muscles #sunnyday #sea . . .

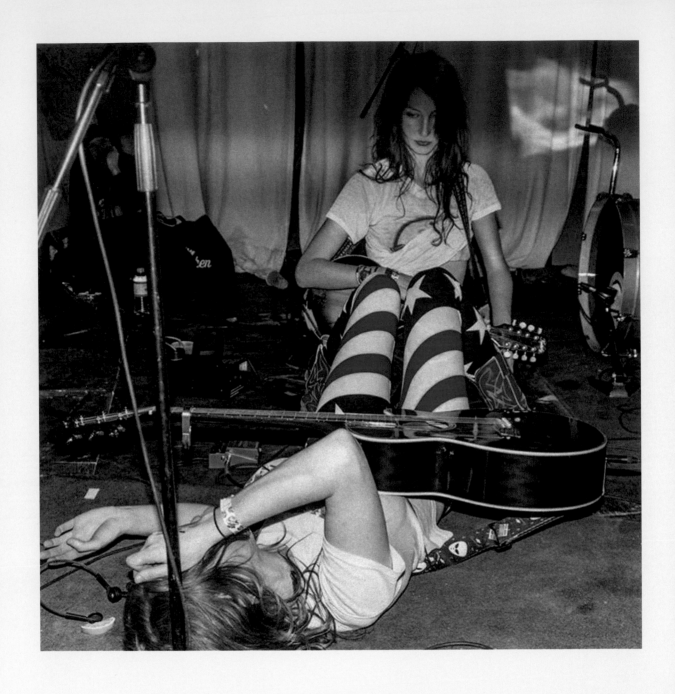

birdcloudusa
nathanedge
Harrisburg PA tonight at
Makespace 8pm $8 8ballz

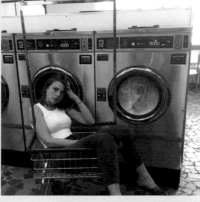
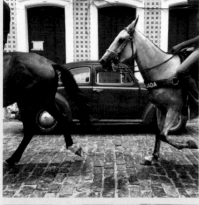
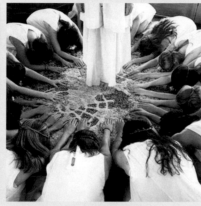
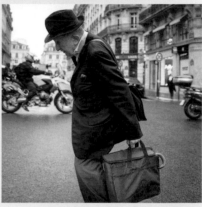
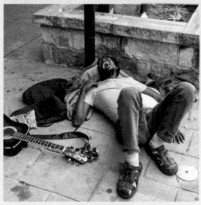
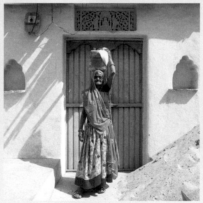

la_mayte
Playa San Pancho
Aquí con San Pancho

deni_perez
Cachoeira-Bahia
#cachoeira #bahia #brasil #brazil #horses
#cavalos #fusca #beetle #recôncavo

sandy_carson
#socloseyetsofarout #sxsw2016 #atx
#streetphotography

edsel
#AFriendlyReminder towards patience today.
I suppose because everyone gets back to work
on Monday, the pull and push of the anxiety to
achieve weighs heavily on me. Achievement is
good, but anxiety isn't a healthy motivator . . .

olivialocher
Happy international women's day! Production
photo from my abandoned film, #thesuninmy-
mouth (2013) #internationalwomensday

ali_berrada
Old woman posing before to bring water
to the house as all women do in small
villages in rajasthan
#rajasthandiaries #rajasthan #india #indian
#travelawesome #traveling #instatravel . . .

juliafox
can someone plz tag me
in some funny memes I'm soooooooo bored

edsel
The city swells and swirls about him, some
monstrous thing, but he fears not, nor steps to the
wringing of restless hands. He belongs to another
world, where rustic joy makes the time-wrought
timeless and the whim of man lives not . . .

sandy_carson
No more fakers, no more clones

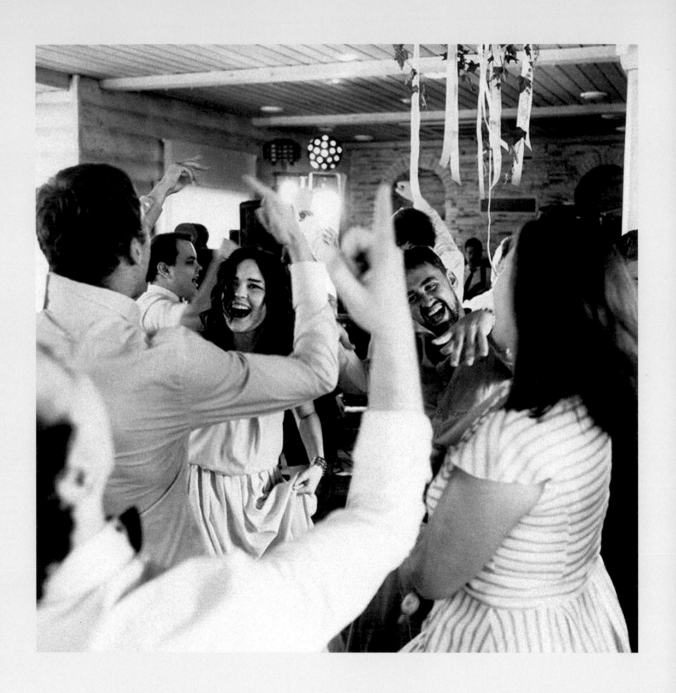

lina_liss
Emotional we

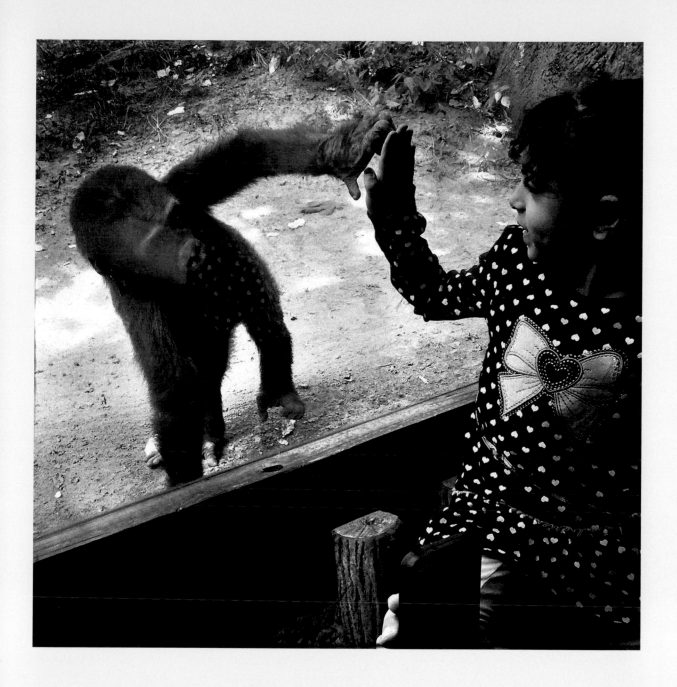

andrewlichtenstein
Job cancelled, good day to visit the Congo

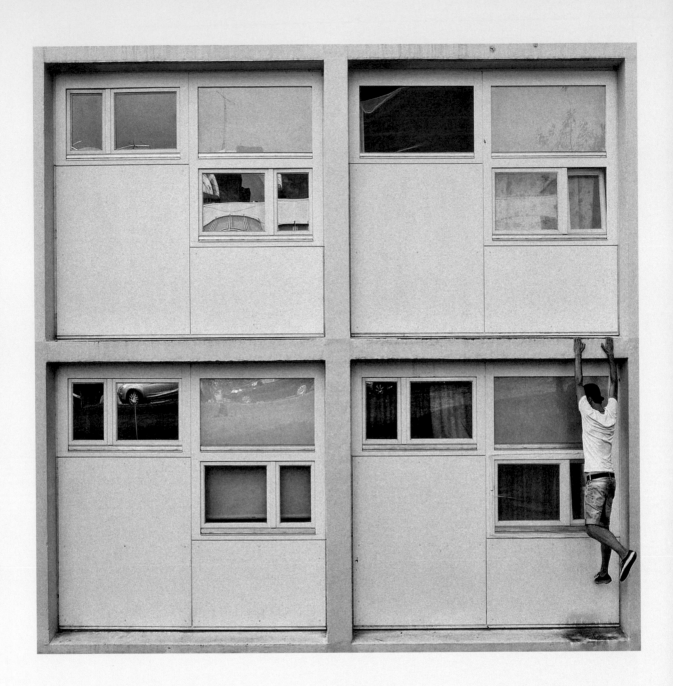

benjamarkoword
Game of Squares
with @nogoartwork
#gameoftones #photowalk #todayimet #todays_
simplicity #jj_geometry #geometry #geometry-
club #shapes #patterns #patternity #cubes . . .

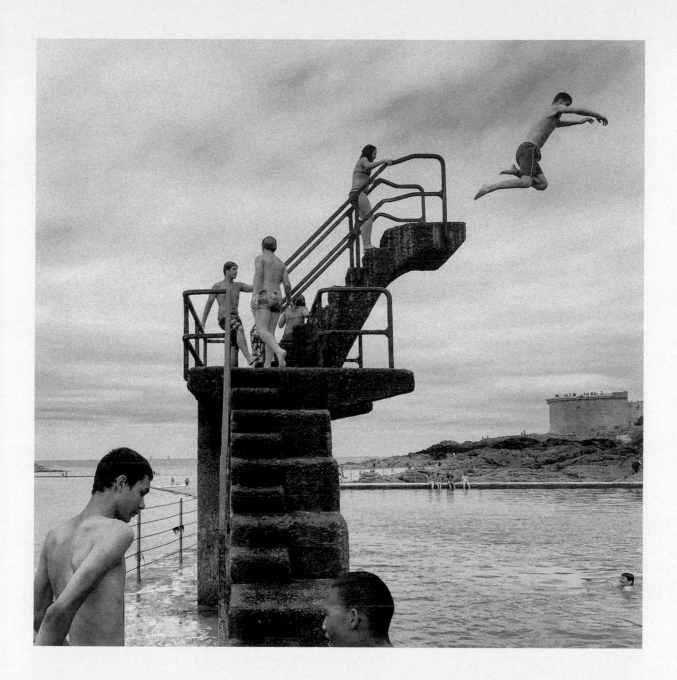

iantehphotography
I'm on assignment in St. Malo, France. I have been traveling through Brittany exploring some of the historical sites in this region. Absolutely loving it. Some days I just love photography, today is one of those days . . .

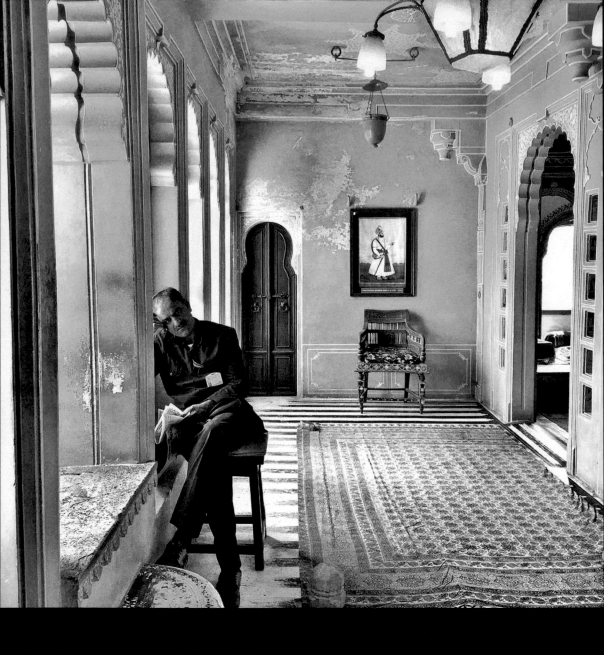

sopheesmiles
Udaipur – The City of Lakes
Missing India like crazy. So much unfinished
business. I need to visit again and stay a while
– a long while

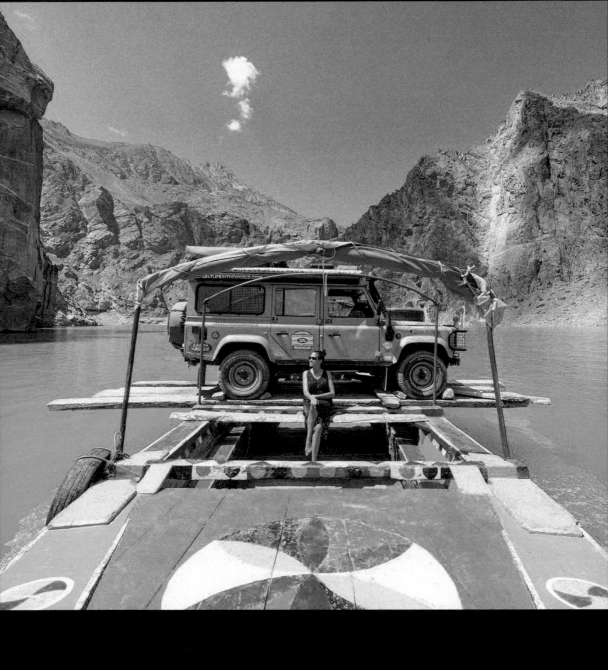

sopheesmiles
This has to be one of the coolest travel experiences of my lifetime – ferrying our @LandRover across Lake Attabad (Pakistan). It was surreal, knuckle-biting and magical #pakistan #travel #wanderlust #landrover #adventure #YOLO . . .

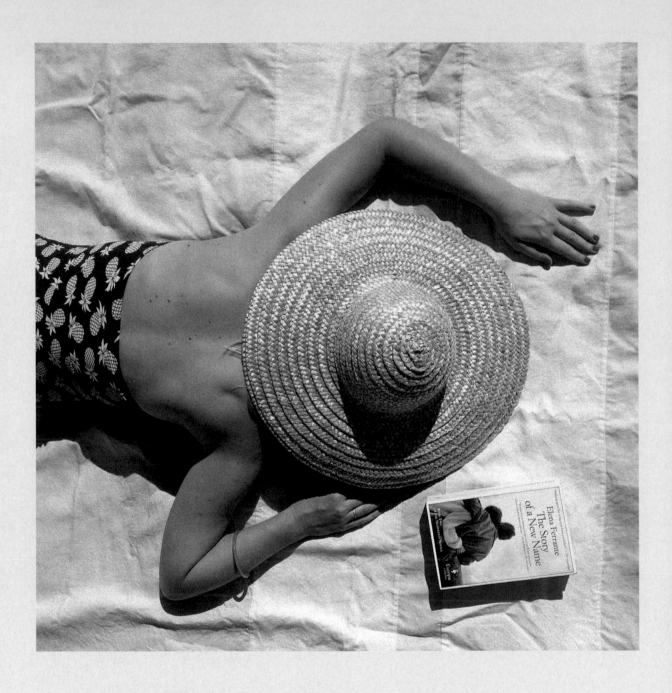

sophiacosmo
Perfect beach day, everyone cum plz

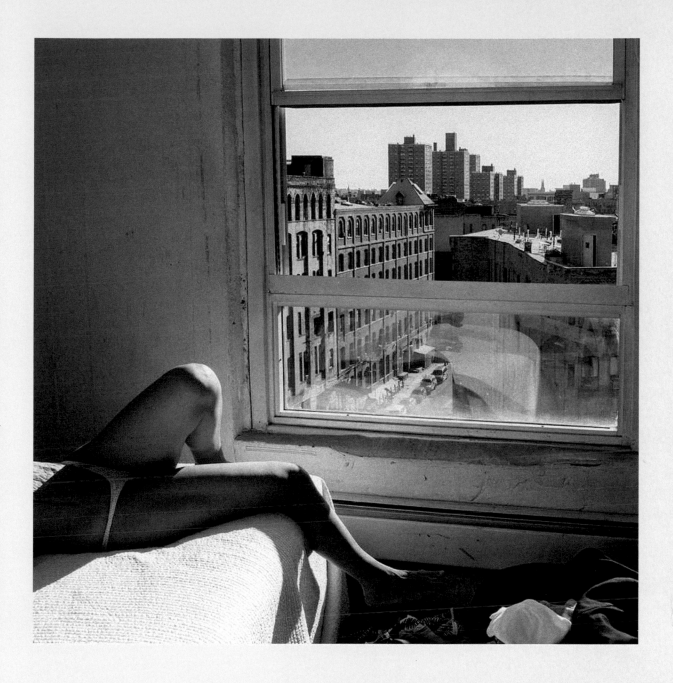

sohailsingh
Magnum Photos/@christopherandersonphoto

nikonandy
Volcán de Fuego
From 4000m on the adjacent Vol-
cano Acatenango, there's really no
better place in the world that I've
found to watch an eruption. Here's
Volcano Fuego putting on a show for
a little #tbt

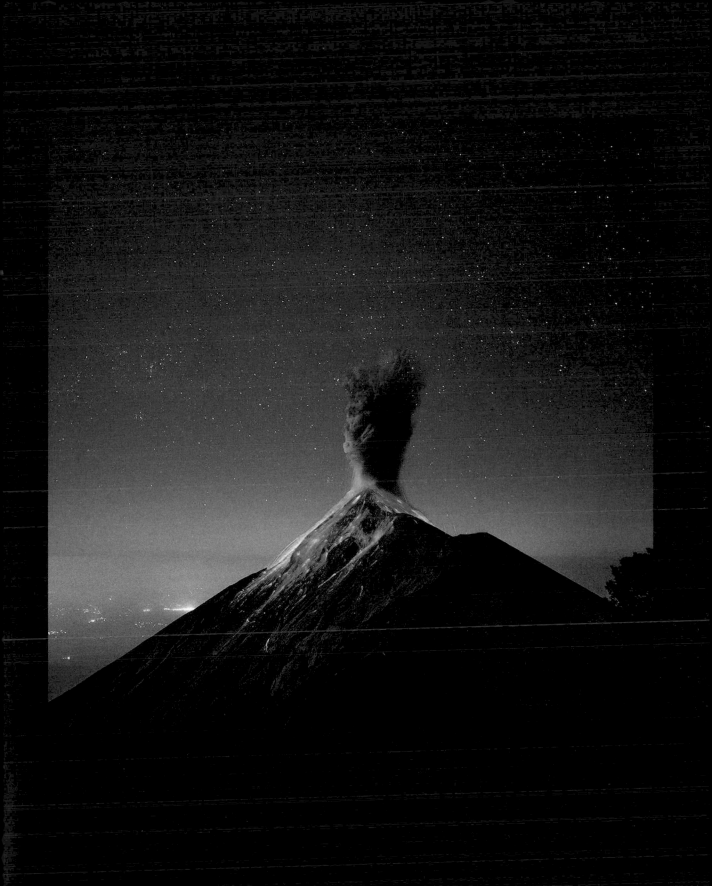

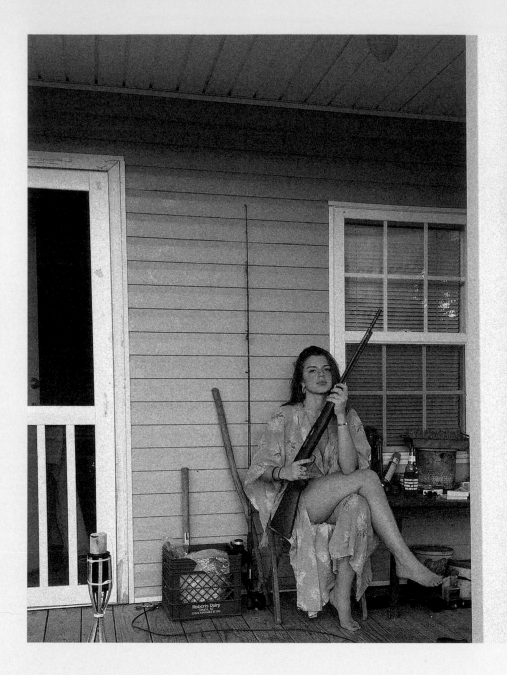

juliafox
Porch bunny

 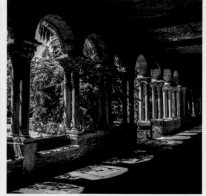 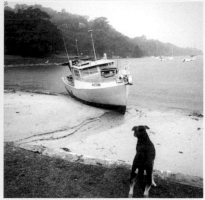

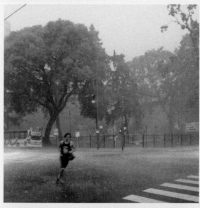 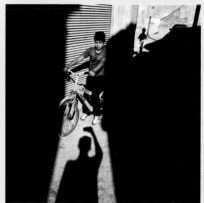 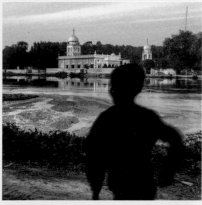

 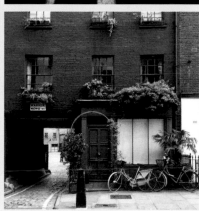 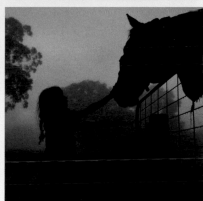

peter_zwolinski
I don't know where I'm going anymore. #philip-
lorcadicorcia #film #35mm #leicaimages #leica
#summicron #popularphoto #vscofilm #awesup-
ply #nycprimeshot #nycgotheat #tgit #streetpho-
tography #streetphoto . . .

cremedelacremeba
Belgrano, Buenos Aires, Argentina
Caught in the deluge : tropical storm this after-
noon and my view from under an awning as I
waited for the storm to pass, yet the roads began
to flood in minutes #igersbuenosaires #igers . . .

ancient_hearts
I put a lot of new things on
@ancient_hearts_vintage
All the witchcraft, magick and vintage goodies...
#witchy #witchcraft #pagan #greenwitch
#witches #handmade #diy #larp #wiccan . . .

pao_lamaga
Abadia San Benito
Claustros.
Dedicada a @amar.es.arte.
Gracias por la info

ali.shms
Street boys | Shiraz • Iran |
@lensculture #lensculturestreets #Hikaricreative
#roozdaily #outofthephone #iranian_selfportrait
#streetphotography #streetphotographers #ever-
body_street #everybodystreet . . .

crazycatladyldn
Warren Mews
This post is in tribute of the 11 mile walk + 3 mile
cycle that I just did. I was also pretty excited that
both bikes were there today. Now to finish stuffing
my face with bagels and donuts!

jacquifink
Vac and I copped a thorough drenching taking
this pic. Not sure what possessed me. This is a
usually calm bay near our new digs. Poor boat.
Big dog. #Sydneystorm #boatadrift

sohailsingh
2016. The year of changes.
Learning to accept goodbyes. Leaving
home to find another home.

nampix
My Horsey Paradise
#fog morning in #Windsor #Sydney #NSW
#australia

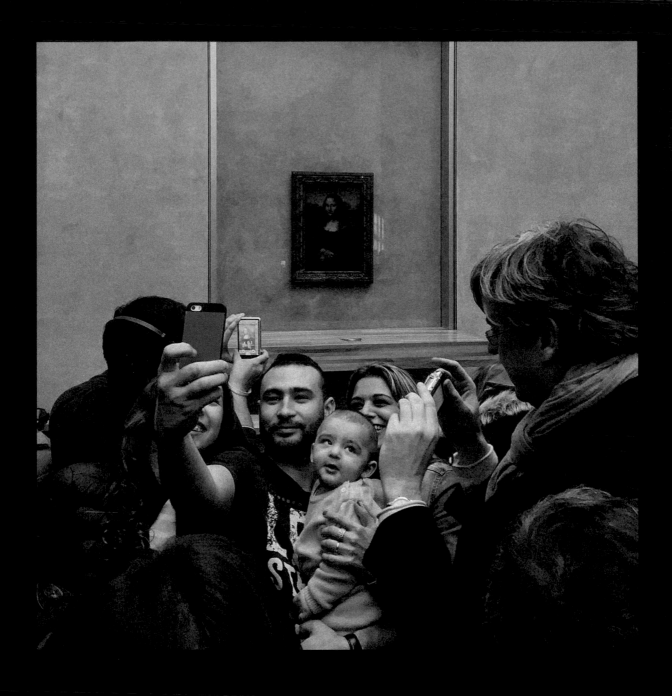

oggsie
Da Vinci's Mona Lisa
Moan Lisa, Paris

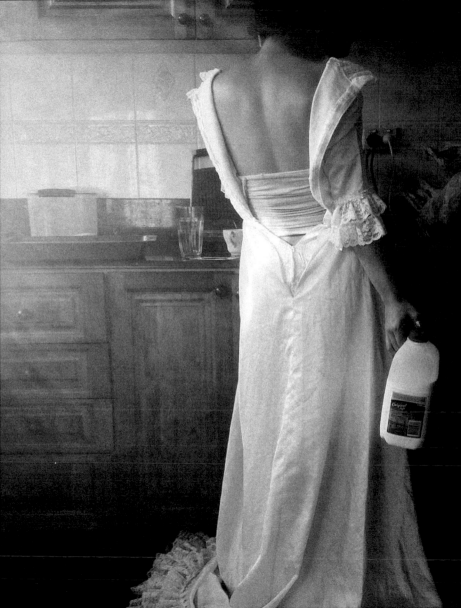

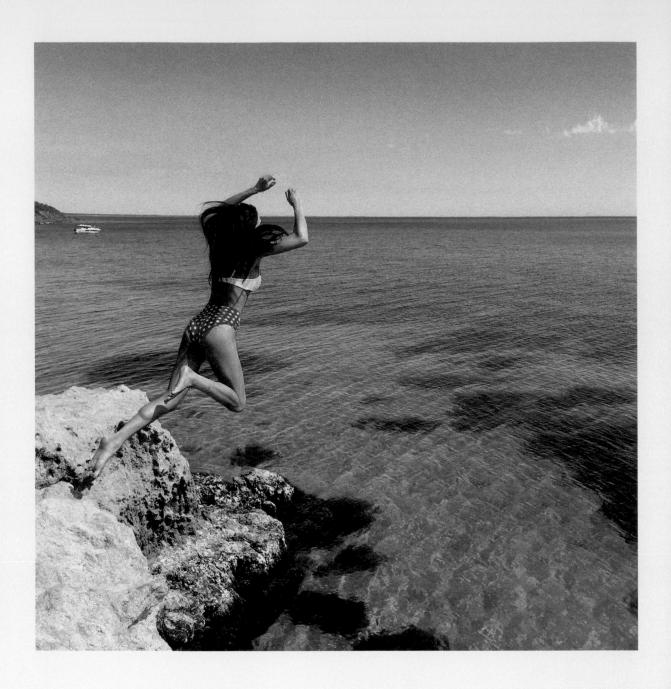

shoonastanes
The Pillars – Mt Mart
Bombs away #happyhumpday @saasha_burns xx
#mtmartha

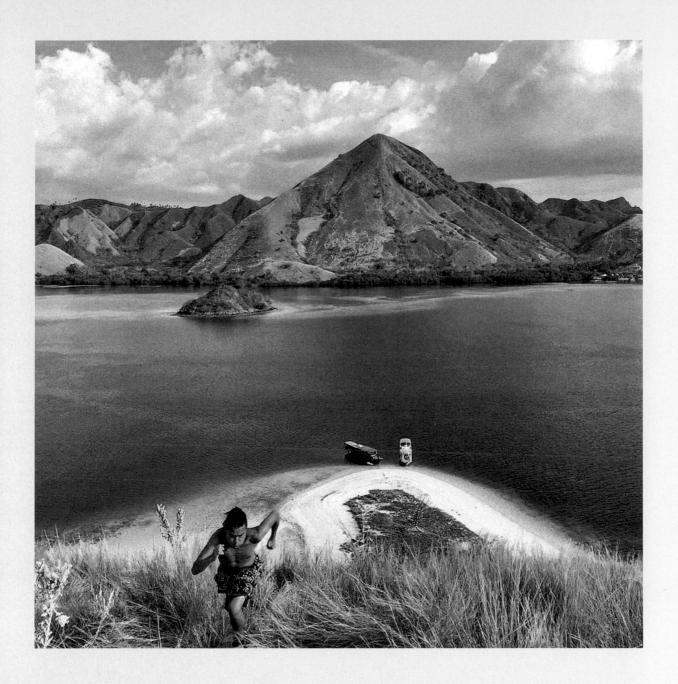

asokaremadja
Pulau Kelor –Flores–
In love with the view of Kelor Island – Flores, hills
in the background, white beach, blue ocean, blue
sky, fluffy clouds – all the colors are too good to
be true . . .

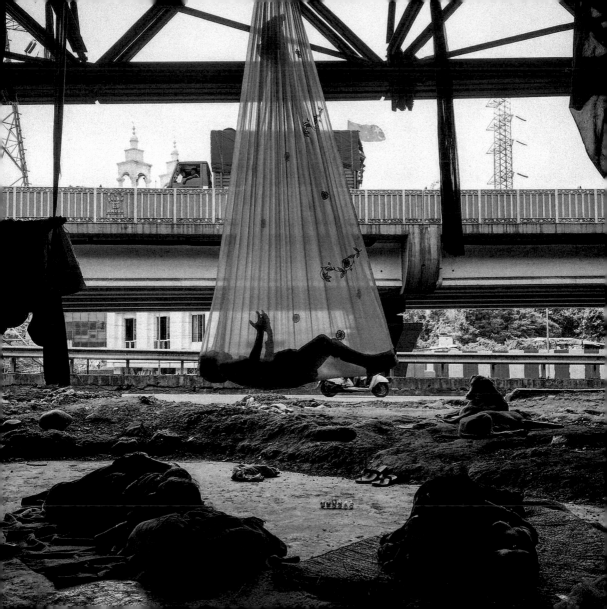

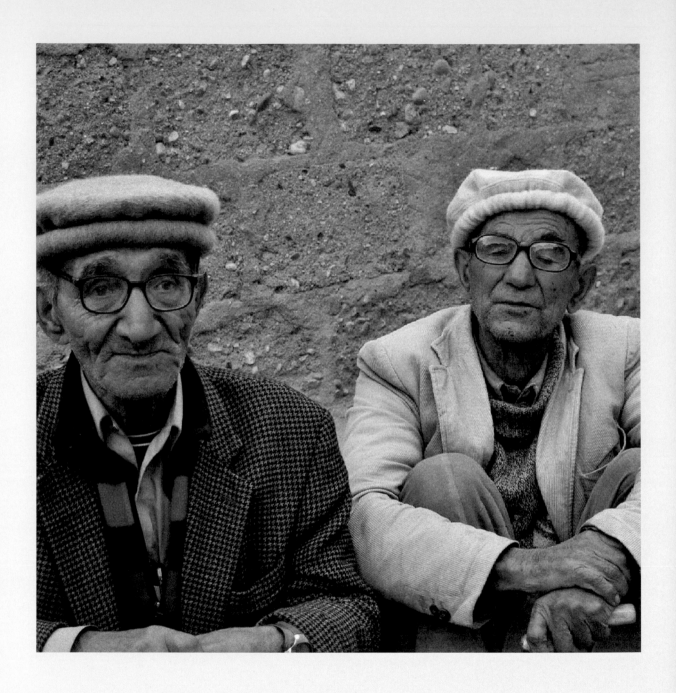

ijlal2278
this is how a lifetime friendship looks like.
got lucky enough to capture it

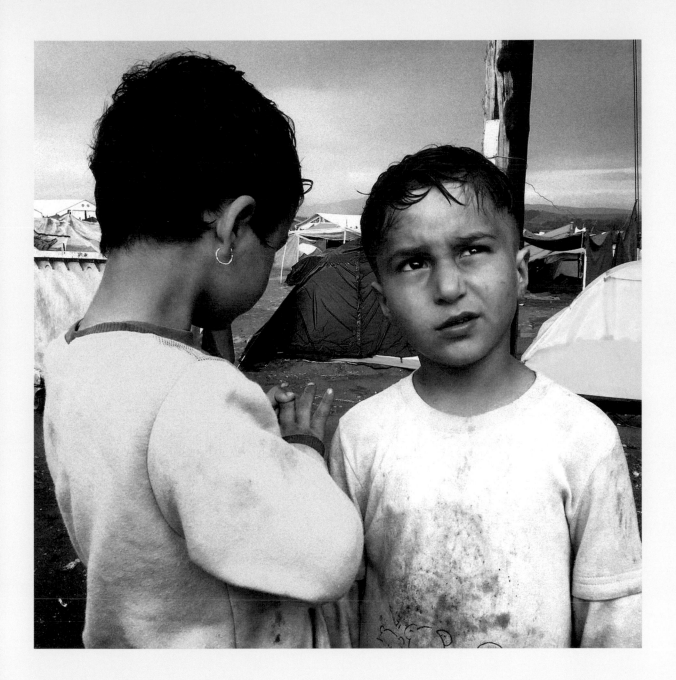

daphnetolis
Idomeni
Idomeni-born friendship.

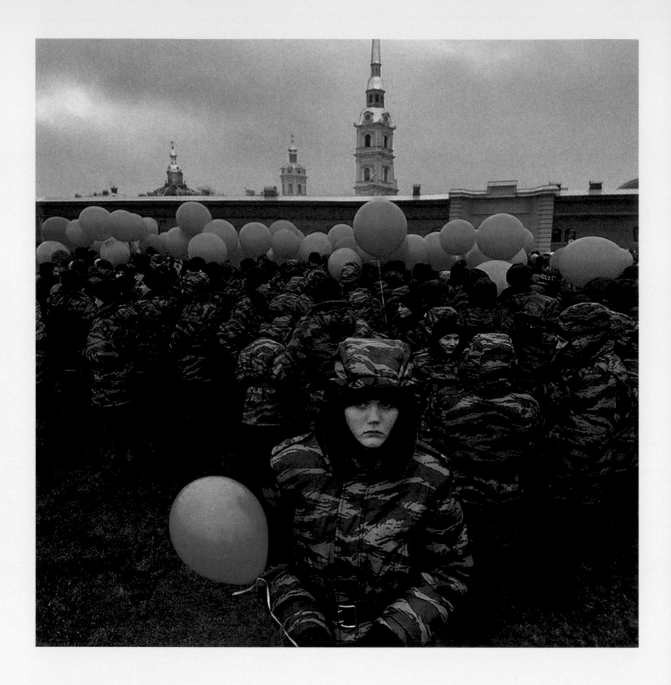

petrosphotos
#petrosphotos #спбонлайн
#александрпетросян #alexanderpetrosyan
#photo#photopher#bestoftheday#picofthe-
day #instagramrussia

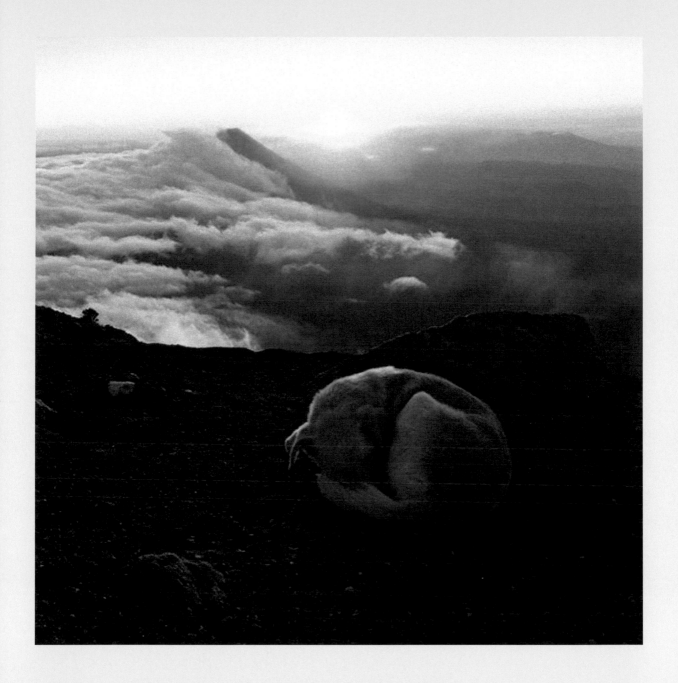

workingwanderer
Volcán de Fuego
Don't waste your time loving people that don't
love you back in this world. There are puppies full
of love even on the top of volcanoes #puppylove
#peaceofmind #gypsylife #nomadlife . . .

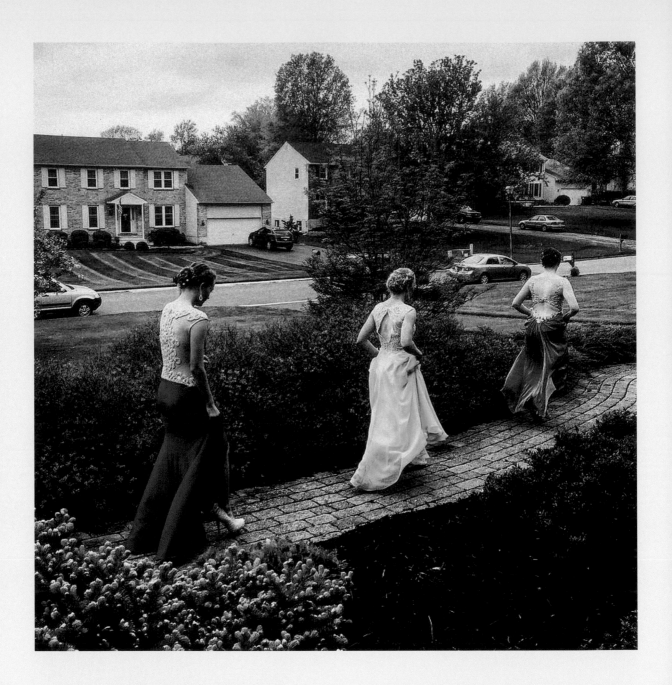

angrylittlenotion
'When I used to read fairy-tales, I fancied that kind of thing never happened, and now here I am in the middle of one!' lewis carroll

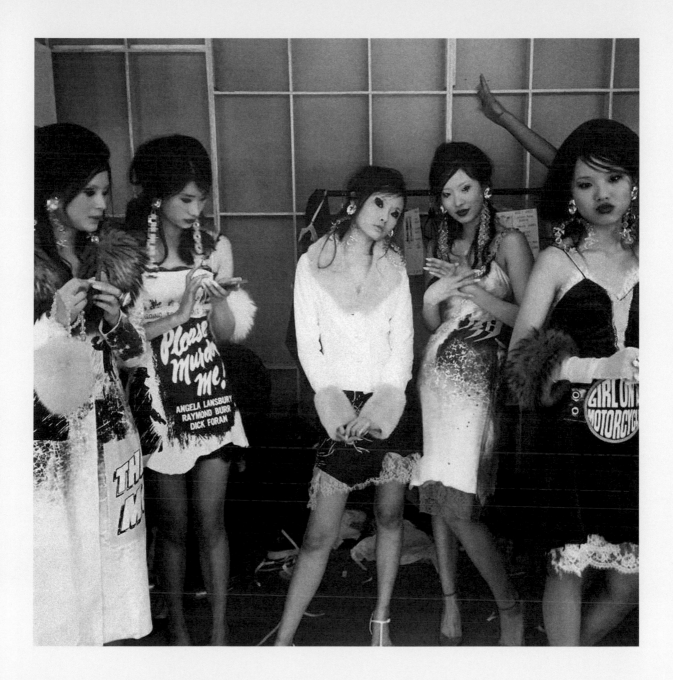

mimi.wade
 #GIRLS #backstage at @fashion_east show in
shanghai w @thehubhk

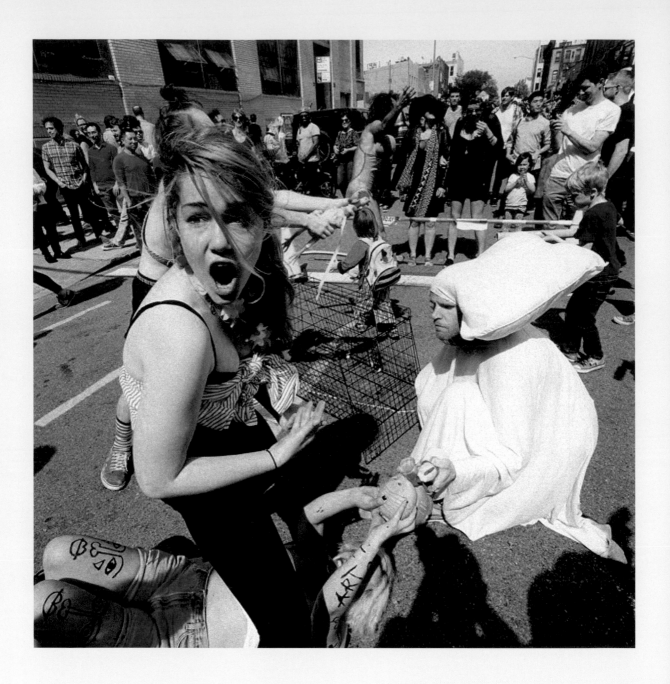

brooklynarchitect
Bushwick, Brooklyn
Crime scene at Bushwick Open Studios.
#BOS2015

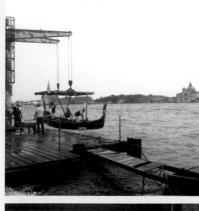
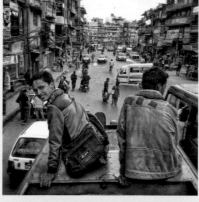
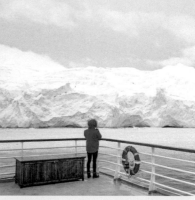

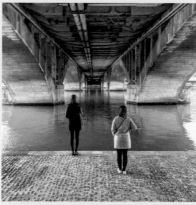
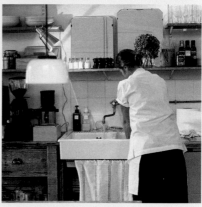
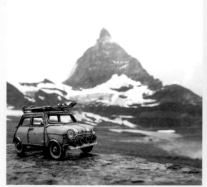

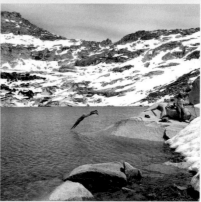

aupresdetoi
Venice, Italy
baptism
#latergram #vscovenice #vsco #vscocam #vs-
coitaly #vscoclassic #vscophoto #peoplescrea-
tives #whatitalyis #artphotogram . . .

irawolfmusic
Yesterday was a lovely last show in Nashville
before hitting the road for five months. Hard to
believe the new album and tour are just three days
away!
#TheGoWestyTour #Honest

travellingcars
Matterhorn
The... I'm-so-tired-I'm-falling-asleep-trying-to-
think-of-a-title-right-now kind of feeling. Can't
wait for the weekend. Off to short nap

hanifshoaei
Kathmandu, Nepal
Riding on a bus roof in #Kathmandu, #Nepal.
#Nepalphotoproject #photoktm

echtoby
Lyon, France
Under the bridge
#igerslyon #exklusive_shot #onlylyon #moody-
grams #lyoncity #shotaward #monlyon #under-
ground #underthebridge #rhone

zishaanakbarlatif
A boy is shocked into stillness by the sudden flight
of pigeons off marinedrive in Mumbai.
Photograph – #zishaanakbarlatif

zarialynn
Standing in front of a glacier is humbling. In an
effort to share this sublime experience as best as
I can, I am planning some very large drawings this
year! #NationalGeographicExplorer #lindbladex-
peditions @westonserame

carolina_ferrer_
It's official, @parkingpizza is now open, best pizza
in Barcelona, and also beat burrata salad get in
and check it yourself.

sharedwanderlust
I never miss the opportunity to hit my restart
button.

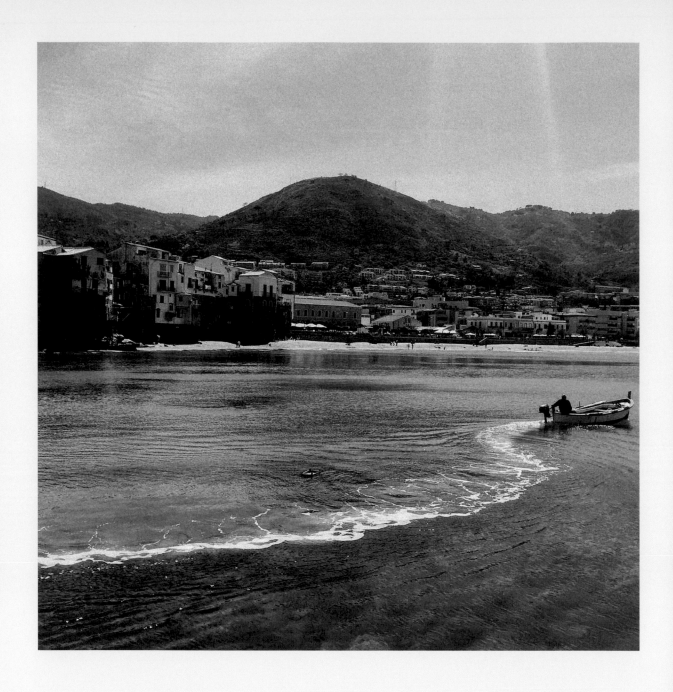

luccico
La Marina, Cefalù
Intanto i giorni passano…

churrito
Gran Via, Madrid, España
Always Madrid #madrid @dianamongealonso

luccico
La Marina, Cefalù
This is my entry for the weekend
hashtag project of Instagram :)
#WHPforeveryoung
Who is the youngest?

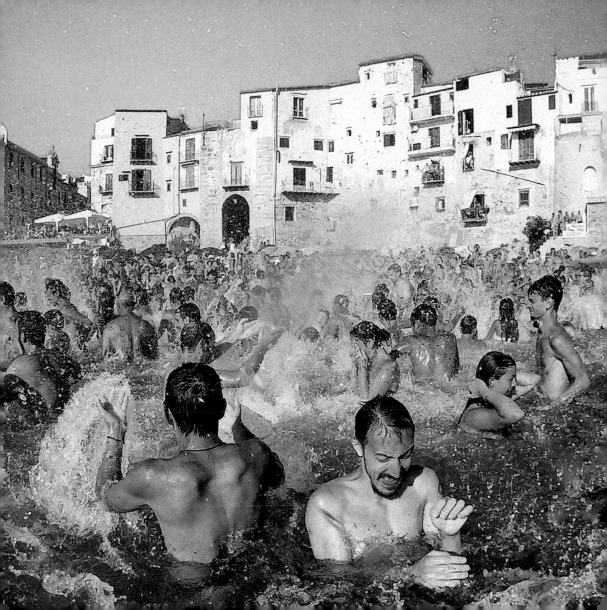

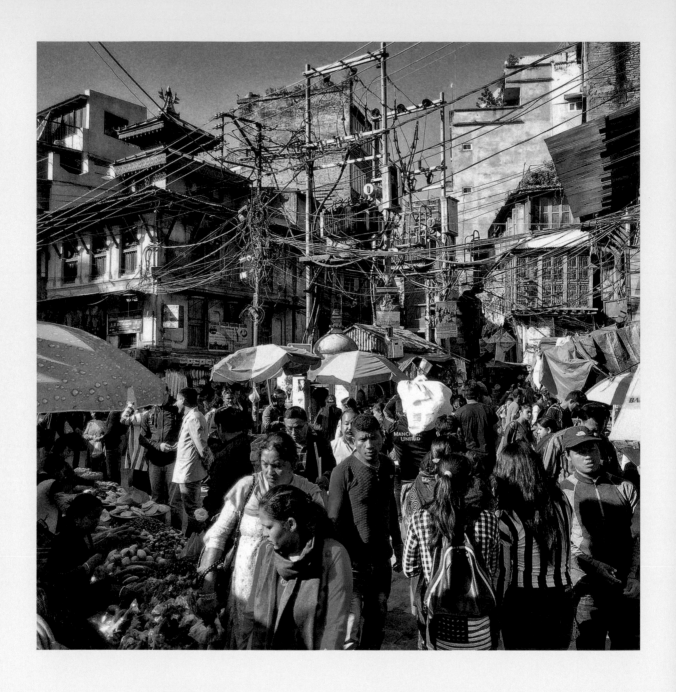

hanifshoaei
Kathmandu, Nepal
#kathmandu #nepal #Nepalphotoproject

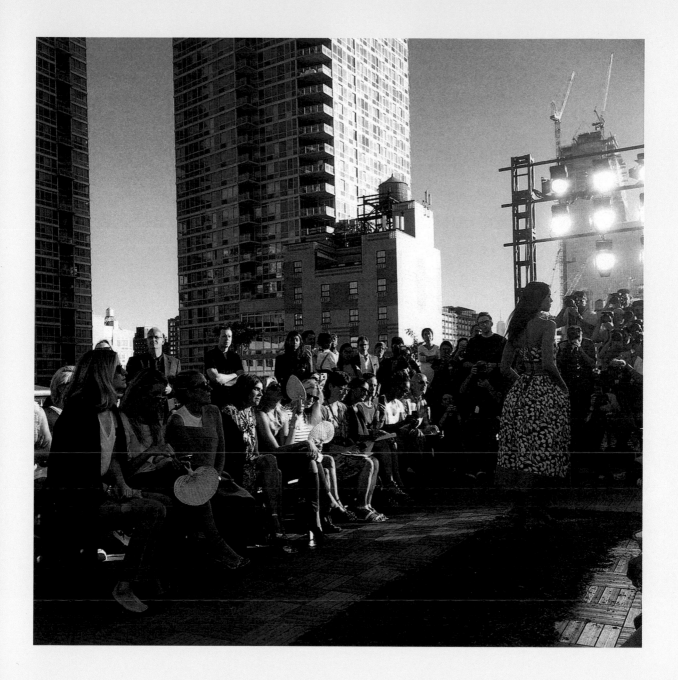

halesnew
Shop Studios
magical collection, lovely textile narration
@sophietheallet @_alexandrelahaye_ #synergy

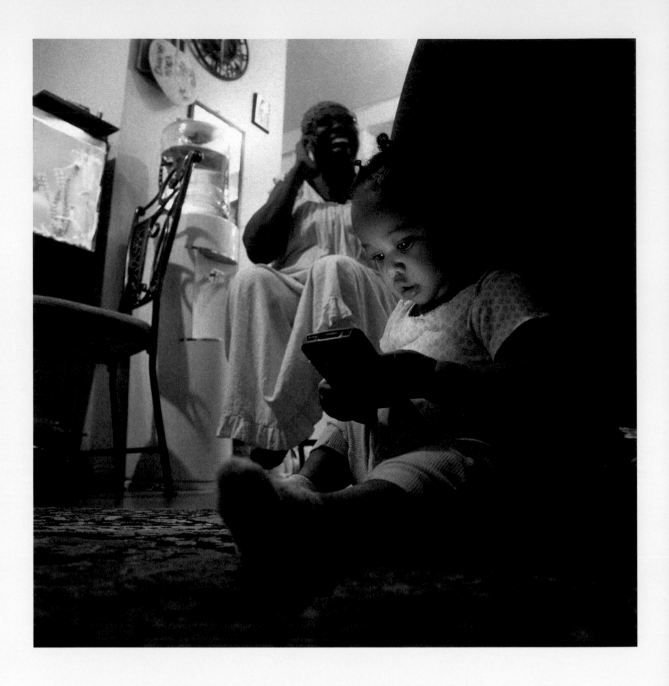

hermoseando
Beautiful family moments. From Honduras to The
Bronx. #garifuna #family #reportagespotlight
#love #everydaybronx #photojournalism #every-
dayusa #bxwomenshistory

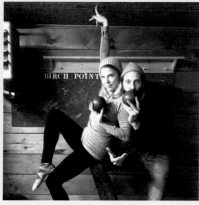

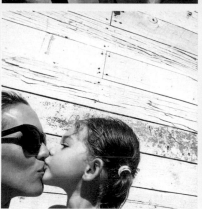
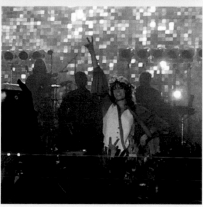

lonnypugh
Refinery Rooftop
#winningshot @urbandaddy

olimpiazagnoli
Sleeping at Grandma's.

gracemlau
#lit

fotolucida
Baby Lemonade • Syd Barrett

chris_mueller
Birch Point
Pre New Years w/ @hellokmueller @cogliantry
and @jencog

zoebuckman
#lastSummer #myCleo

halesnew
West Village
elegant moments w @snugglysadist

kierandodds
The Bank of China flies the flag opposite the
Bank of England. #bank #london #finance #china
#politics

pixie.zi
Atlas Arena
#florence #florenceandthemachine #fatm #lodz
#coÐpiÐknego #queenofpeace #vsco #vscocam

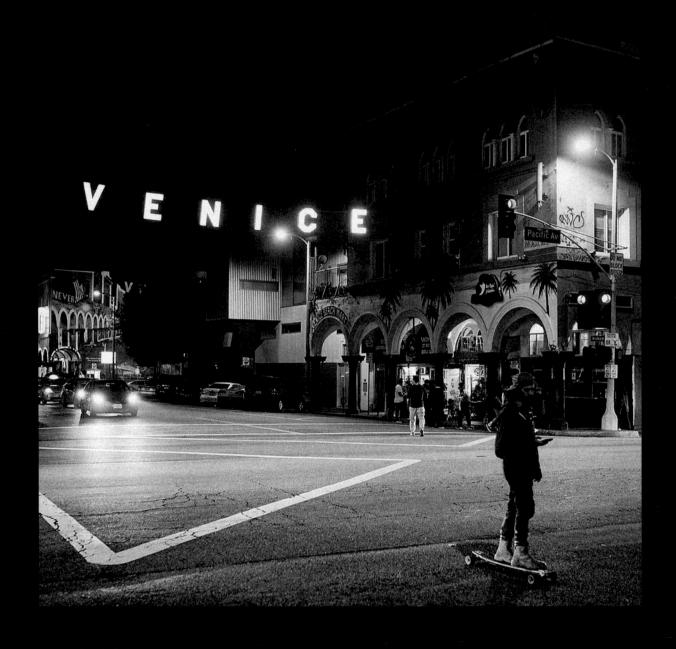

reycanlasjr
Los Angeles, California
classic or cliché?

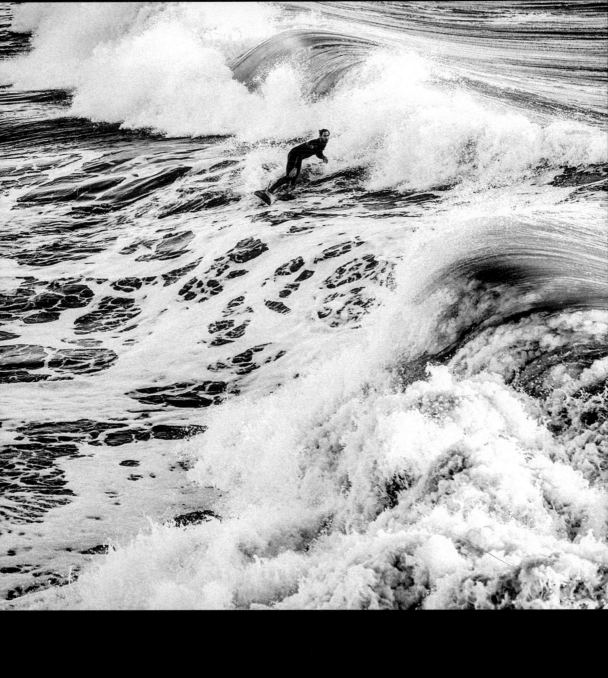

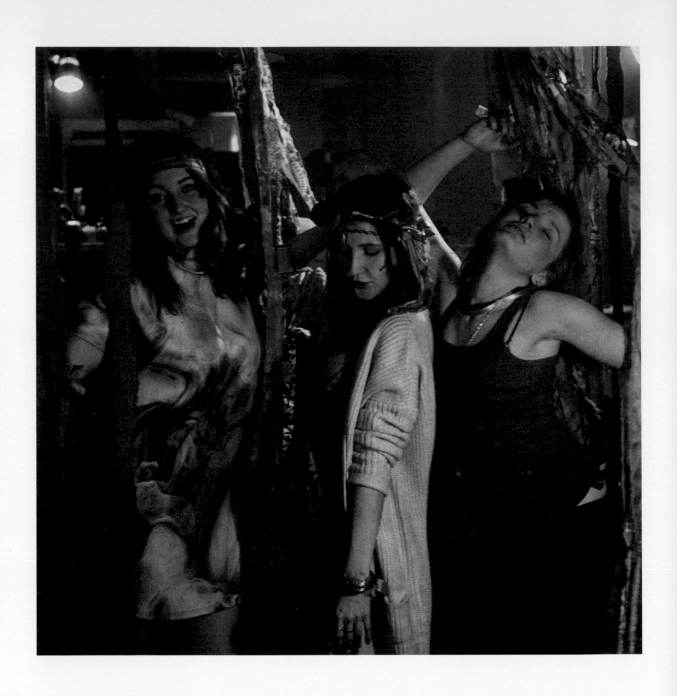

diana_lars
Циферблаг
Тем временем, пока половина моей ленты
продолжает постить цветочки, старина
Петербург снова покрывается снегом . . .

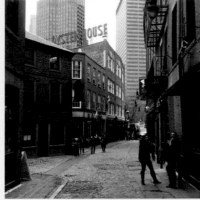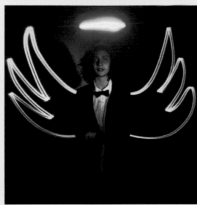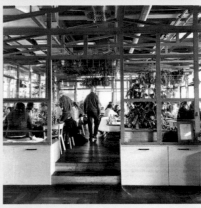

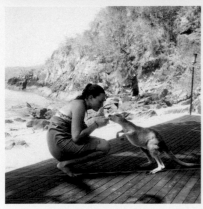

artist_cp
Monte-Carlo, Monaco
Someone thinks he's getting lucky tonight
@jamielegg29 thanks @jonnyboud for the snap
and amazing time at #lovebrunch

djasonnam
Union Oyster House
Many things about this exact location I like:
the smaller scaled buildings, cobble stone path,
and the Union Oyster House sign. — #Boston
#curvingstreets #djasonnam_travels #vscocam

dorina_wayfarer
Day Dream Island
#australia #kangaroo #ocean

chiaraluxardo
Beautiful #sunset #rooftop #concert in #down-
town #yangon #myanmar

arayan_photography
Nor Nork', Yerevan, Armenia
When you have an angel in your house,the only
thing left to do is to take a picture of her. Loca-
tion:Armenia Yerevan. Date:About 2y. #photogra-
phy #lightpainting #painting #light . . .

_foveola
splash! Festival
#latergram #splash18

lauragoodall
Uluwatu

youseful.dk
NENI Berlin / Monkey Bar
Neni Berlin | Budapester Straße | Berlin |
#restaurant #neniberlin #hotel #eat #food #lunch
#dinner #persian #spanish #urban #green #plants
#view #rooftop #style #lifestyle . . .

chiaraluxardo
#music #school #yangon #myanmar

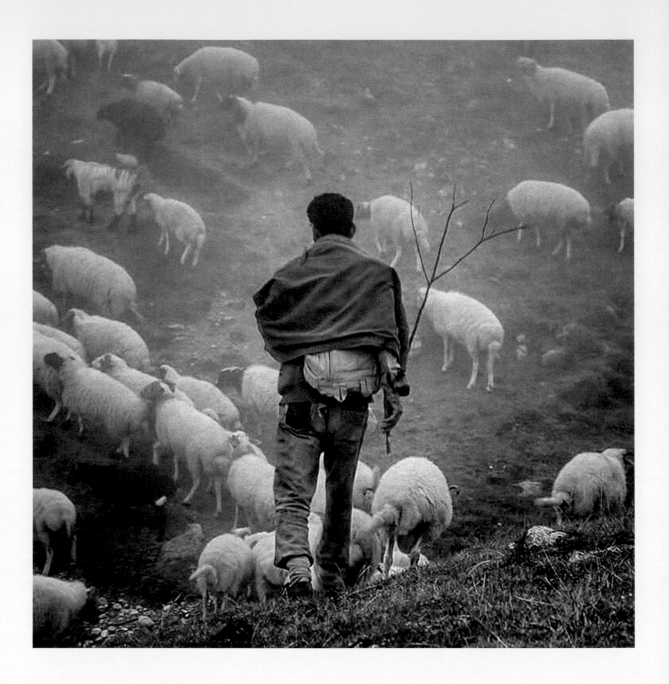

sadeghheydarifard
An Iranian shepherd and his Sheep in historical
forest of Siahkal
#iran #gilan #simply_noir_blanc #one__shot__
#burndiary #photojournalism #documentarypho-
tography #lensculture #hikaricreative . . .

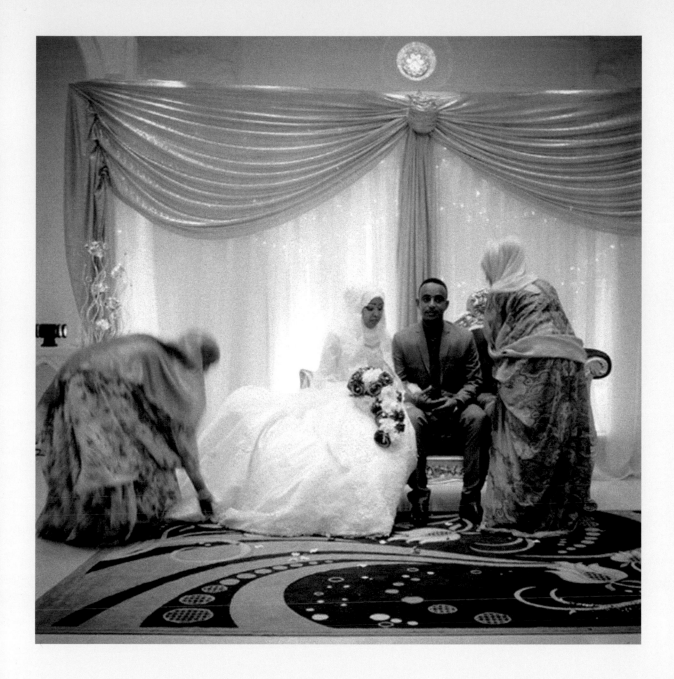

simona.ghizzoni
The wedding of Maha and Khadar. He's in the staff of Actionaid Somaliland, an NGO which advocates for eradicating FGM in the country. Hargeisa. Somaliland. #uncutproject #journalismgrant

anushree_fadnavis

A lady touches her phone to her head
while she prays in the ladies compart-
ment of the Mumbai local train.
I was sitting opposite her when this
lady got up and folded her hands and
started praying. Before she did that
she made sure that she removed her
feet from her shoes, a custom that
all Hindus usually do before praying,
something which my mom also does
in the train. After that she started to
pray, read some scriptures from her
mobile, I am guessing from some App.
Later she touched the phone on her
forehead, I am guessing there must
be a picture of her Guru or God in the
app. I guess she was standing and
praying for a good 2 to 3 minutes.
After that she sat and started listening
to a holy song from her mobile, again
I guess from the app.
In this busy Mumbai life everyone,
most of us, pray in our travel time.
I used to do it too I don't do it much
now because most of the time my
attention is on everyone inside the
train. In this changing world I have
loved the way technology has weaved
its way in our small little world. Earlier
women would carry scriptures, holy
books, small posters of God but all
that has been resolved by today's
technology. They carry pictures in
their phone and some like this woman
download apps. My mom hates it
when I disturb her while she is praying
so I didn't get a chance to speak to
this lady because she was praying
till the time my destination arrived.
#traindiaries

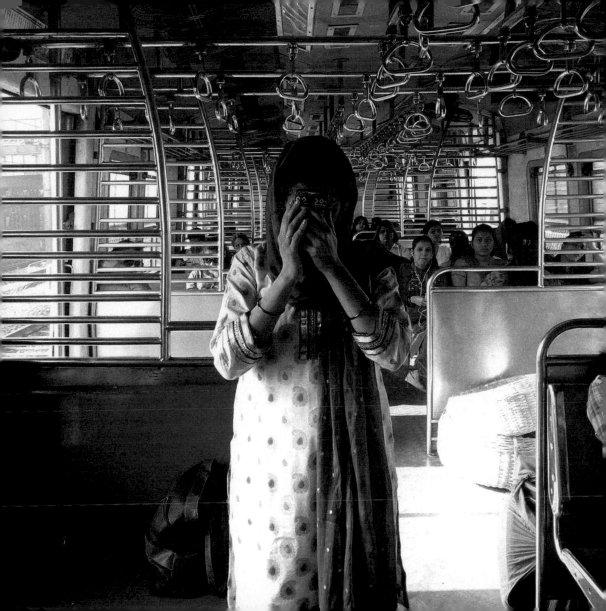

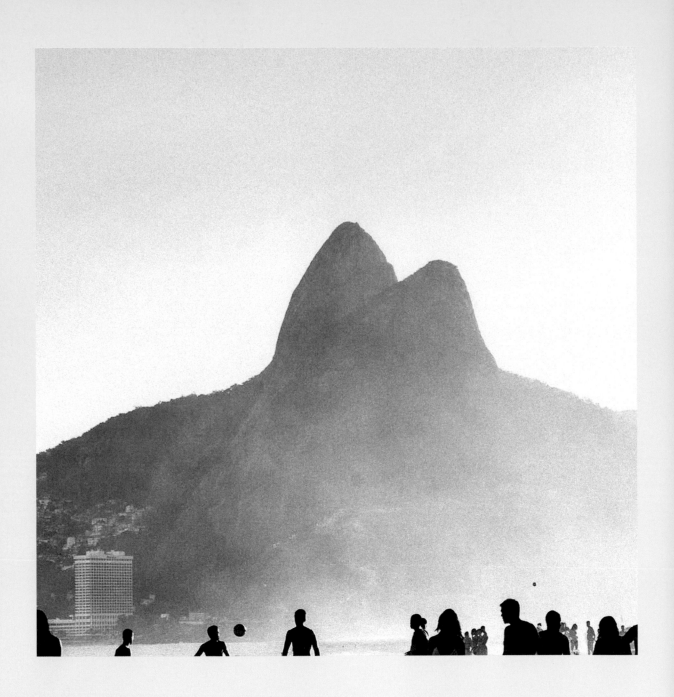

paulinhohop
Rio de Janeiro, Brazil
Parabéns Rio de Janeiro! Continue maravilhoso
cada dia mais!

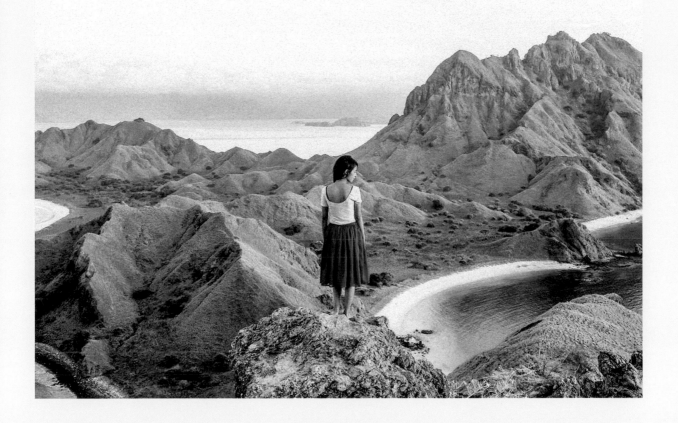

dailyaima
Padar Island
Who has cool weekend plans?
Still trying to plan mine

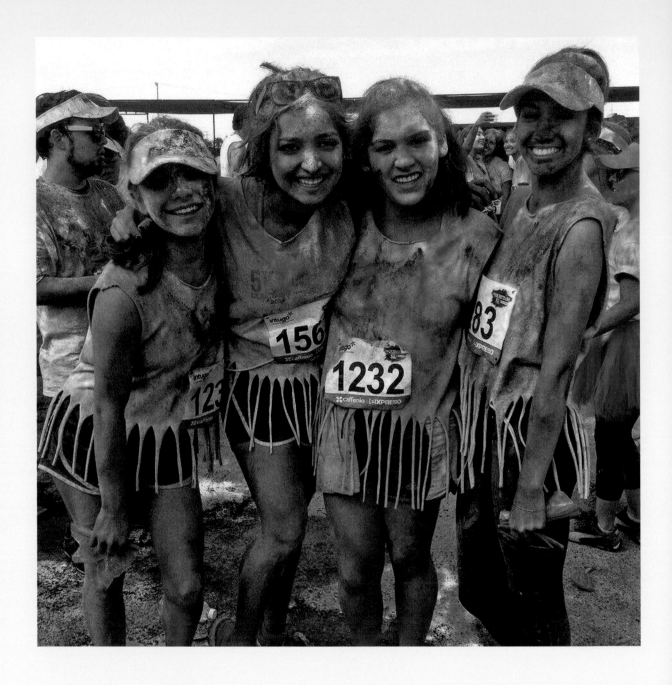

runaholic.mx
Mi color run favorita con mis amigas #corre
#womenrunning #halfmarathontraining #runitfast
#nikerun #colorrun #colorfun #runmx #runners
#running #fitness #fitgirls #fitnessaddict
#runhappy #runwithfriends #yoelegicorrer . . .

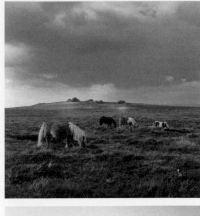

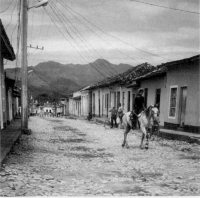

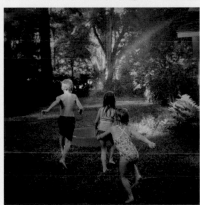
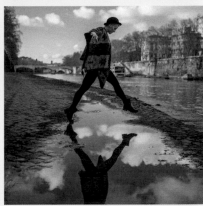
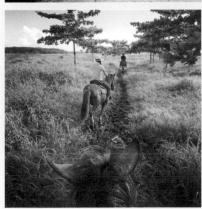
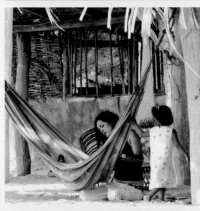
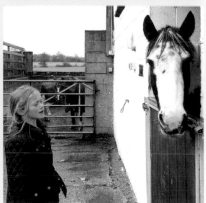

greenislandstudios
242/365 A family of wild #ponies let me get quite close on #Day242 of my #Dartmoor #365project in #Devon. Forgot to tell you I've been made an ambassador for Visit Dartmoor, the official tourism org for the Moor. Cool huh! #feelinghonoured

hellokmueller
Ready for action

taomeitao
Heading forward to 2016

mimi.wade
Hilles House
Me and Julio xxxx

la_mayte
Playa La Palma Sola, Michoacán
Buenos días!!

kinzieriehm
Watching the news around the globe today... It just felt like it was a good day for making rainbows. #lovewins #amazinggrace #WHPÐ

kajeh
Trinidad, Cuba
Colorful streets of Trinidad, Cuba

alessioalbi
Post n. 1000 on Instagram! :) thank you all for your support
Yesterday with @laura_zalenga_photography in Rome

bonzojones

mishkusk
Manly, New South Wales, Australia.
Manly locals going for a swim a
couple of hours ago. I was next to
them frolicking wearing a wetsuit
#ocean #underwater #sydney #man-
lybeach #documentaryphotography
#australianlife

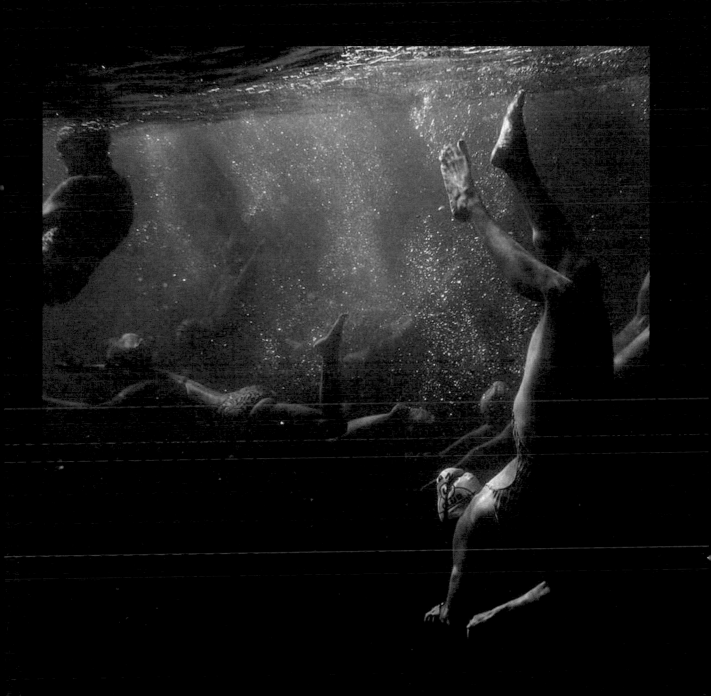

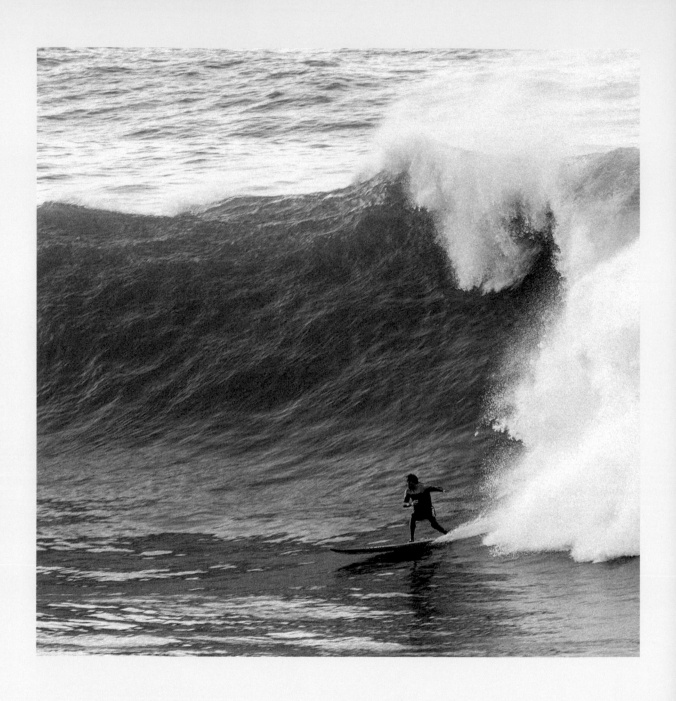

inigoagote
Donostia-San Sebastián, Spain
@indar inspiring people

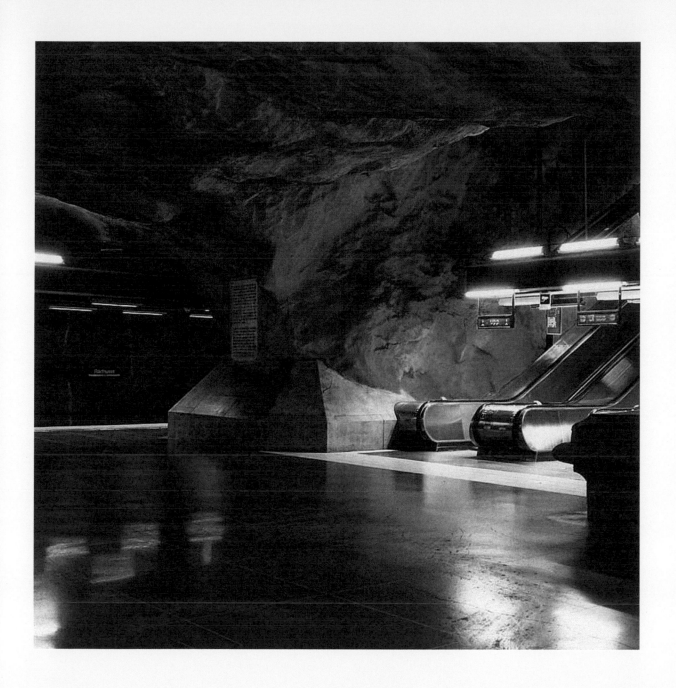

cimek
T-Bana Rådhuset
underground dressed in red.

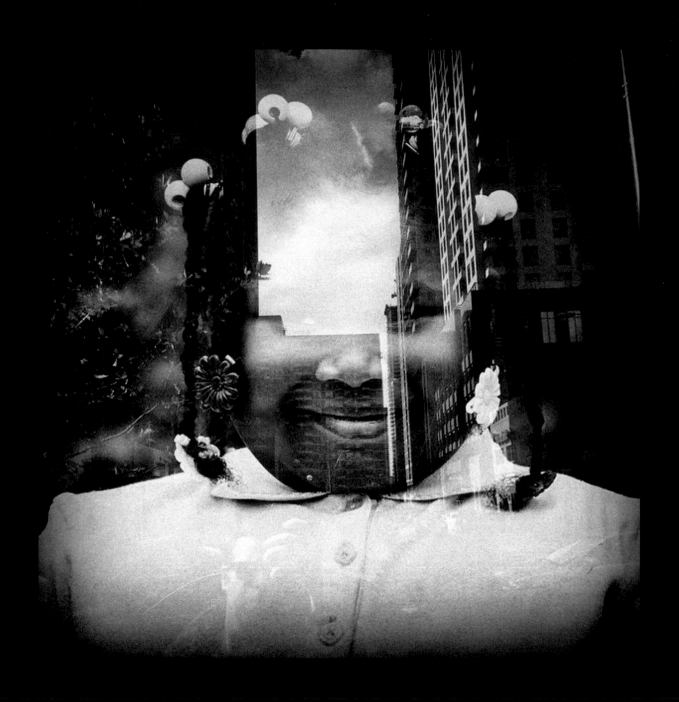

m_mateos
#bnw #stories #streetphotography
#outofthephone #hipstamatic #toronto

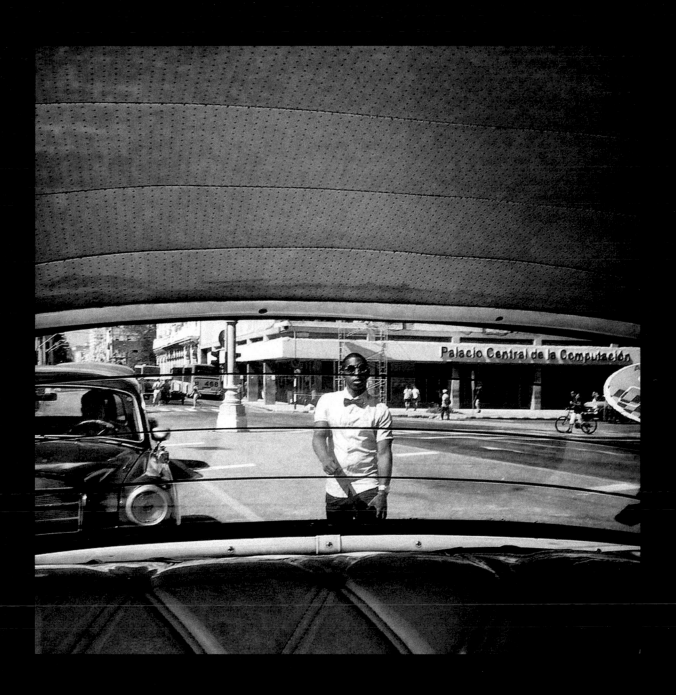

m_mateos
Untitled • Havana
#tinycollective

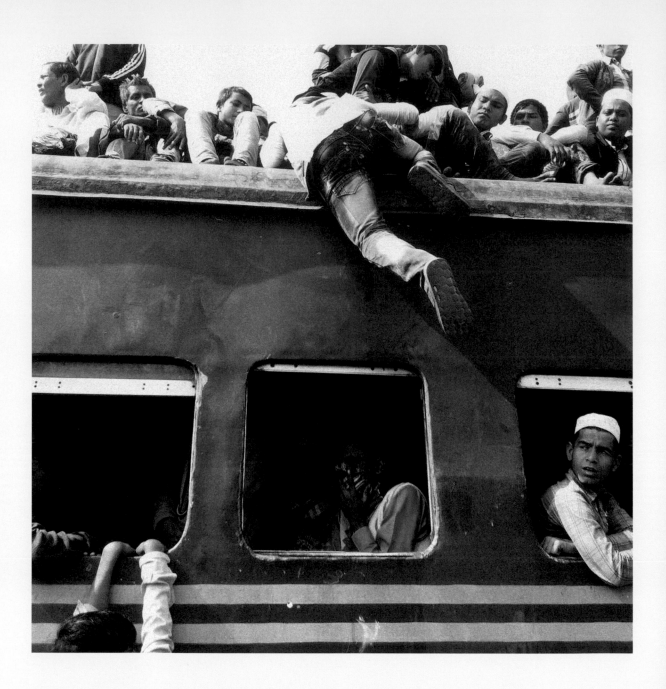

muradsfoto
Tongi Rail Station
Risky Journey
#istema #journey #people #dailyLife #risk #travel
#dangerous #iphoneonly #instabest #instadaily
#instagood #everydayeverywhere #every-
daybangladesh . . .

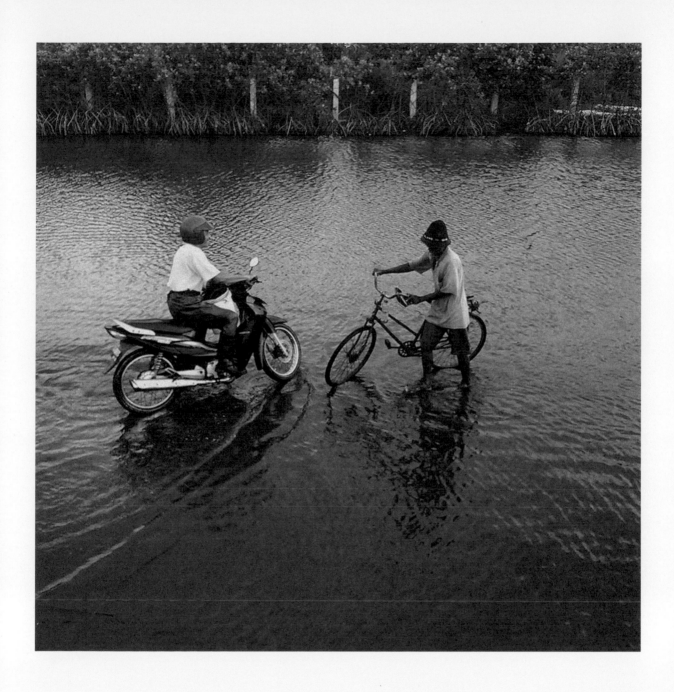

awoxsa
#whplocallens
#explorepekalongan

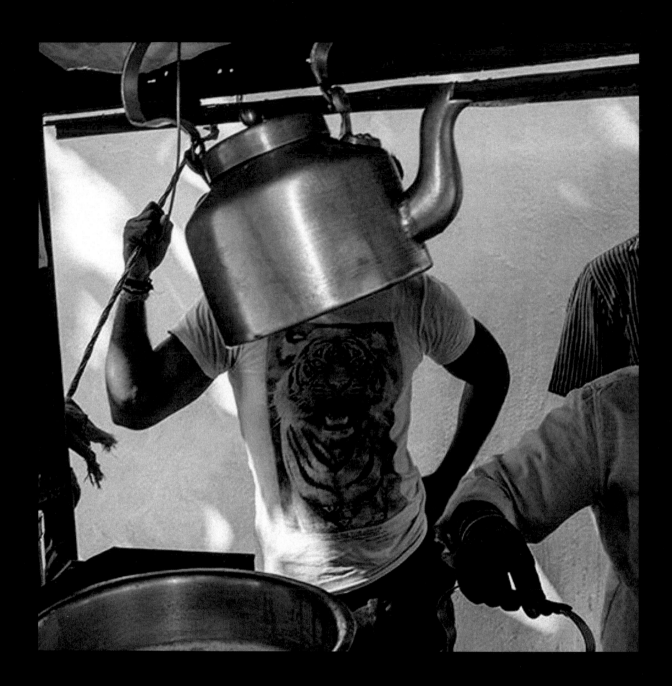

lookdoyousee
Kolhapur
The past few days have seen a dead phone come
back to life and a series of conversations with
@benlowy on the streets of Hyderabad and
Kolhapur. We discussed ways of seeing . . .

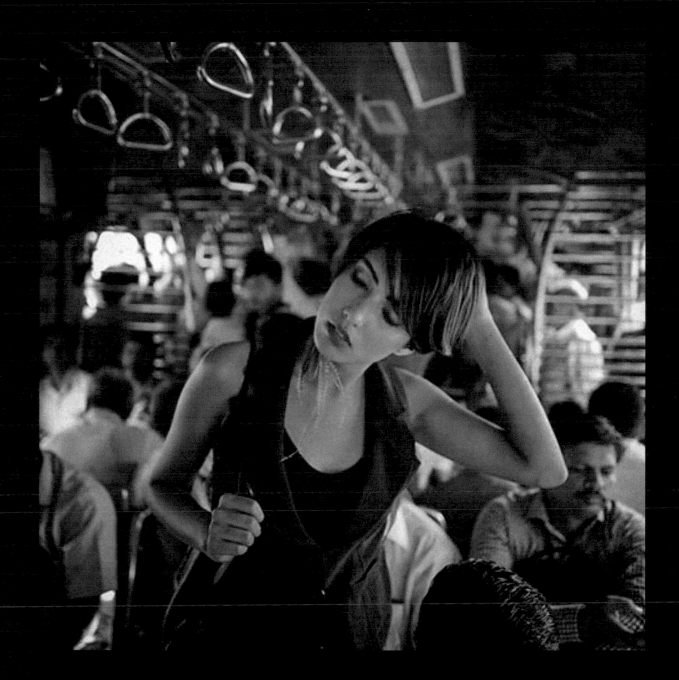

lookdoyousee
Outtake from an ongoing project, where
I photograph Teena Singh, as we wander
through this gorgeous city.

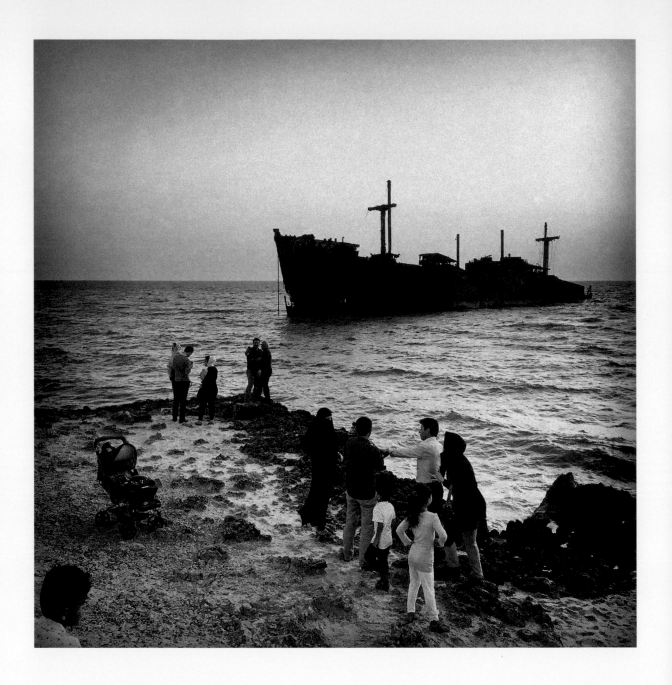

dakiloulou
Tourists strike poses and snap pictures in front of a stranded Greeek ship nobody ever had the means to remove, and the sun always sets #Kish #snap #picture #shipwreck #moderntourism #iran #persiangulf

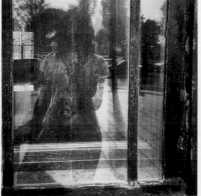

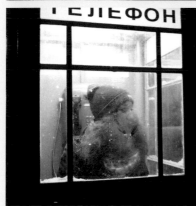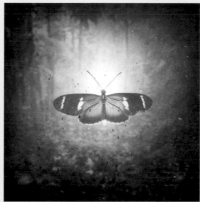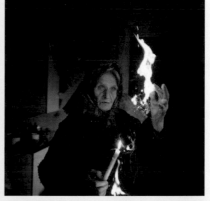

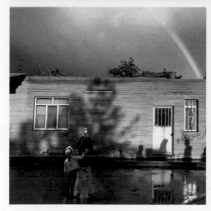

photoaskew
science fiction

elyasami
Тогда, когда любовей с нами нет,
тогда, когда от холода горбат,
достань из чемодана пистолет,
достань и заложи его в ломбард.
Купи на эти деньги патефон . . .

nastaran__fp
Mashhad, Iran
The kids are taking a photograph of the rainbow
at the entrance of a hospital.

sabrinaromahn
searching and finding

tonyinseattle
•
Thoughts, Untethered
Thank you to @hikari.creative for yesterday's
feature.
•

photoaskew
RW 'THE ONLY LIVING BOY IN NEW YORK' //
shot by @photoaskew. modeled by @seanpenn-
cils. styled by @jussydean. Shot on location in nyc.
#rareweaves

corasacher
Too many violence in this world.
#welovestgt#igersstuttgart#stuttgart#haupt-
bahnhof#stuttgarterhauptbahnhof#fassade#lich-
tundschatten#lichtspiel#farben spiel#sonnenli-
cht#dunklefarben#atmosphäre

markosian
In Rutka, Poland, Anna Bondaruk, 84, burns
horsehair to ward off evil spirits. Bondaruk claims
to have a direct connection to the Virgin Mary,
allowing her to heal people. There are about a
dozen 'healers' in eastern Poland . . .

churrito
Interior 2 #cuba #lahabana #havana #centroha-
bana

jsph
Chiang Mai, Thailand
So humbled to experience an early
start to Loy Krathong, which will fall
on the full moon this Wednesday,
November 25th. Originally started
to honor Buddha, Prince Siddhartha
Gautama. A celebration to shine light
and letting go of the past. Cleansing
your thoughts of negativity. Looking
forward to these next 2 days to
continue to celebrate this beautiful
tradition. #LoyKrathong #ChiangMai
#Thailand #jsphTH #festivaloflights

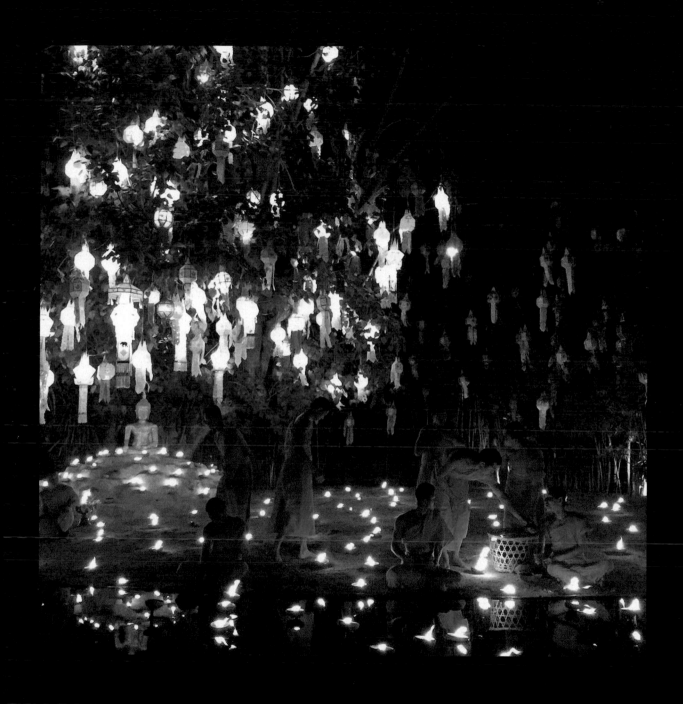

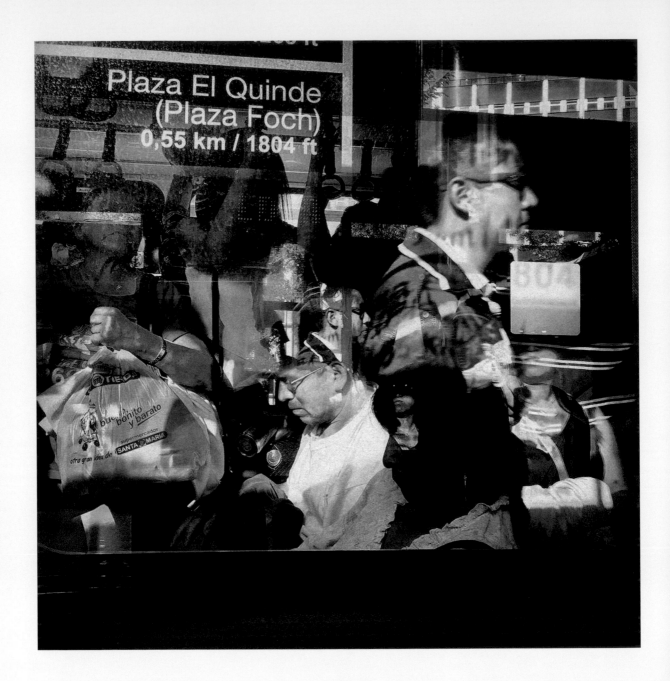

mishavallejo
Hospital De Niños Vaca Ortiz
QUITO-ECUADOR
Hot ride – another scene of my ongoing mobile
phone project #TomandoElBus in #Quito,
#Ecuador #EverydayEcuador @runa_photos

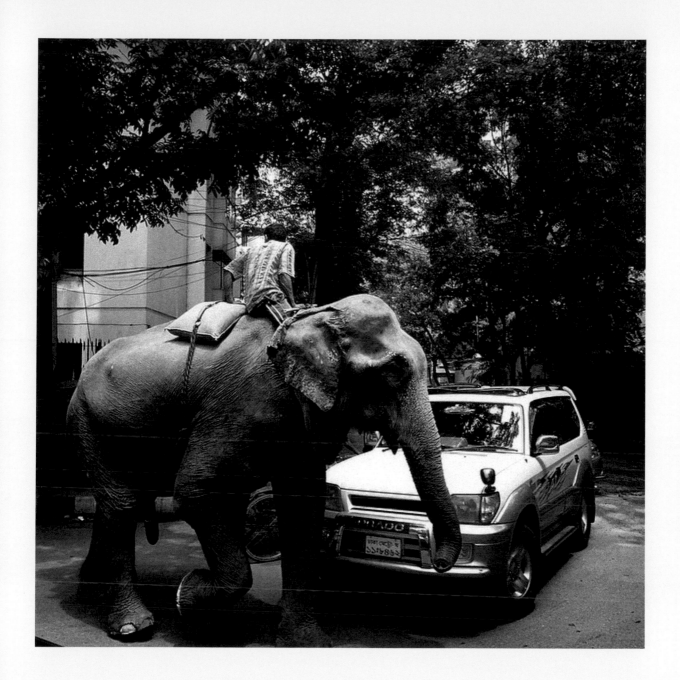

ismailferdous
Wonderland
Ah Dhaka again and its traffic elements!
#iphoneonly #dhaka #bangladesh
#dhakatraffic #gulshan #dhakastreet

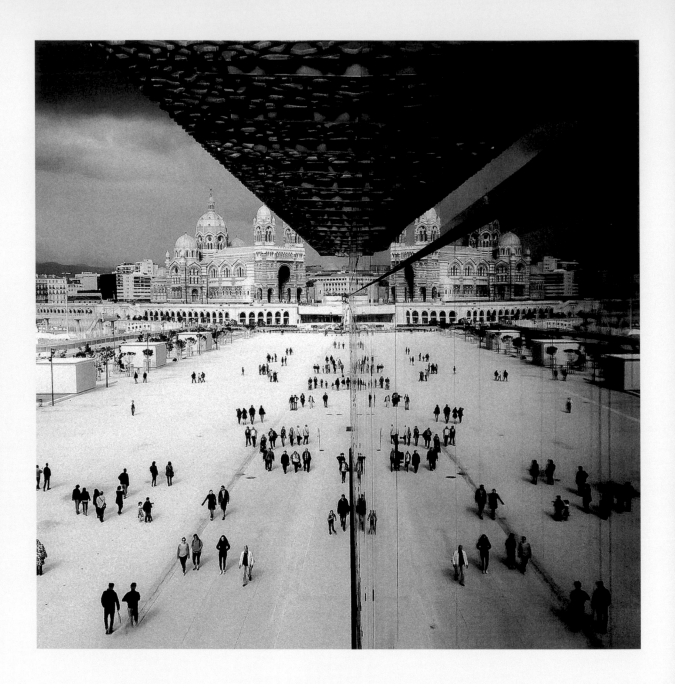

romdilon
Mucem
#WHPreflective @instagram #marseille
#JJ_Forum_1404 #talentsgp2016_archi

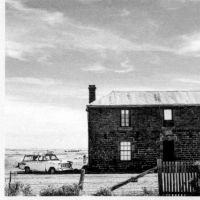
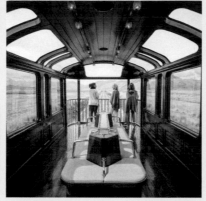
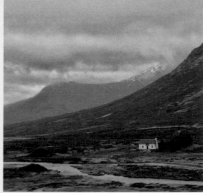

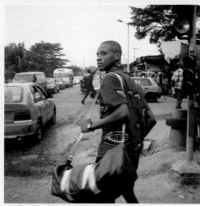
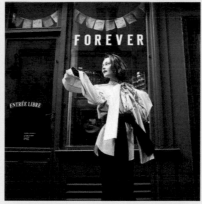
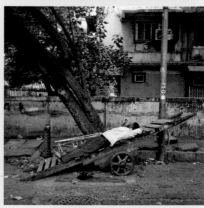

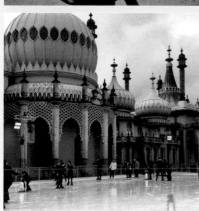
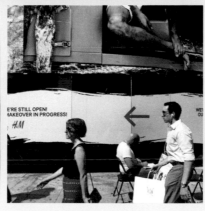
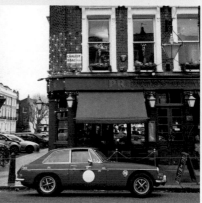

kararosenlund
Newstead, Victoria
On the highway.... Hello new house crush!
You have a lot of good things going on here.....
prepare to be stalked! #howaustralianslive

arristide
It's been too long for me to remember it all. It's
been eleven years in fact. Finally a son of the
motherland has returned home to recall a song
long forgotten. #civ #visiterlafrique . . .

lowfatroubo
What's Indian on the outside, Chinese on the
inside with an ice rink in the front garden? The
#royalpavillion of course #regency #excentric
#bonkers #brighton

seojups
Every time I travel this vivid sense of adventure
grows and changes constantly into new forms of
seeing what's upon me.

b.e.s.s.a.r.i.o.n
Beautiful
@daria_shapovalova wearing BEssARION
fw/16 #bessarion #paris #studio_verba
@moredashshowroom @annasnd

m_mateos
Humans

berriestagram
#dreamhome if I owned it,
I would paint the roof red!

banerjee.anurag
Recliner.
Khar.

a_ontheroad
London is...
...ready to ride on!
#london_is

mimi_brune
November Sundays are for comfort
foods. Especially when the snowflakes
outside are slowly whirling and end
up covering everything with a white
blanket of first snow.
That's why we eat warm pumpkin
soup with roasted seeds, smoked
paprika and a pinch of parmesan.
So rich and flavoury.
And most likely we will leave the
dishes unwashed till tomorrow.
Because who cares about the dishes
when you can cuddle up under the
blanket and watch the world get
whiter and lighter?

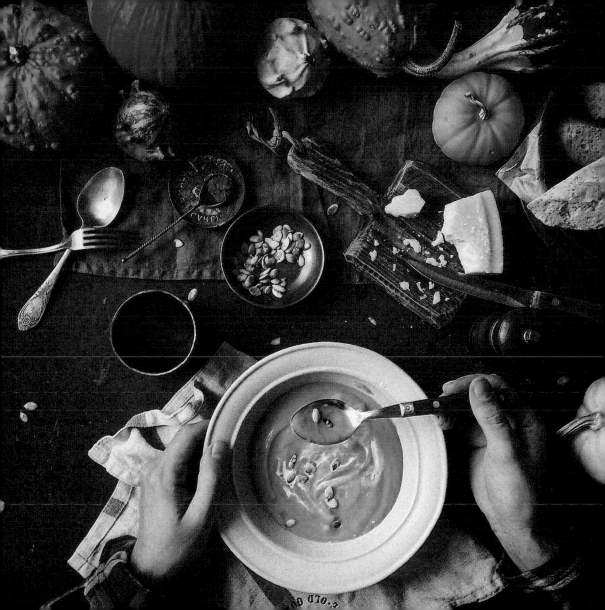

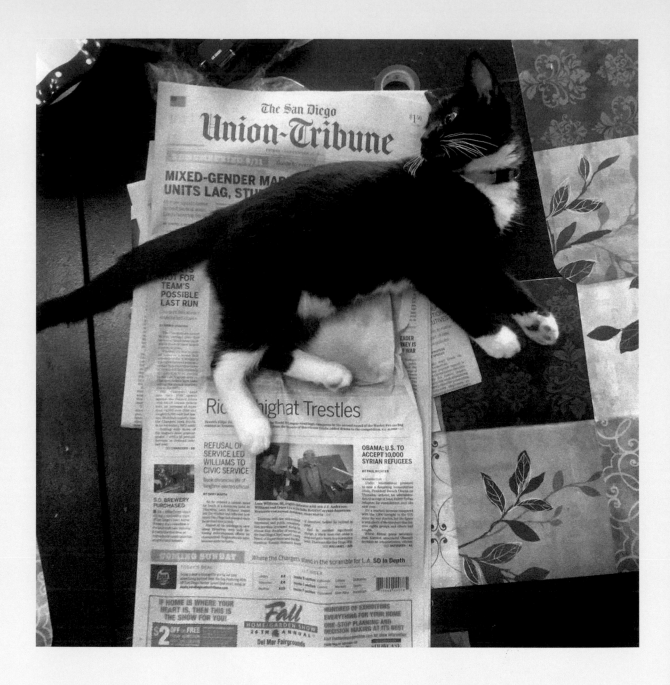

sandy_huffaker
Why do cats do this? Every time I want to read
my paper she just plunks down right in front.
#BadKitty

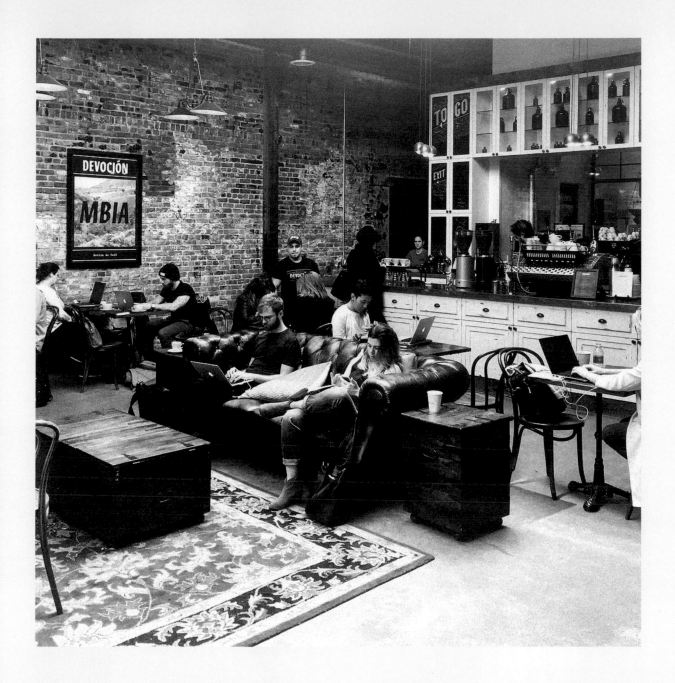

youseful.dk
Devocion USA
Devocion | Grand St | Brooklyn | #devocion #cafe
#coffee #coffeeshop #coffeetime #espresso
#juice #fresh #brew #colombia #interior #design
#interiordesign #raw #industrial #urban . . .

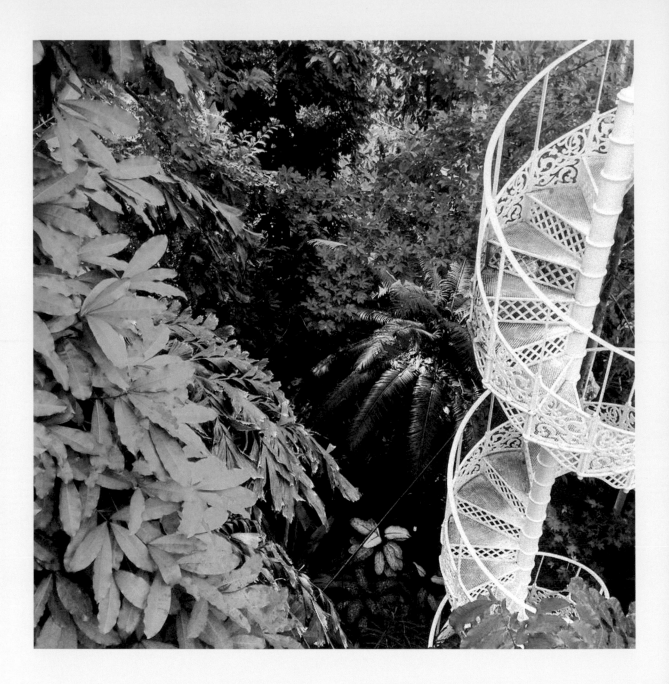

theerissara
Botanisk Have, SNM
#travel #traveling #TagsForLikes #TFLers #va-
cation #visiting #instatravel #instago #instagood
#trip #holiday #photooftheday #fun #travelling
#tourism #tourist #instapassport ...

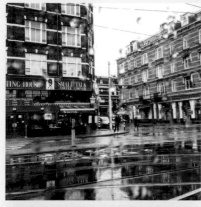 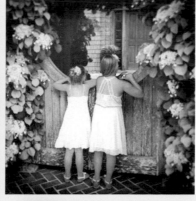 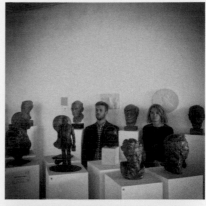

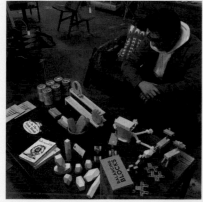 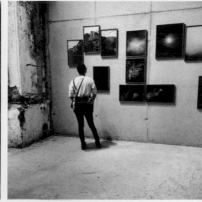

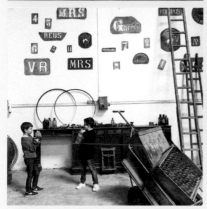 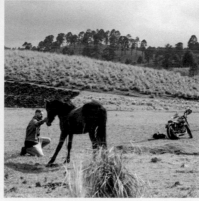 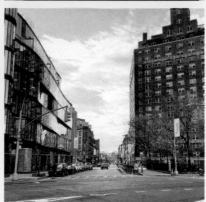

theerissara
Stedelijk Museum, Amsterdam
#travel #traveling #TagsForLikes #TFLers #vacation #visiting #instatravel #instago #instagood #trip #holiday #photooftheday #fun #travelling #tourism #tourist #instapassport ...

raaaqlkm
Beam & Anchor
My heart is overflowing with joy and gratitude #goodcompany #thankyouLord

monicatorne
Restaurant Vermuts Rofes
Tinc una idea... Fem una guerra de sifons mentre els pares fan el vermut?
-Siiiiiiiiiiiii

haytay1010
#mackinacisland #secretgarden #summertime #myloves

thesmartview
Apartimentum
A glance at the awesome photographic work of Arno Schidlowski exhibited as part of a group exhibition at the gallery of @dear.photography #dearphotography #apartimentum ...

seojups
Man chose machines over nature. From a horse to a motorcycle. But sometimes, some rare times, we go back.

spispispice
Royal Opera Arcade
Spot the live ones @officialalicebee @hen4dogbreath ...

_dersash
Stuttgart West

lonnypugh
West Village
#nyc #newyorkcity #newyorklike #newyork_instagram #westvillage #vsco #vscocam

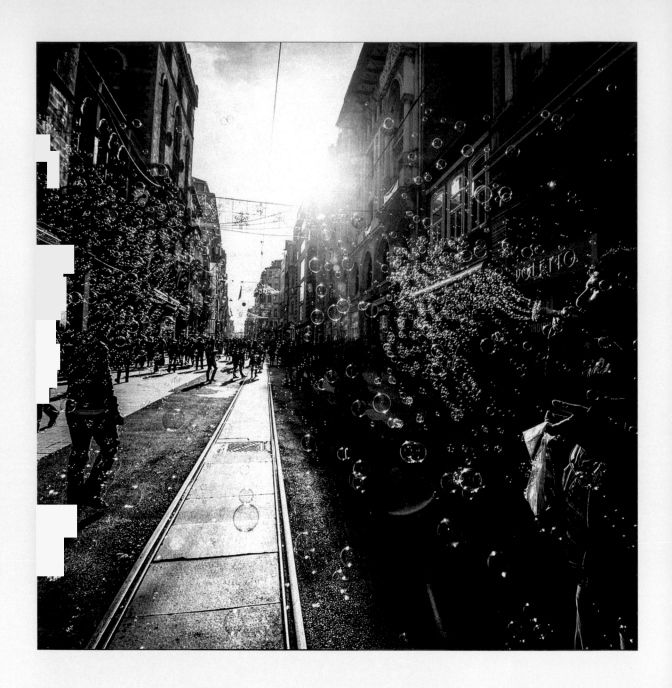

merichakan
İstiklal Caddesi
Güzel günler göreceĐiz...Güne li günler...

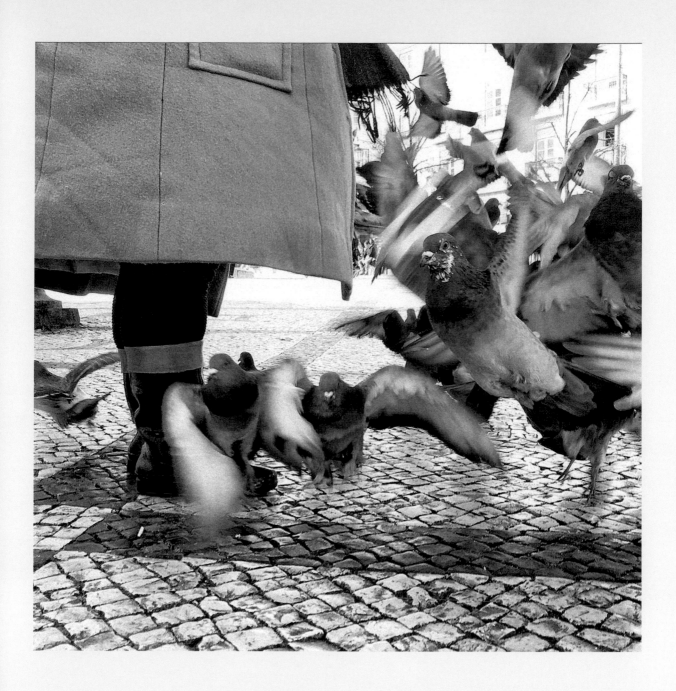

voodoolx
monday situation

saunakspace
Staten Island Ferry
This past weekend was lit – with the
moody queen @so.shauna at the
#PoPxMoody 'In the Mood for Love'
meet. Such amazing weather, such
amazing company, we couldn't have
asked for anything more. #pursuitof-
portraits #moodygrams

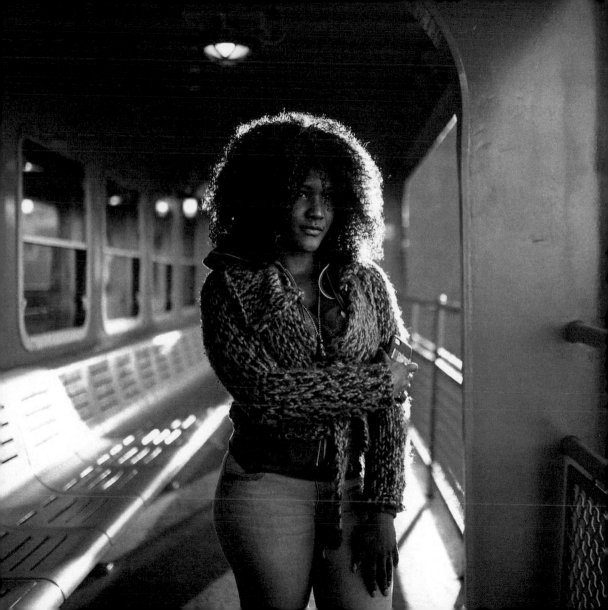

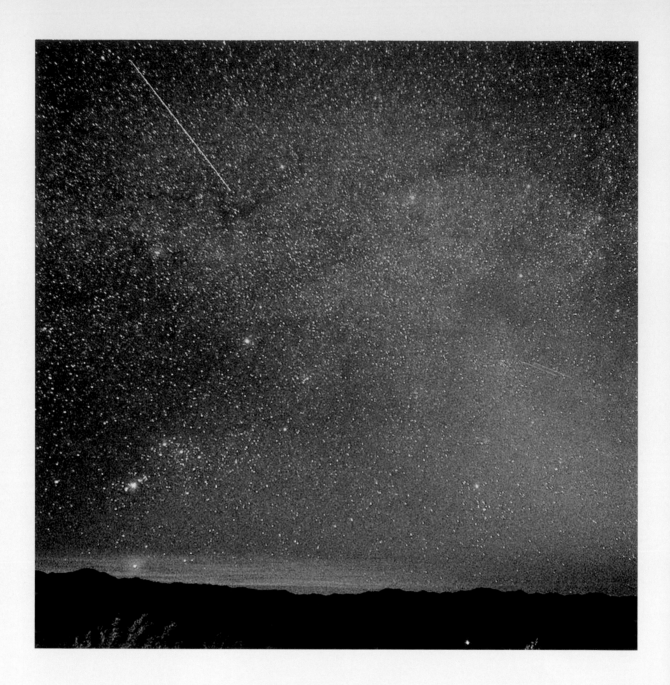

tatiruediger
Death Valley National Park
Silently, one by one, in the infinite meadows of
heaven, blossomed the lovely stars, the forget-
me-nots of the angels • Henry Wadsworth
Longfellow

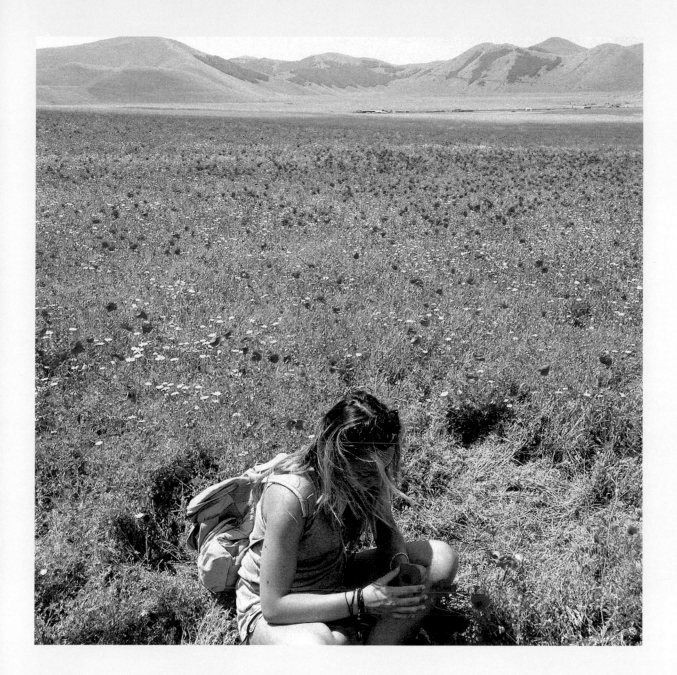

cecis.r
Castelluccio Di Norcia 1452 Mt.
• È come per il fiore. Se tu vuoi bene a un fiore che
sta in una stella, è dolce, la notte, guardare il cielo.
Tutte le stelle sono fiorite •

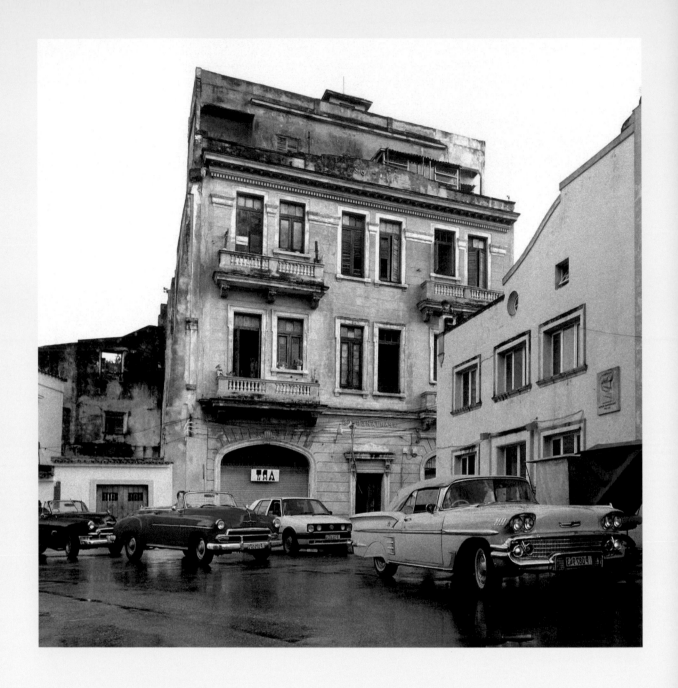

erbilkececi
Havana, Cuba
H A P P Y S A T U R D A Y
#küba #cuba #havana @instagram

sevilita
#selfphoto #me

eddiedaws

djasonnam
Divoká Šárka
I was a bit nervous co-hosting today's #instameet-prague, but look at all these awesome people who showed up! Thank you a million times. And thank you @instagram for connecting us together . . .

aliashollygolightly
From where I stand I can pick up my car and park it right.....

bonzojones

a_ontheroad
Alésia, Paris
It's nearly time to go home! I spent a lovely time here in Paris and I definitely couldn't leave the city without posting a last picture of it! I spotted this little guy yesterday during my late Christmas gifts quest!

chiaraluxardo
So many #amazing #women in #myanmar #dry-zone #cesvi

floradawson4

spispispice
Nike the Nature of Motion

kurtarrigo
Aeolian Islands
In between spaces.
#rolexmiddlesearace #aeolianislands
#calmseas #mediterranean

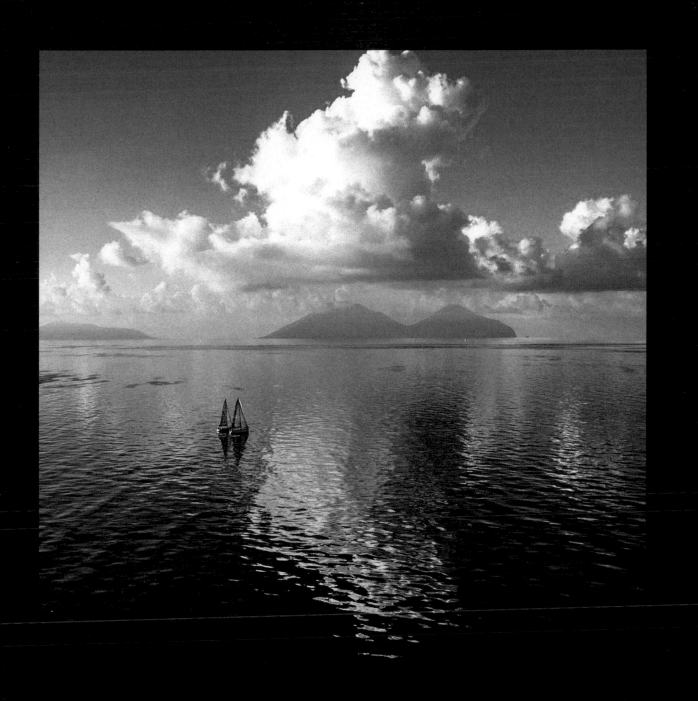

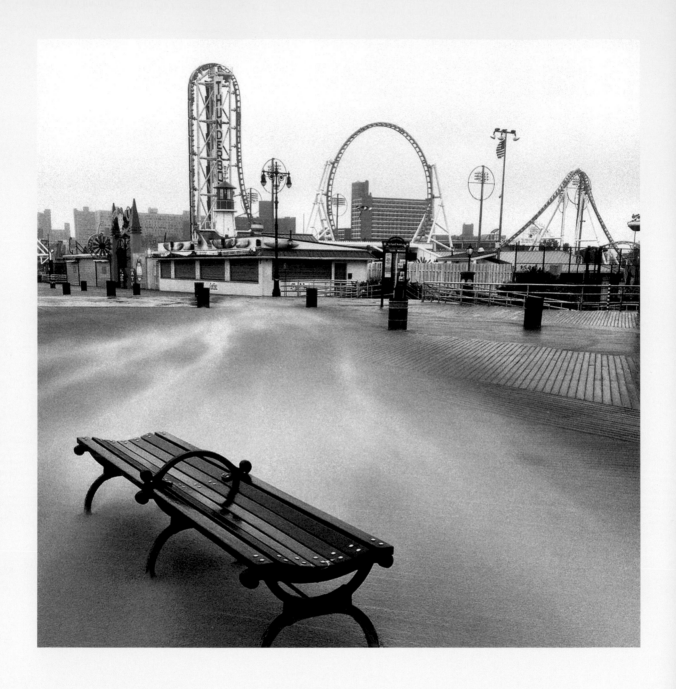

jamesrosen
Coney Island Boardwalk
#offseason

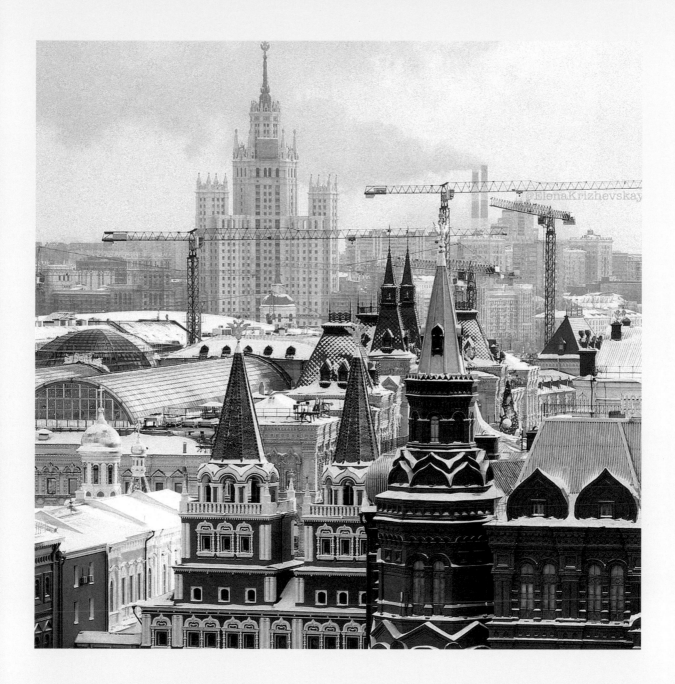

elenakrizhevskaya
Manezhnaya Square, Moscow
Доброе солнечное утро, друзья! На фото –
башенки Москвы! Good morning, friends!
The towers of Moscow
#russia_ww #igglobalclub #фотодляроссии

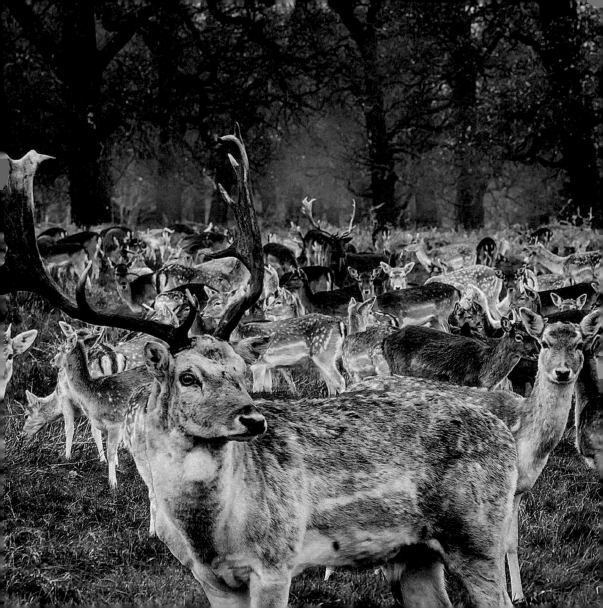

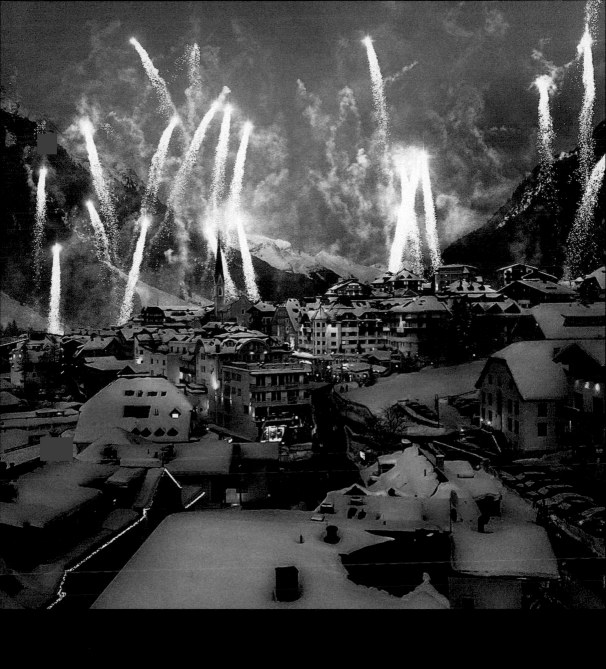

hobopeeba
Ischgl
Ишгль, Австрия, Альпы. Обожаю, как пишется
название этого городка на английском / Ischgl,
Austria, Alps

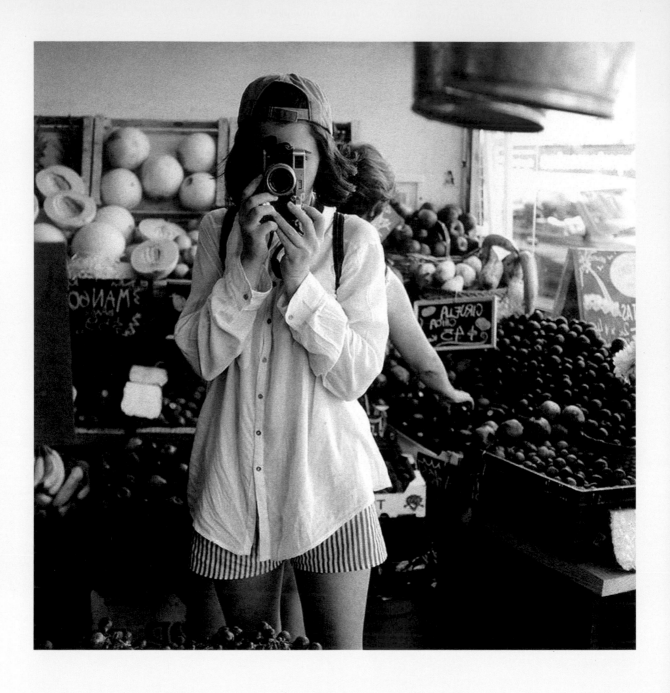

clementinaltube
uvas; el aperitivo de la tarde

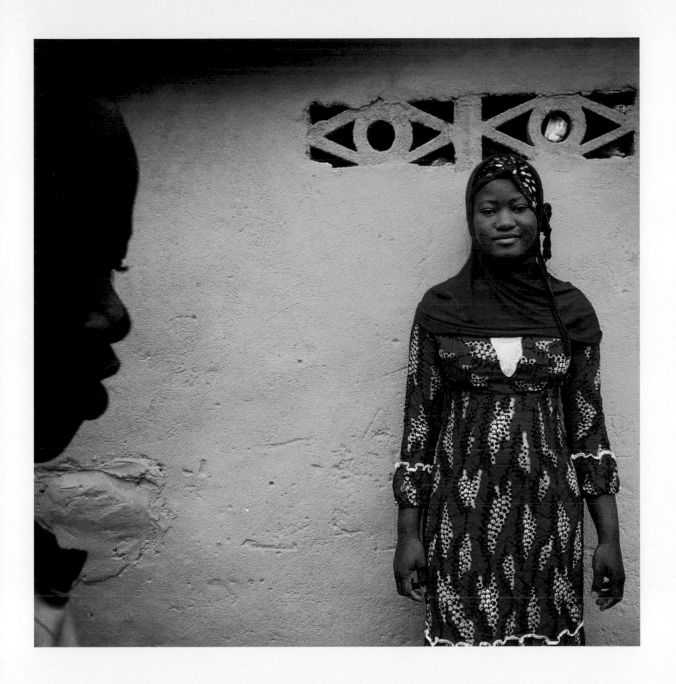

f64s125
Portrait of a Muslim girl #africa #abidjan
#cotedivoire

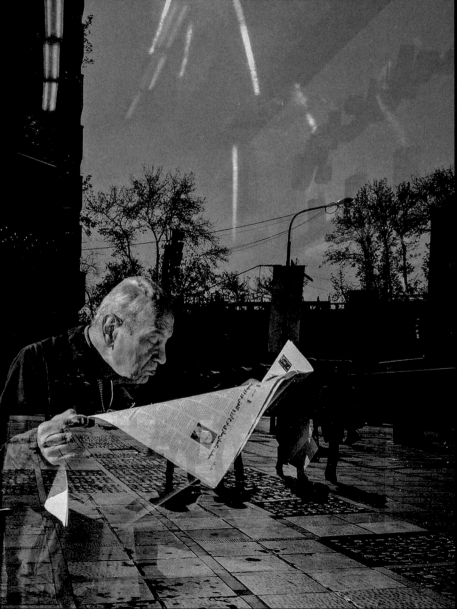

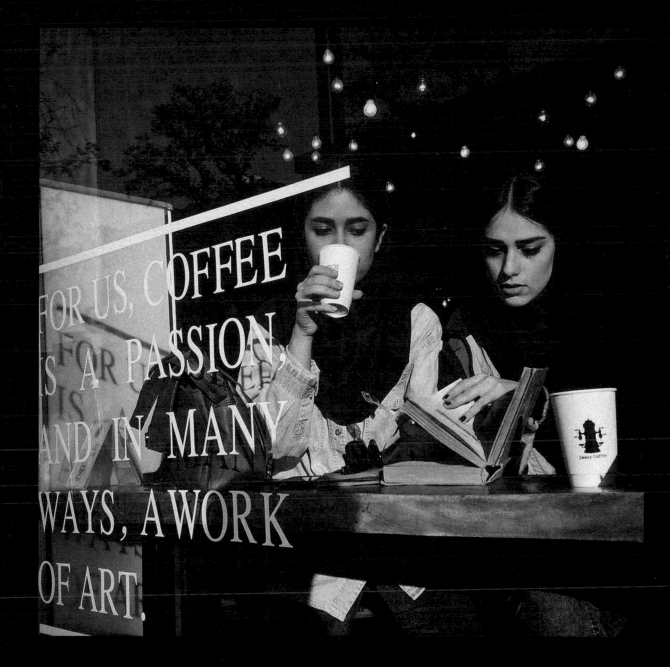

nesam.keshavarz
For us, coffee is a passion, and in many ways,
a work of art.
#Iran #Tehran #hikaricreative #lensculture
#outofthephone #1415mp #lamizcoffee
#womenandcoffee

luciazolea

 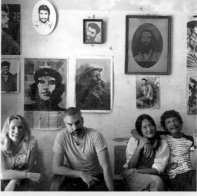

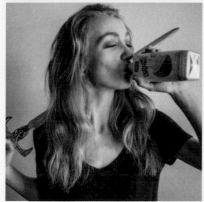 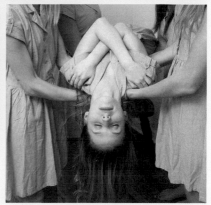

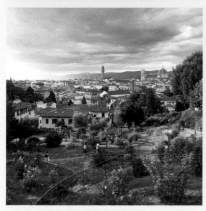 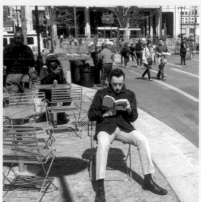 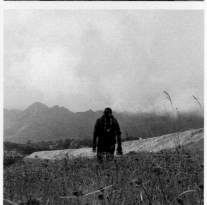

jhows_
Oscar Freire – Jardins
Agora é de verdade sem mais desculpas...
2016 e suas 325 chances restantes pra gente
tentar ser feliz

mermaideleh
outlierimagery
juice of arc

aedelweiss
Giardino delle rose
The Rose gardens #prettyasapicture #italian-
rosesinbloom #quirkystatues #italyiloveyou
#firenze2015 #firenzetiamo #piazzalemichelangelo

taomeitao
Hangin' with this cool cat Chino

sevilita
Green! #hartcollective

chuckseye
Dilworth Park
Don't you just LOVE a good book?

tatiruediger
Getty Center
50k!!! Thank you, thank you so much you guys are
the best #communityfirst

olivialocher
How to Trust (2015) cropped to for Instagram.
#olivialocherhowto

kingofmongols
Pali Highway
Embrace // Blackmill

haytay1010
Chicago River
He said he wanted to take a picture
at 'our spot', asked a random gentle-
man to take our pic, and then this
happened!
I said yes of course, and couldn't be
happier that I get to spend my life
with this man, my best friend and
soulmate. He had the sweetest, most
sincere words, which I later made
him repeat because I got so excited
I blurted out 'YES' right in the middle
of it lol. 3•21•2016
@ntelder #engaged #isaidyes #love
#perfectproposal

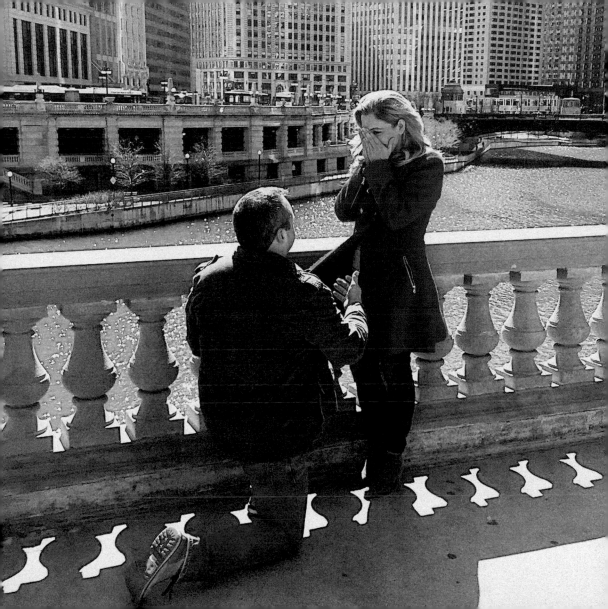

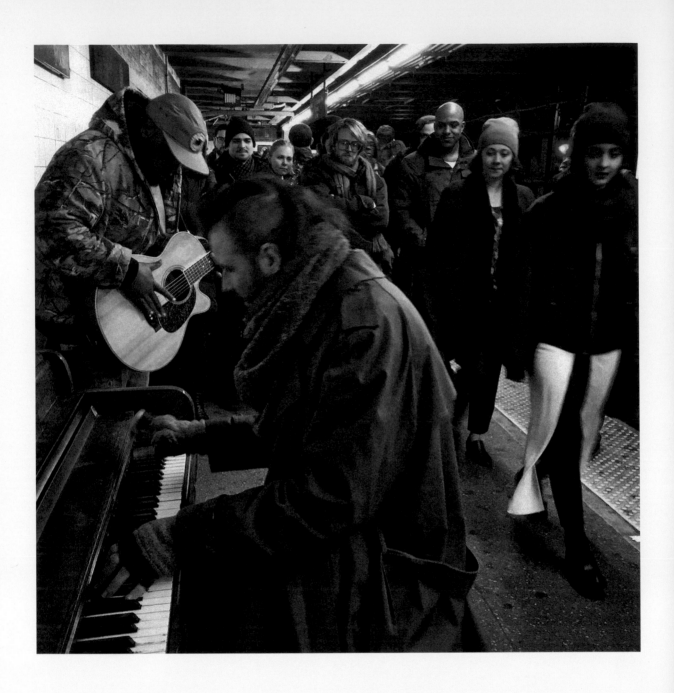

dianazeynebalhindawi
1st Avenue L Train Station
I don't know how they got this #piano all the way
down to the #subway platform, but I'm happy
they did. This was wonderful. :) #fridaynight
#Ltrain #eastvillage #NYC

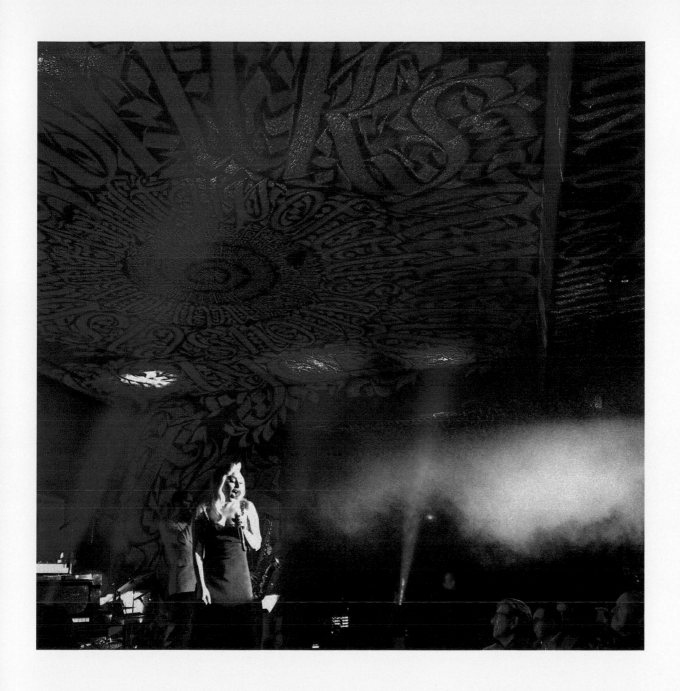

sdadich
SLS Las Vegas Hotel & Casino
Lady Gaga killing it tonight.

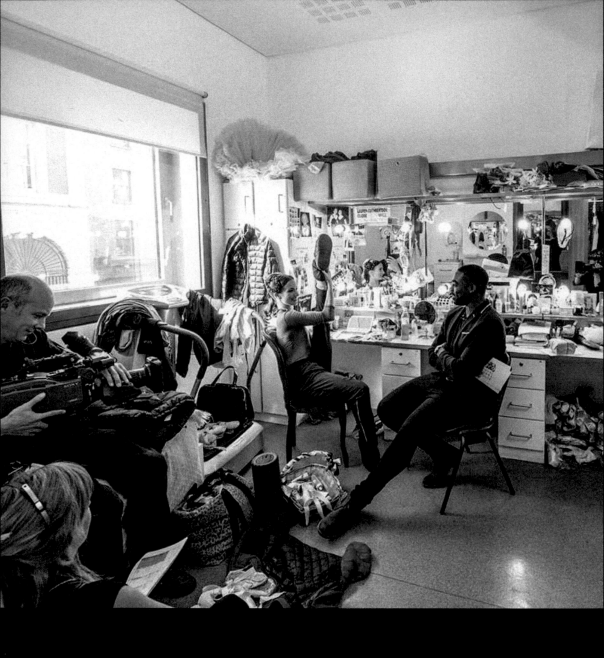

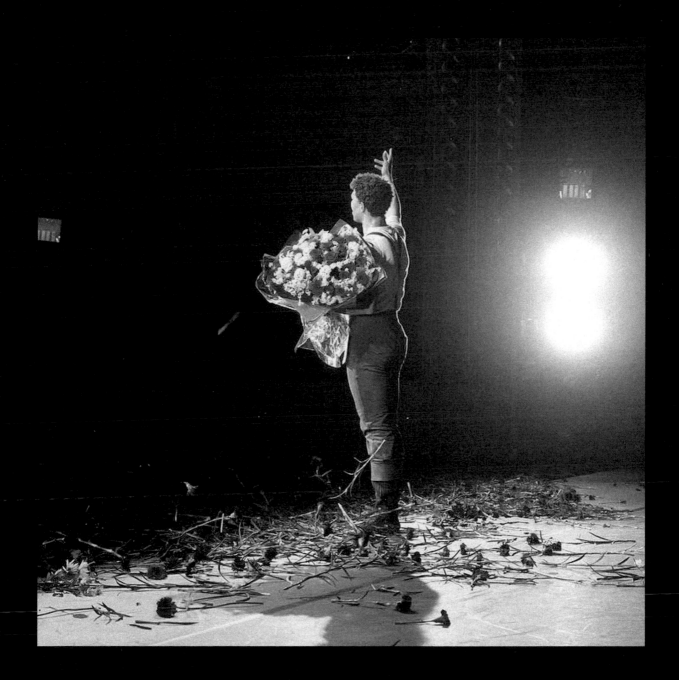

royaloperahouse
Flower power
Carlos Acosta's curtain call for his final performance with The Royal Ballet on the main stage of the Royal Opera House on 12 November 2015, performing Don José in Acosta's ballet Carmen
© 2015 ROH. Photograph by Andrej Uspenski

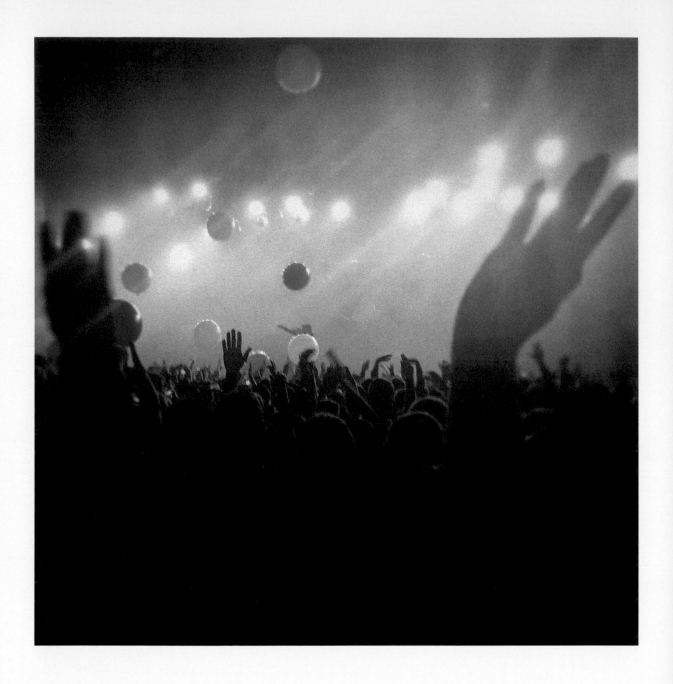

melanappe
Le Dôme de Marseille
Je ne me sens jamais aussi seule que quand
la fête bat son plein
#nekfeu #feutour #seinezoo #marseille
#marseillerebelle #concert #lefeu #rap
#rapmusic #vscocam #music #bestconcert

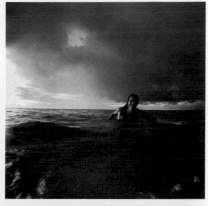
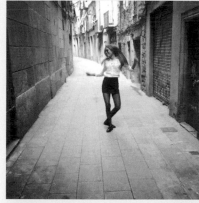
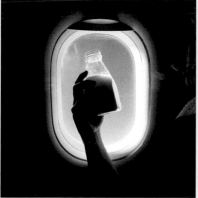
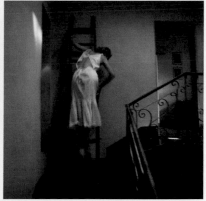
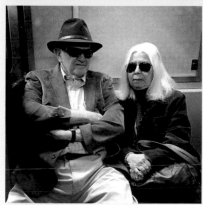
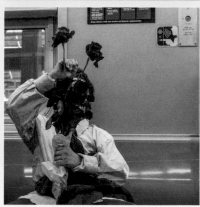
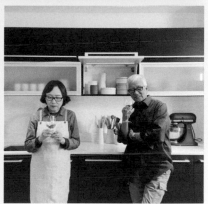

littleredapple
#glastonburytor

camilla_engman
#davidbowie

hellosearah
summer nights

iamnicolem_
Los locos abren los caminos que más tarde
recorren los sabios.
#livingLaVidaLoca #spazierengehen #good-
People #goodday #celebrateTheLittleThings
#yeah #photographies #street #doors #walking . . .

iringo.demeter
Sitting on a chair, in the sky.

simona.ghizzoni
Marina Bay, Marina Barrage
selected works #photomedliban2015

bro_ker326
#nyc, #newyorkcity #lensculture #streetpho-
tographer #streetphotography #1415mobilepho-
tographers #subway

juancristobalcobo
NYC Subway
Roses in the subway. Dressed up and arranging
the bouquet on his way to a celebration.
#nycsubway #flowers

mimiochun
Mom & Dad Enjoying the Props #shootday

jitskenap
Warehouse Elementenstraat
Let's share more love in the future.
My thoughts go out Paris while I am
at @welcometothefuturefestival !
More french kissing for a better world.
#welcometothefuturefestival #jes-
uisparis #paris #sharethelove #love
#jesuischarlie #love #kissing #kiss
#frenchkiss #amsterdam #whare-
house @xoclickchick #clickchick

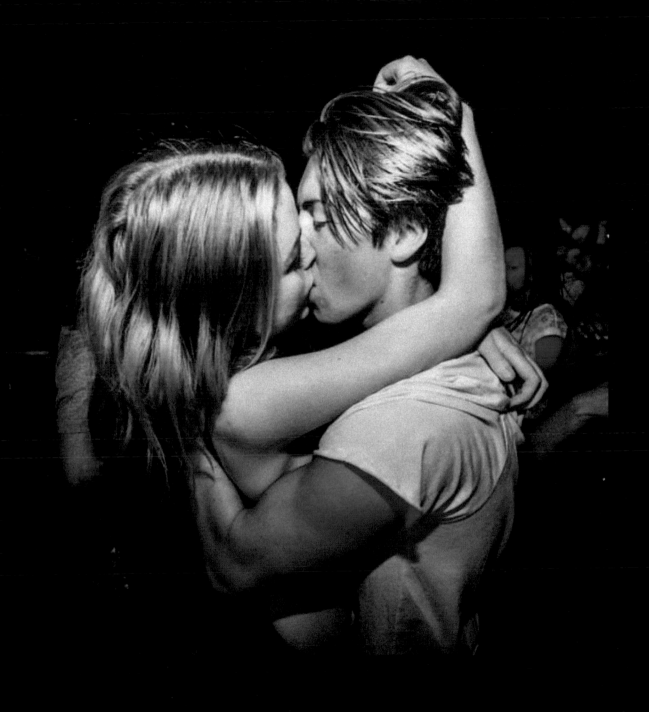

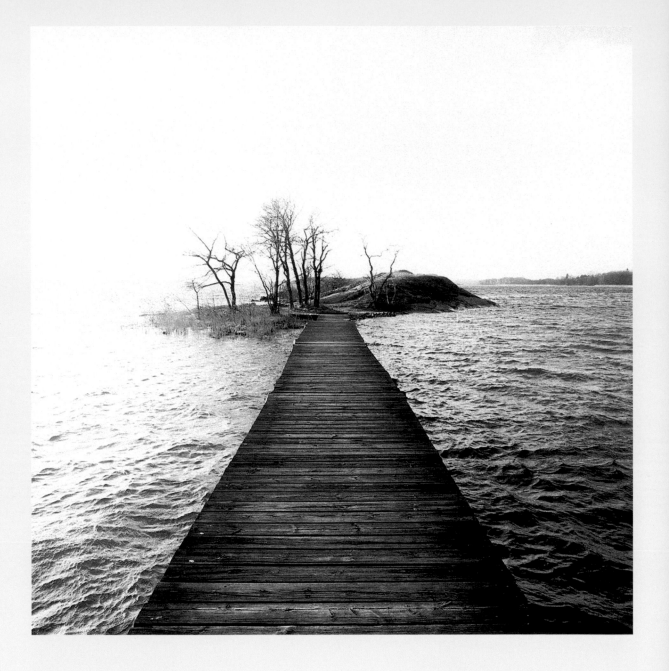

locarl

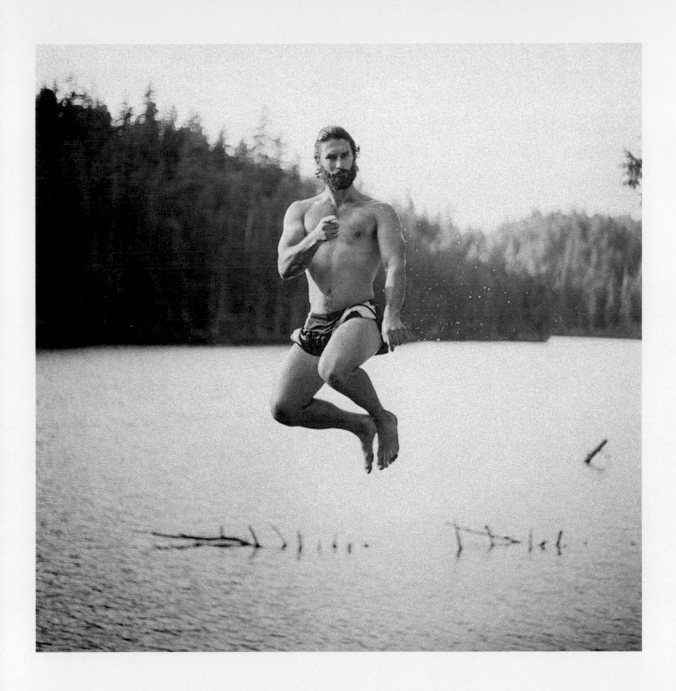

richcrowder
Smokey the Bear says 'Only you can prevent
forest fires' @btrap thanks for take the leap. #pnw
#bc #canada

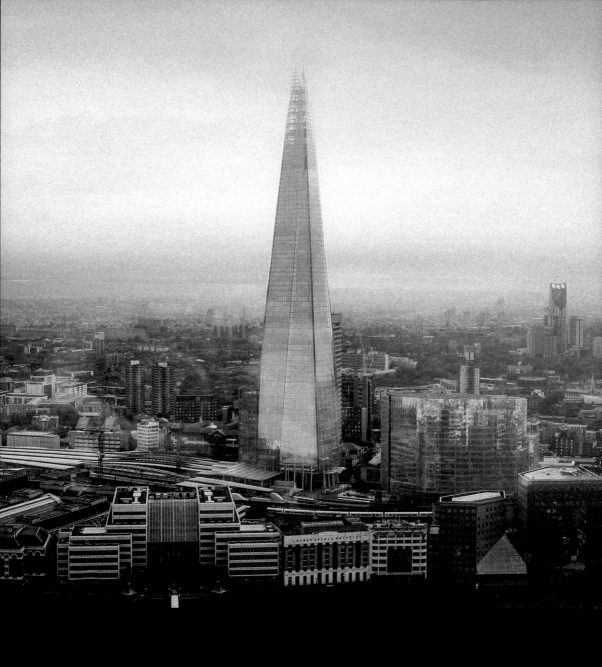

piergiuliocaivano
The Sky Garden
{ unusual sight }
• a different view of a classic London •

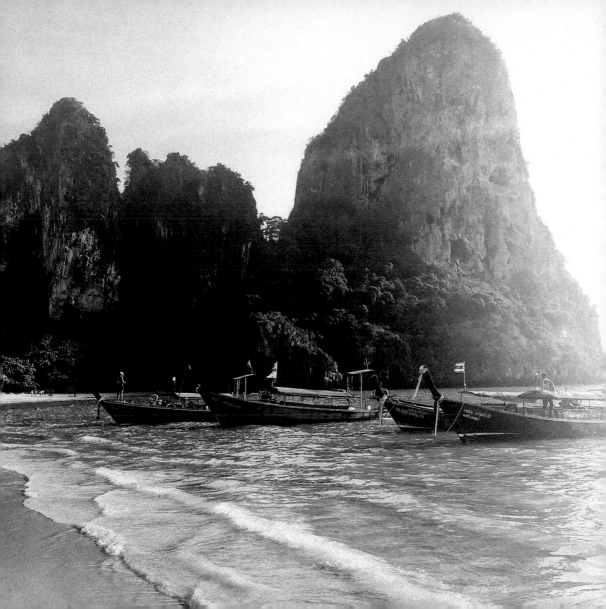

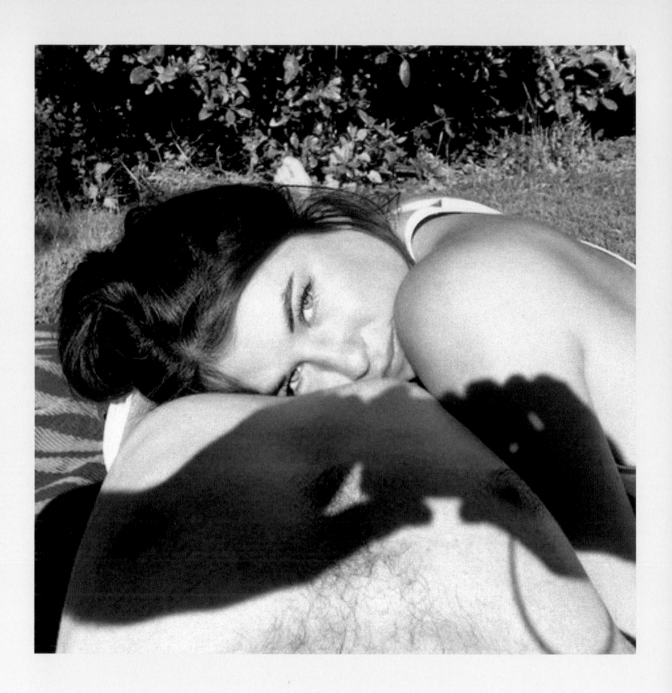

yandelli
@nataliesytner

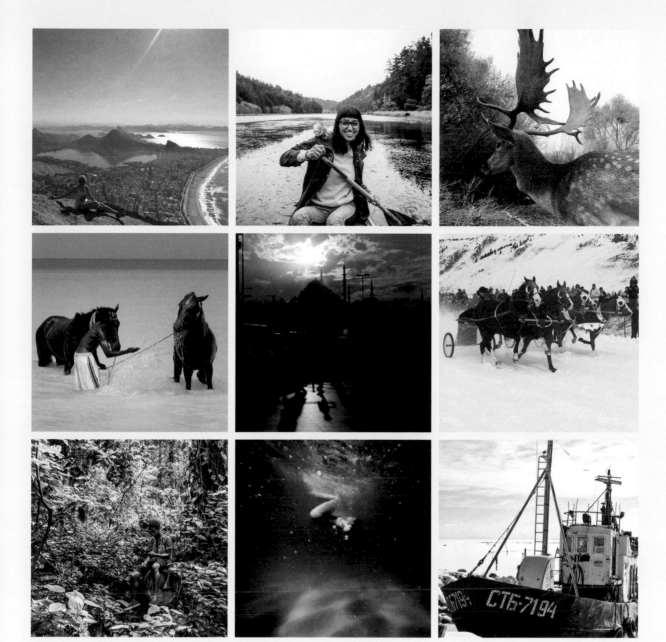

nyc.globetrotter
Morro Dois Irmãos
On today's agenda: wake up at 5:30am, go hike a gorgeous mountain.

ashwellmatthew
Antigua, Caribbean
Horses in the sea! #antigua

paulinhohop
Esse final de semana trouxe muitas coisas que gosto de fazer, estar com a natureza, a fotografia, e com amigos que me acompanham sempre, obrigado pelo shot brot her @vitordamasio #MomentoWestwing @westwingbr

m.kulio
Mendocino, California
don't let this adorable photo fool you – I was definitely the only one paddling 90% of the time

emrhbg
Eminönü, Istanbul, Turkey
#streetphotography #istanbul #streetlife #photography #photooftheday #streetportrait #nofilter

hellosearah
Waimea Bay, Hawaii
#GoPro

maryloo_berlin
#hirsch #animal #mallorca #islasbaleares #diewocheaufinstagram

liz_appa
It's a race ! This is from cutter races a few weeks ago. #cutters #Jackson #wyoming #race #fast

diana_lars
Осиновецкий маяк,
тему про любовь к воде. Любовь к кораблям ещё сильнее! Это у меня от папы, мы с ним, приезжая в любой город, где можно прокатиться на кораблике, сразу выполняемся этот пункт плана! . . . #ladogaduga

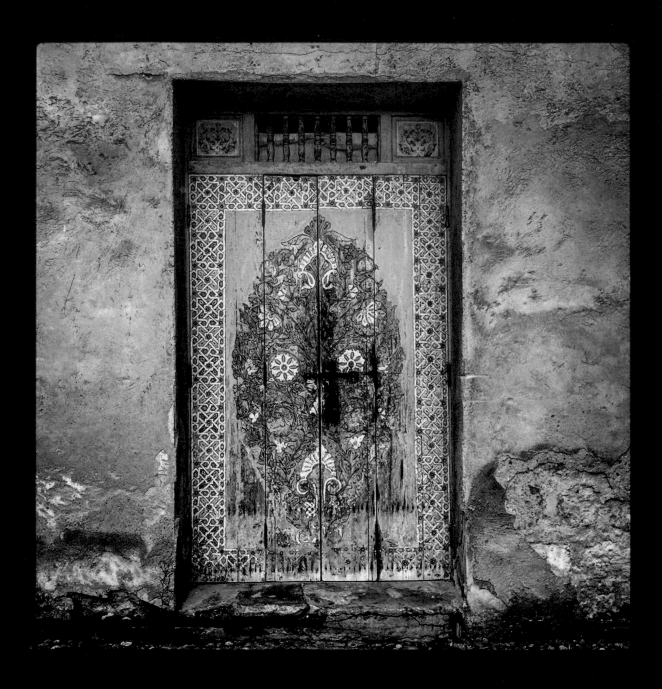

cncndn
Café Maure – Jardin Des Oudayas
#maroc #2015 #rabat #fas #morocco #medina
#door

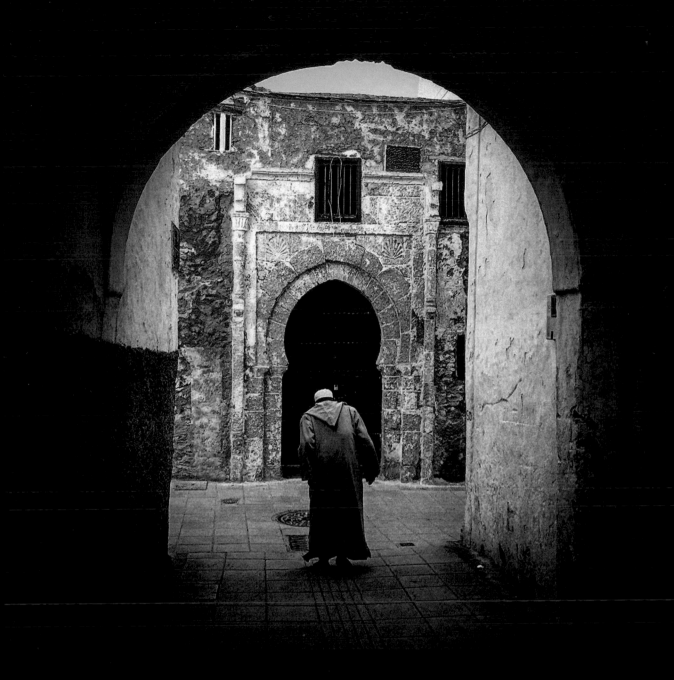

cncndn
Rabat Médina, Maroc
#2015 #morocco #morroccan #medina #oldcity
#oldman #rabat #traditional #urban #walking

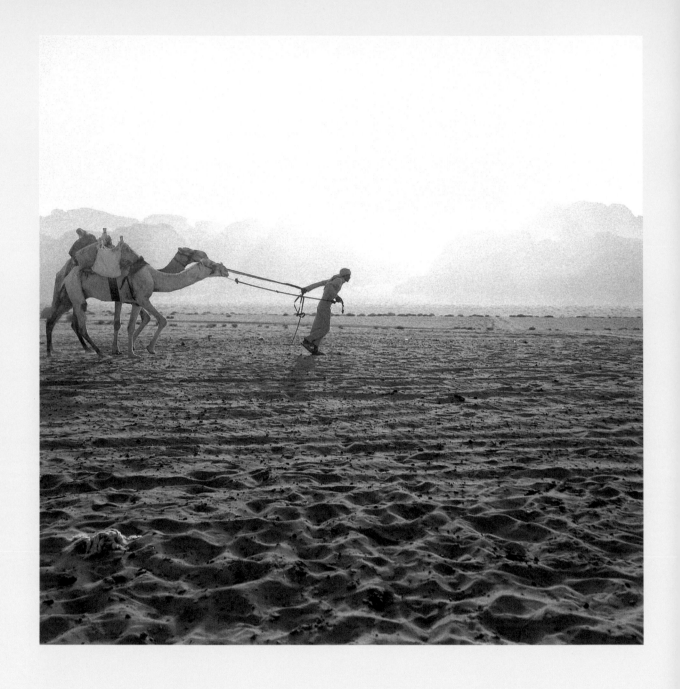

followkk
Wadi Rum, Jordan
#ShareYourJordan @visitjordan

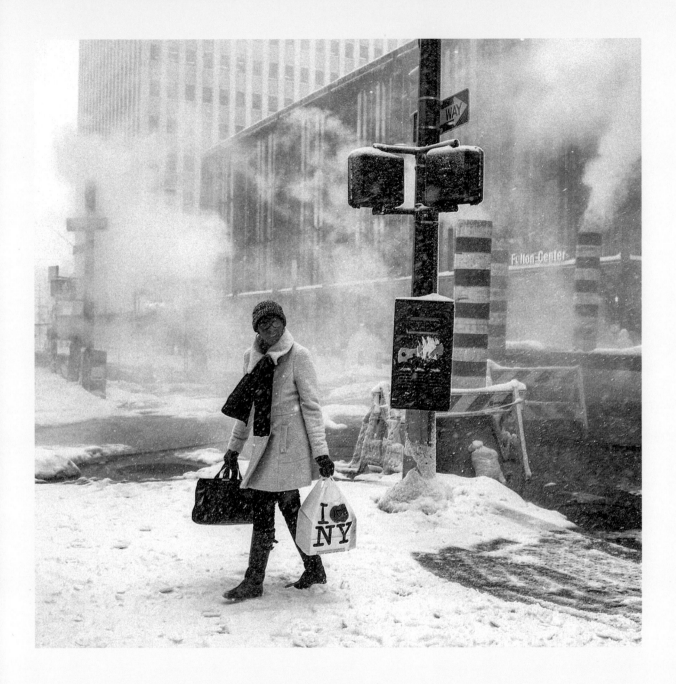

darosulakauri
#NY #snowstorm #nyiloveyou #shopping
#wallstreet #snowstorm2016 #nycoveredinsnow
#stormjonas #jonas #blizzard

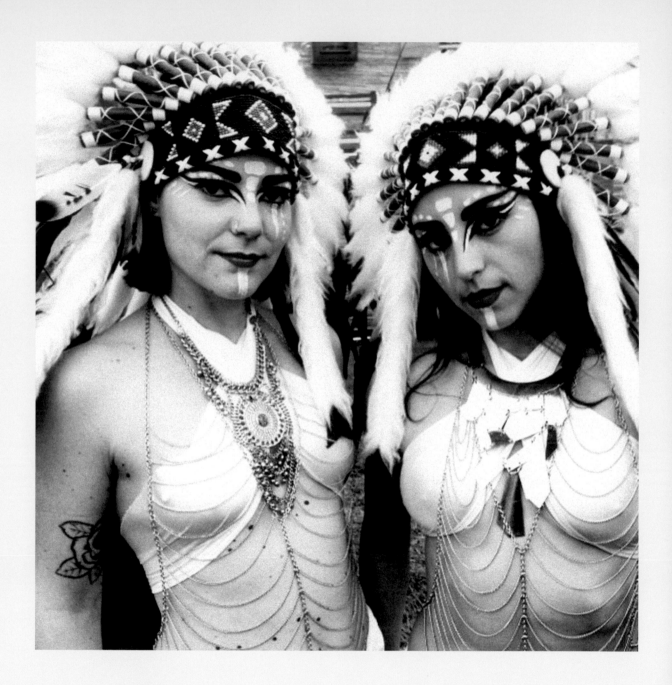

jitskenap
Beyond with the gorgeous Roxy and Alexa
#beyond #roxyandalexa #iphonephotography
#mygirls #girlpower @denisekooij @kierelier
#beyondmagic

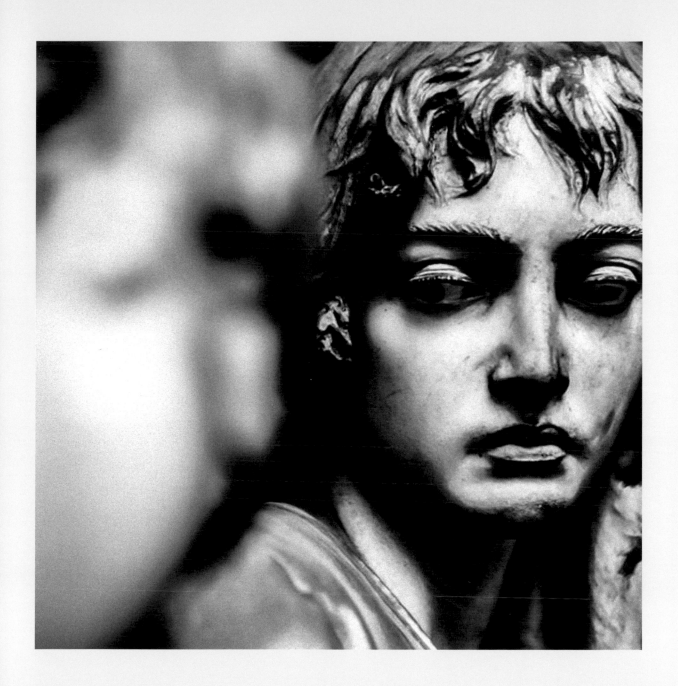

lorenzosalvatori
Statue che hanno un' anima
#monument #statue #staglieno #blackandwhite

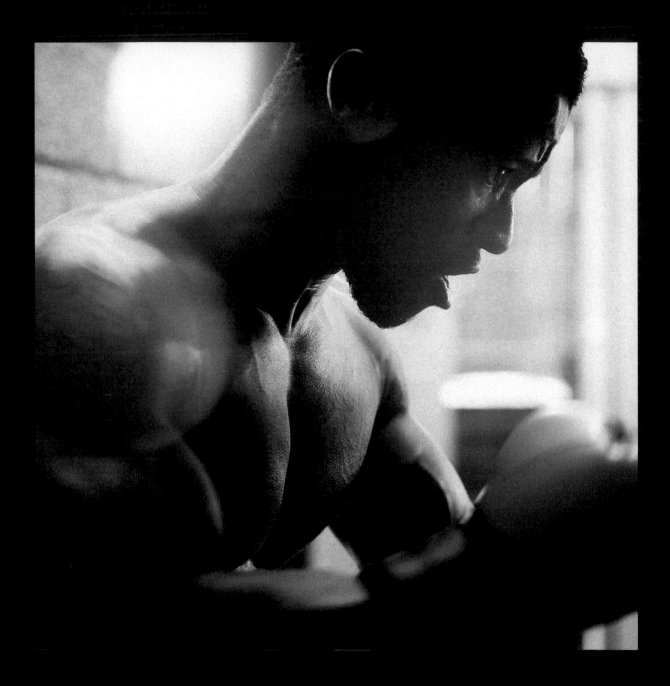

zenography
'But there is suffering in life, and there are defeats.
No one can avoid them. But it's better to lose
some of the battles in the struggles for your
dreams than to be defeated without ever knowing
what you're fighting for.' Paulo Coelho – boxer

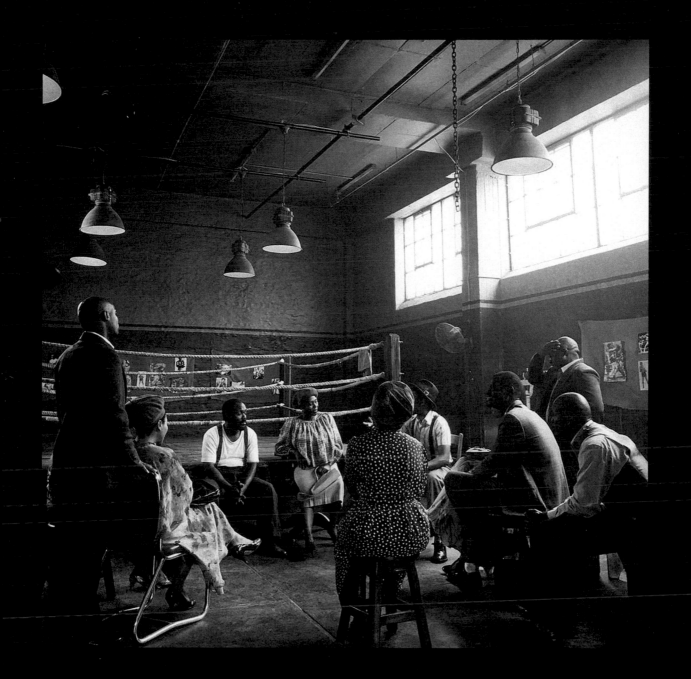

zenography
'We often hear of important gatherings of the "great and the good." Sadly the great have not often been good. But the good have learned that it is better to be good than to be great. Rare is the person in this life who is both great and good.'
Grant Fairley

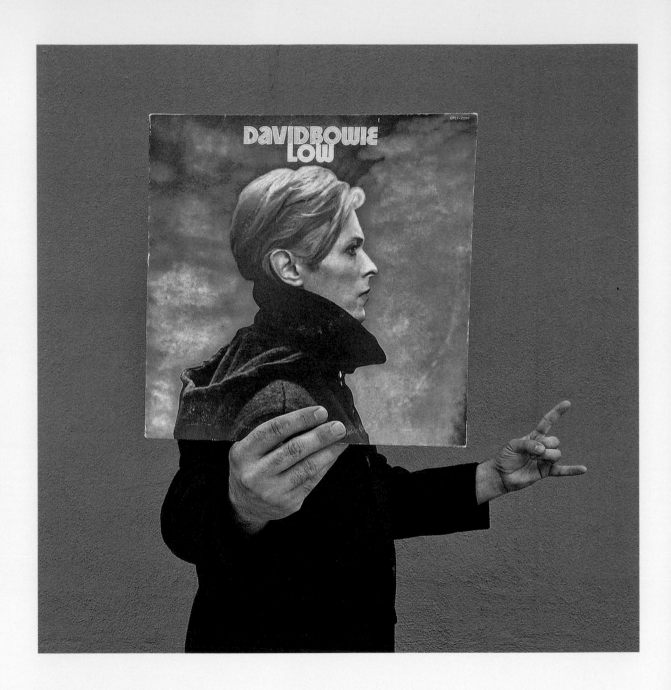

merileeloo
Feelin' 'Low'.
#davidbowieforeverandever #tbt

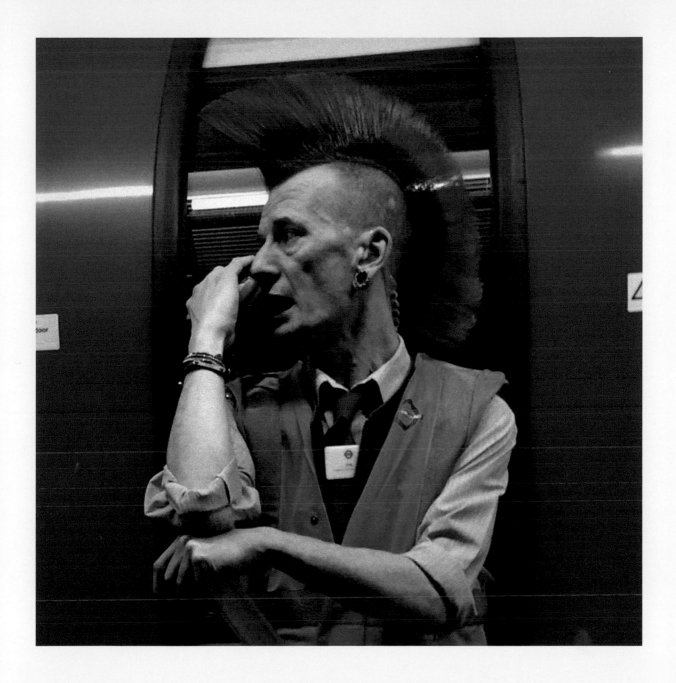

cherkis
Missed Connections: Oxford Circus tube station
around 2pm.

bethanytoews
once upon a time there was a fair maiden, or an
old maid, depending on how you look at it. she felt
things very deeply and everything she did made
people feel a lot of things, too many things they
would sometimes say . . .
photo by @nadinbrendel

beau.thomas.travel
#japon #kyoto

jsph
Washington Square Park
Trainspotting

justinestoddart
Big cousin Araina's handwork

jotasphotography
I think I'm losing my mind now
It's in my head, darling I hope

samishome
Hotel ICON
Scones for daysss @hoteliconhk @smithhotels
#hkig #Smith24 #hotelicon #foodporn
#thatsdarling

mich.dee
(@mich.dee)

tatiruediger
Cordão Do Boi Tolo
Jogue suas tranças de mel, Rapunzel

shoonastanes
Halcyon House
I have tile envy

barbenvakil
New York, New York
Colors are everything #barbenvakil

paperaxxe
Hardwick Hall
Been to this lovely place today #hardwickhall
#hardwickpark #hardwick #uk #iphone6s #ipho-
nephotography

mau.cp
@glittereater's pink phase is over ... stalk his feed
to fall in love with the new monochrome work
(i already did, it's dreamy) #minimal

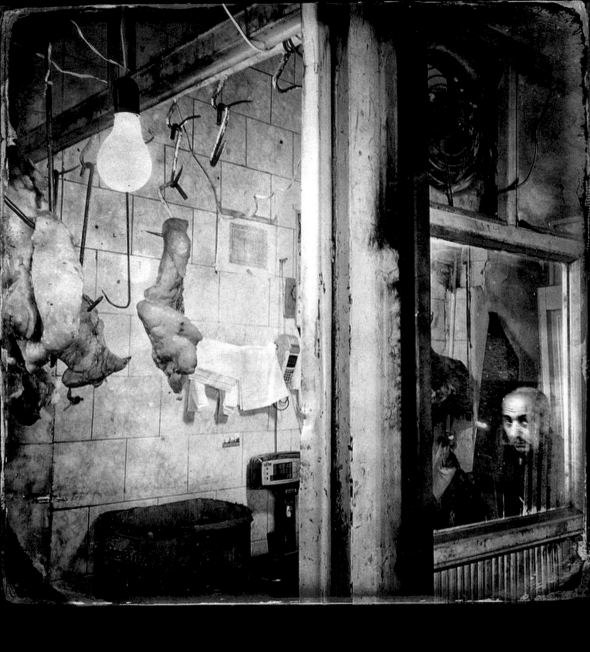

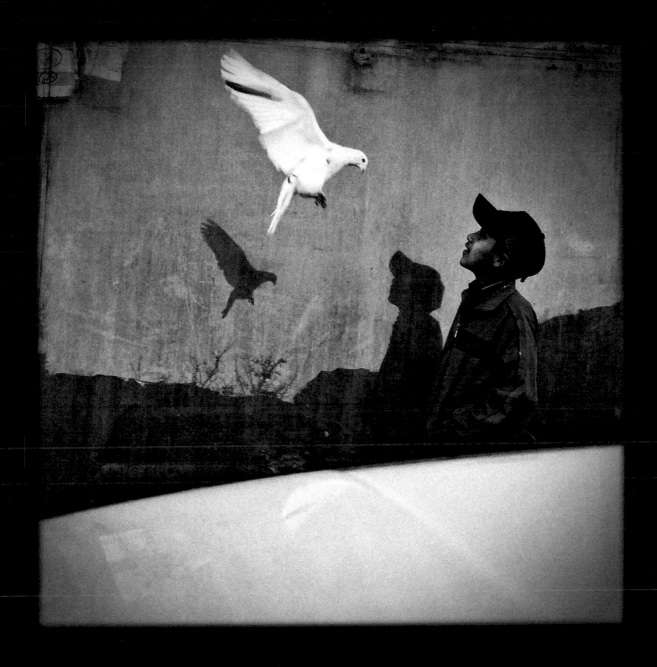

ali.shms
Birdman • No.3 • Qazvin • Iran |
#roozdaily #hikaricreative

elizabethsmart
Team Hennessy

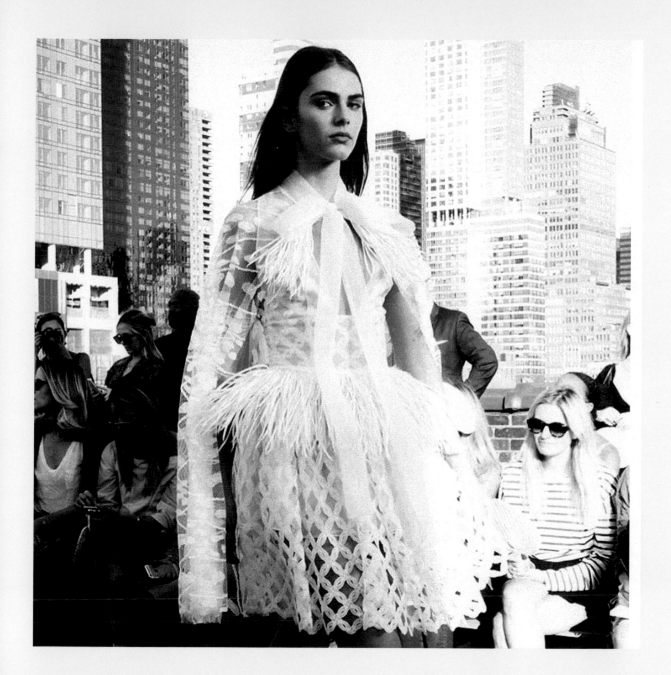

alexandrelahaye
Shop Studios
I'm just a bit obsessed with this dress.
#SophieTheallet #Spring2016 #AfricanQueen

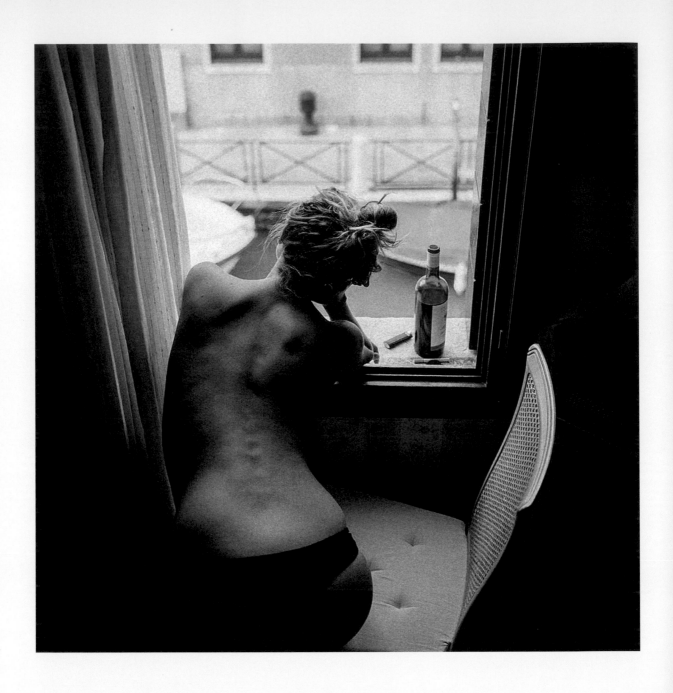

esteeveeen
Grand Canal Of Venice, Italy
Enjoy the finer things | @ladyleuh

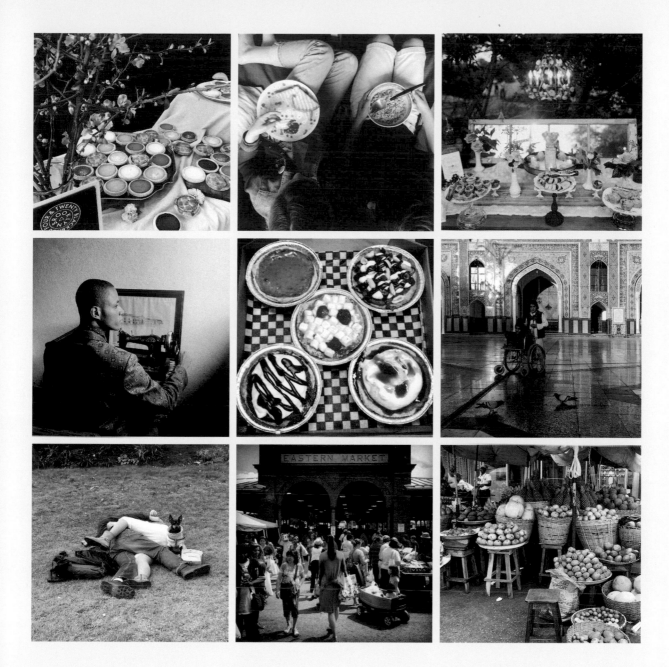

cleo_thebunny
The High Line Hotel
We made a special Spiced Carrot Pie with
@birdsblack in honor of moi! Thank you
@cherrybombemag for pairing us up! #cbjubilee

arristide
If only dreams could become reality by waving a
magic wand or snapping a few fingers, then every-
one's goals would be accomplished and this world
would be a much better place to live in. However,
that's not the case for anyone of us . . .

becstocks

claudiavdbroek
She & him, sandwich & noodles, always

miyukiadachi
sweet pie making day, yey
available at @thepiecommission

salwangeorges
Eastern Market – Detroit

tinypies
Eat pie and be married! On track to surpass last
year's 165 weddings. #AustinsOriginal #tiny-
pies #weddings #tinypiescatering #weddingpie
#pieislove

nastaran__fp
The boy is helping his handicapped brother
in order to go to pilgrimage.

a_heidari20
Cotonou, Benin

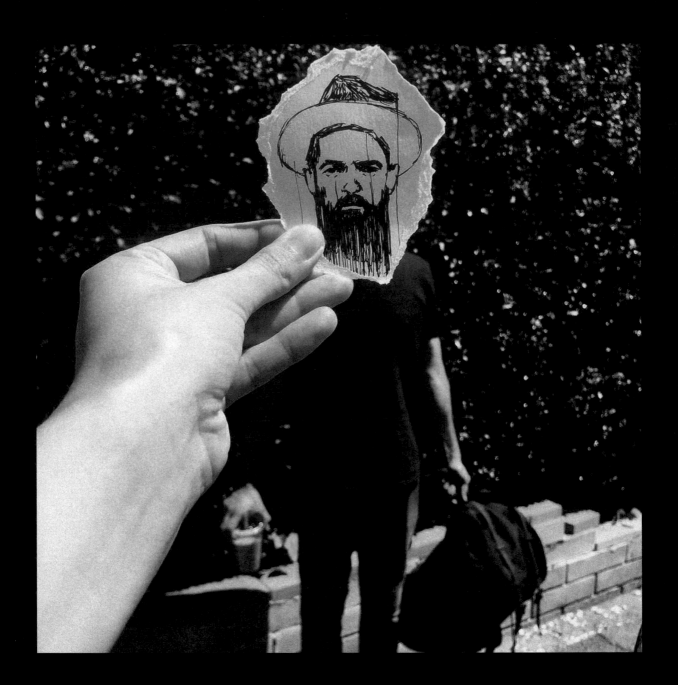

denissewolf
Hold on.... Dont move. #cariton #guapeton
#esposo #draw #illustration

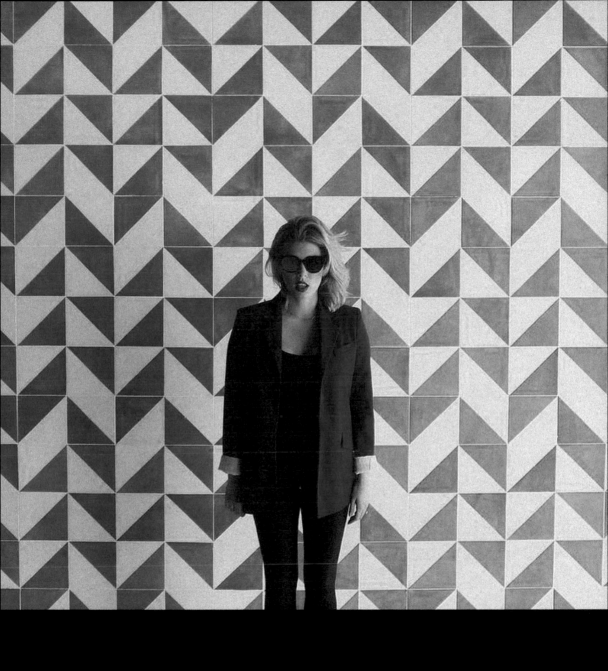

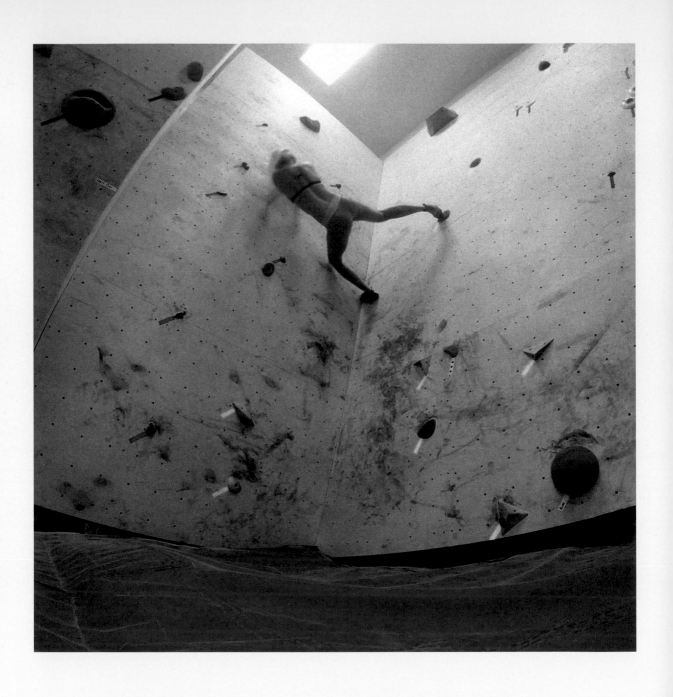

sierrablaircoyl
Getting worked on these new problems
@climbxgear

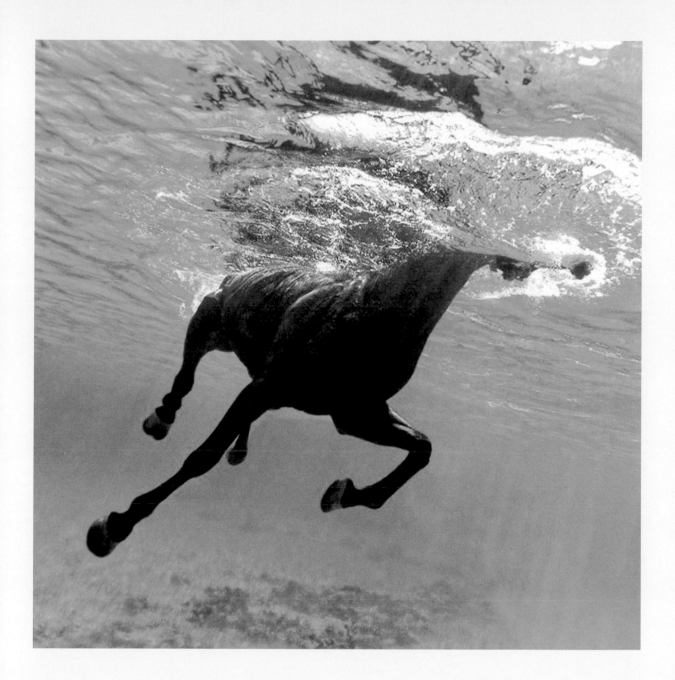

kurtarrigo
We are all somehow connected to the ocean.
#seahorse #underwater #animals #horses #ocean
#awesomeness @awesome.earth

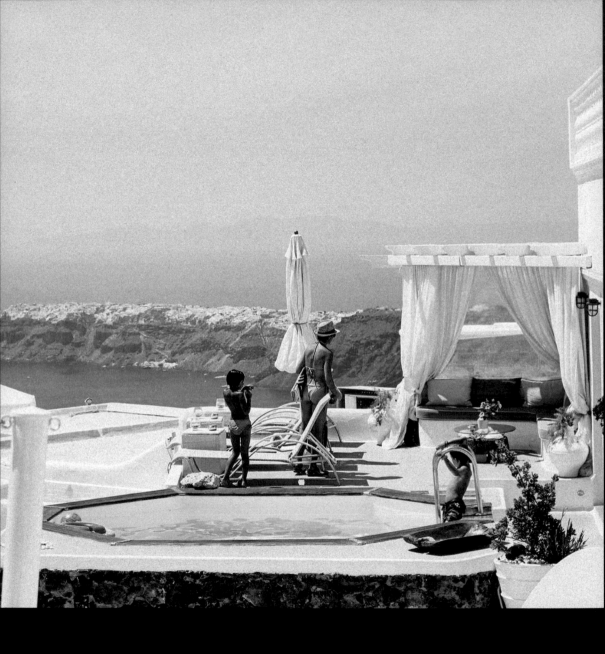

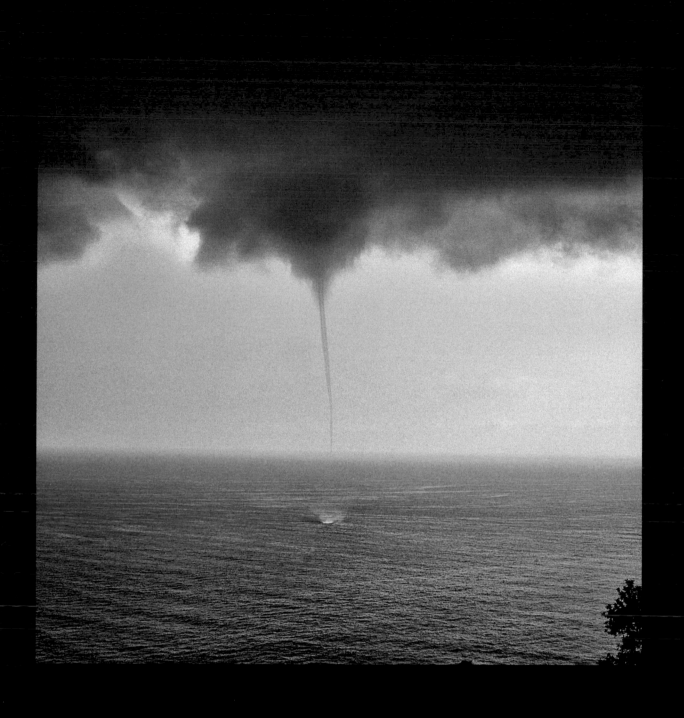

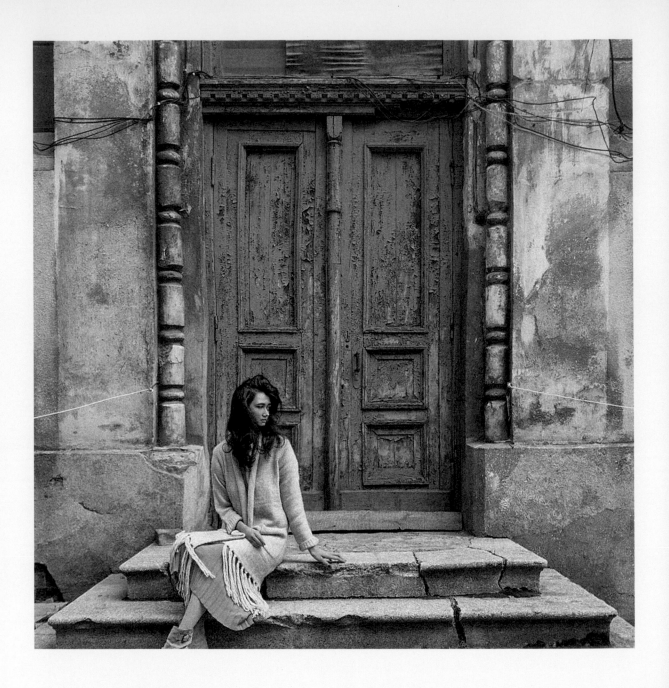

mimi_brune
Odessa, Ukraine
When every yard hides treasures of time covered
with cracks and peels. And all these wrinkles of life
passing by make them even more priceless . . .
@garbuwka @mashadaff @spring_sunshine

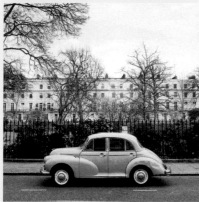
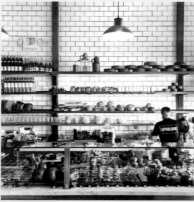
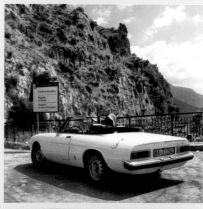

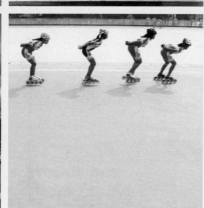
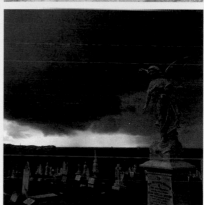

bethanytoews
Wasserfall Bad Gastein
guten morgen

a_ontheroad
Notting Hill London UK
London is . . .
. . . a vintage beauty!
Hello les Frenchy de Londres!!
Avec mes copains Instagramers . . .

paperaxxe
Embarrassment of riches #birmingham #city #uk
#urbexphotography #urbexexploration #urbex
#graffiti #streetart #streetphotography #urbanart
#urbandecay #graffitiporn #nikon #nikond3200

jeffmindell
Downtown Los Angeles
Another beautiful day out here! #dtla

jeffmindell
Republique
Starting this day off right. With a side of granola.
#jminteriorspaces

iqbalbabon
Saparua Jogging Track
#whpsplitsecond

locarl
Urban tundra #stockholm #olympusomd

danrooms
Our wheels for the day #spiderlifestyle #amalfi
#italia #alfaromeo

nampix
Waverley Bowling Clubs
weak #winter #storm off #Sydney Coast
#weather

alessioalbi
Castelluccio Di Norcia 1452 Mt.
Taking a little break from my before
and after series to post this shot I took
today with
@elsa.facchin
As a lot of you always ask, the camera
is Nikon #d810 with #sigma 35 1.4 art
Just a little bit of postproduction on
color, reds and greens :)

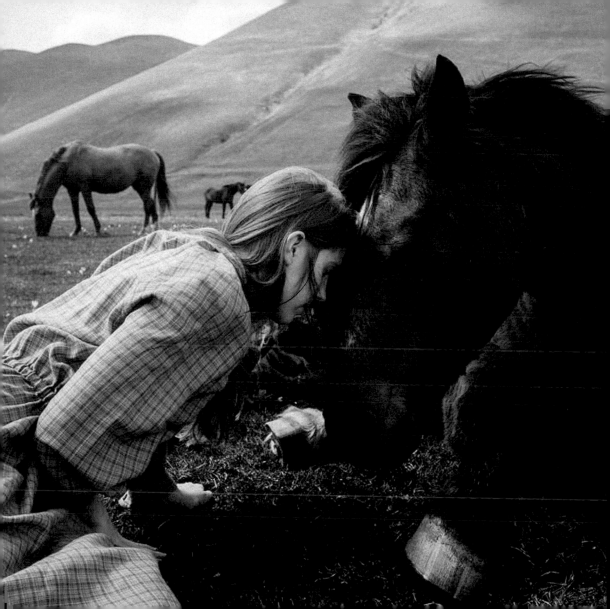

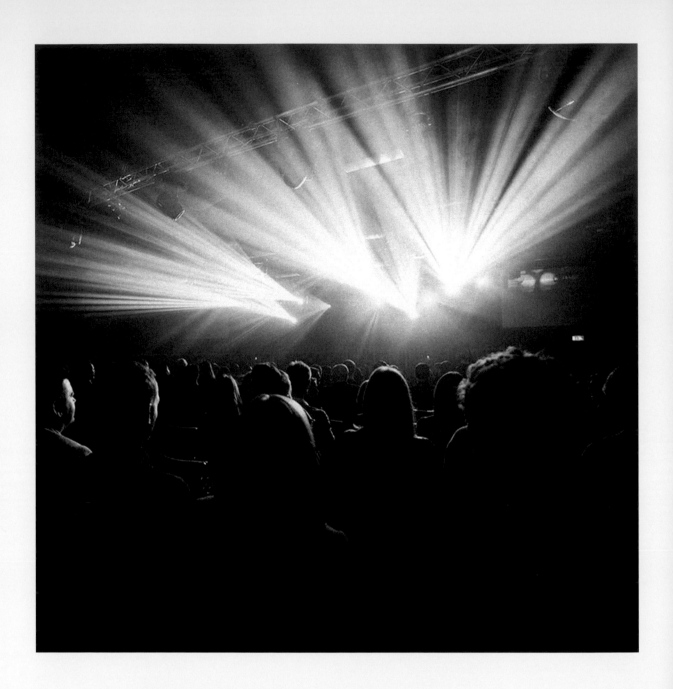

rolfemarkham
Ministry of Sound
Great light show at the Global presentation

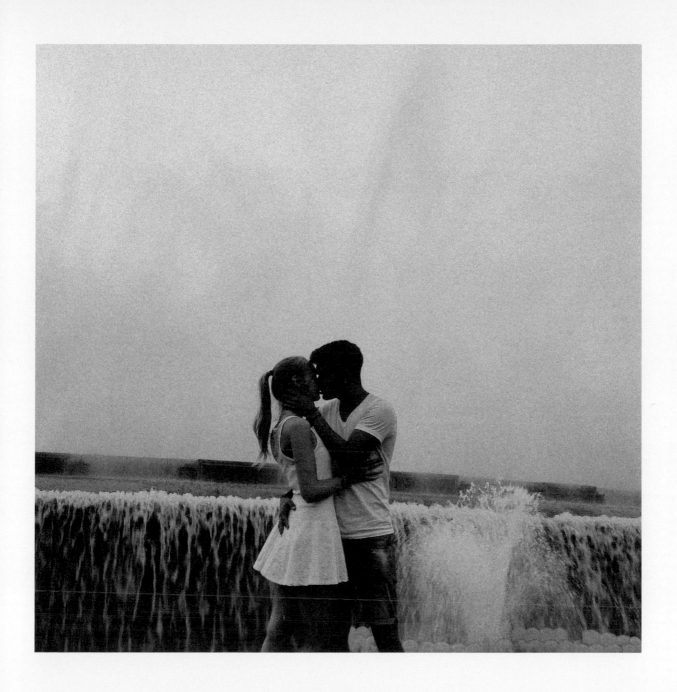

maxgehl
La Fontana Magica, Barcelona
font màgica #barcelona

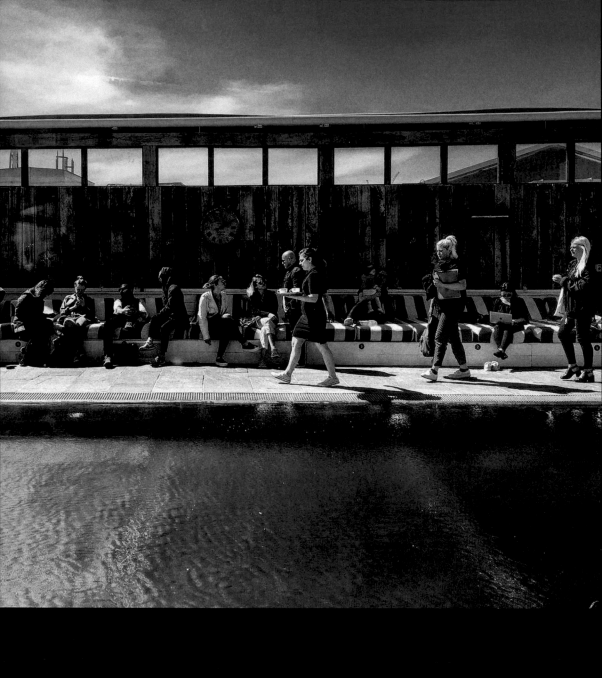

alexfawks
Shoreditch House
#summer #swim #shoreditch #house #london

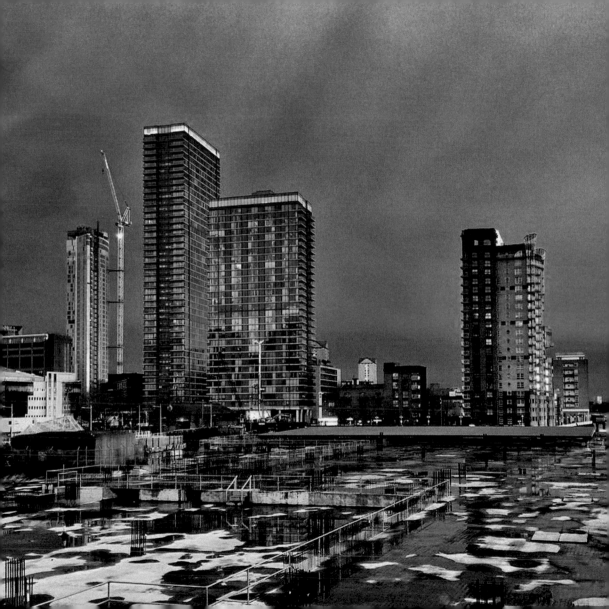

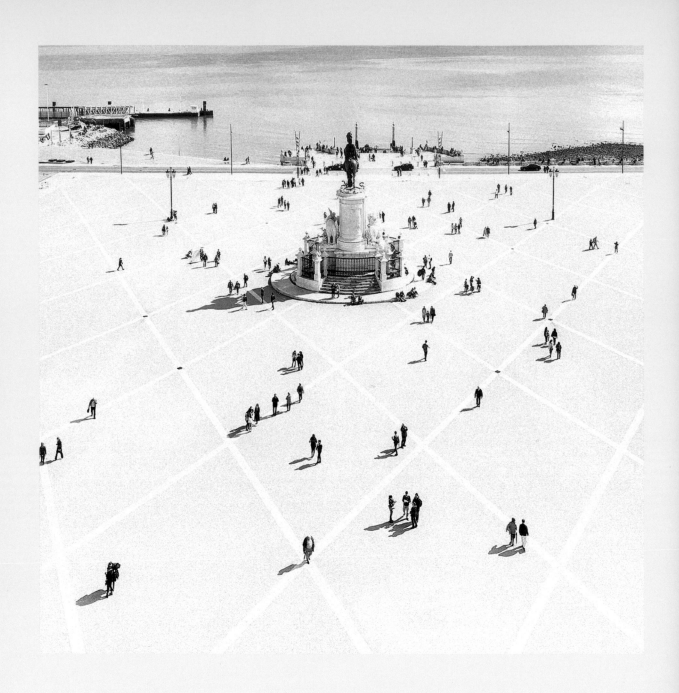

voodoolx
even flow

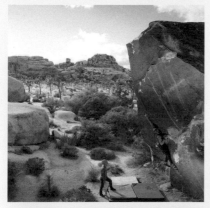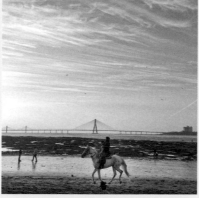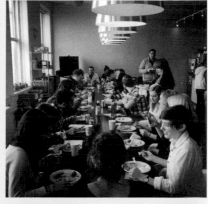
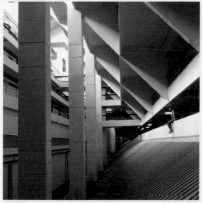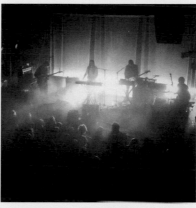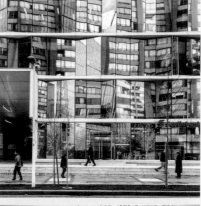
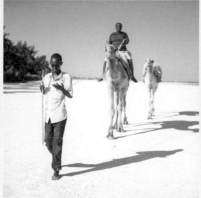

kailightner
matthewhulet
Joshua Tree National Park
While gym hopping during my winter break,
I managed to sneak in a few hours to climb
at this beautiful place . . .

blackmobil
Singapore
#architectureandpeople

_lumberjake__
'The real man smiles in trouble, gathers strength
from distress, and grows brave by reflection.'
Thomas Paine
#glow #cat
#moodygrams

banerjee.anurag
Glorious day at the beach.
Dadar Chowpatty.
#Bombay

kylehuff
Union Transfer
Myth

jaydabliu
On one of the walks on the beach, I met Abdi, the
Camel Whisperer. I noticed he was praying every
time he walked the camels. So later I asked him
why ... he said he thanks God for every customer
he gets and tries to maintain a heart of gratitude.

matiascorea
Behance
Thanksgiving lunch @behance style! #fatty
#turkey

el_caps
Deloitte Chile
Kaleidoshood
Credit: Eleazar 'Caps' Briceno

klsmeanders
You never know what awaits for you at the the
Stanley. #stanleyhotel#creepy#jacknicholson
#redrum#jacktorrance#theshining

sydellewillowsmith
Cape Town days #unsettled
#cityscapes @therealcityofcapetown
@everydayafrica

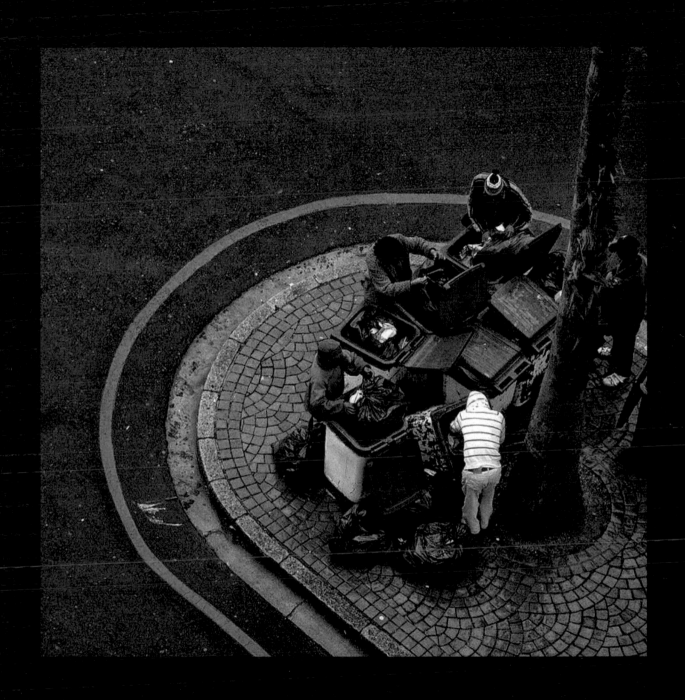

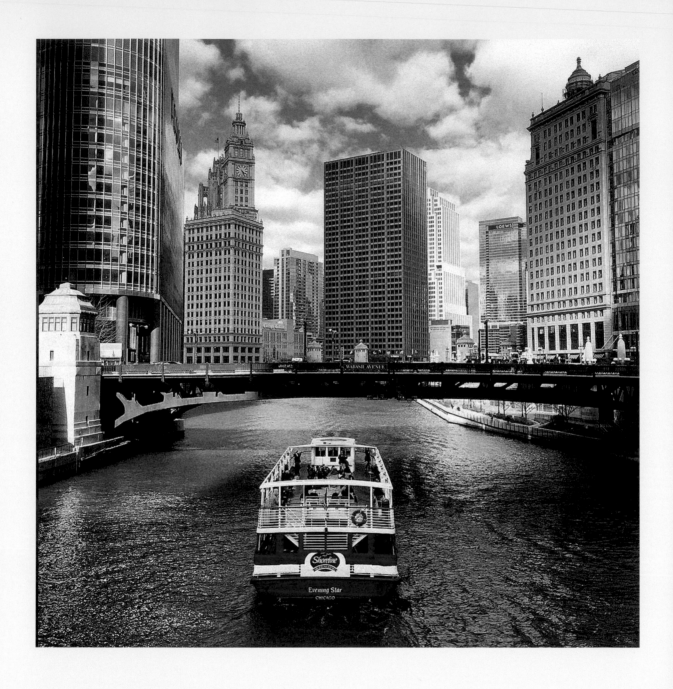

partha14
Chicago River
Okay, Spring is here, so are the boat tours.
#chicagoDiaries #Spring #sunny

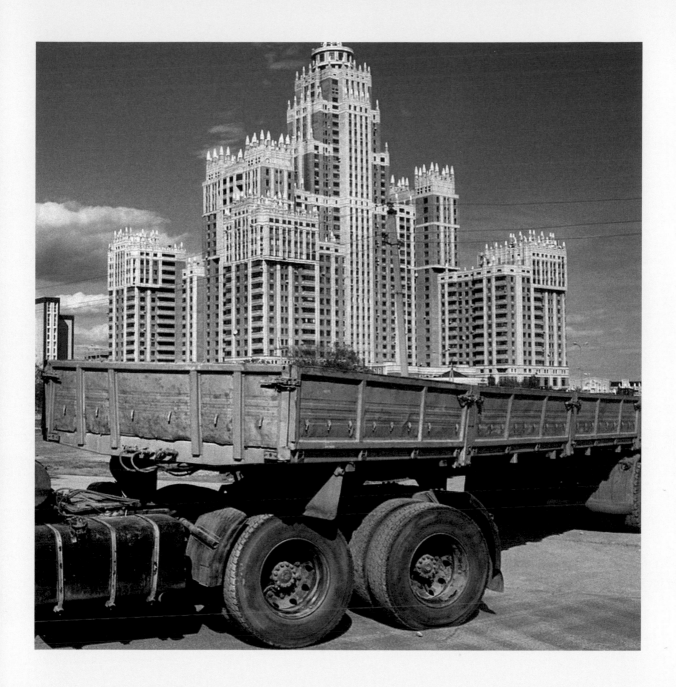

ryan.koopmans
Full Load #kazakhstan #astana #architecture

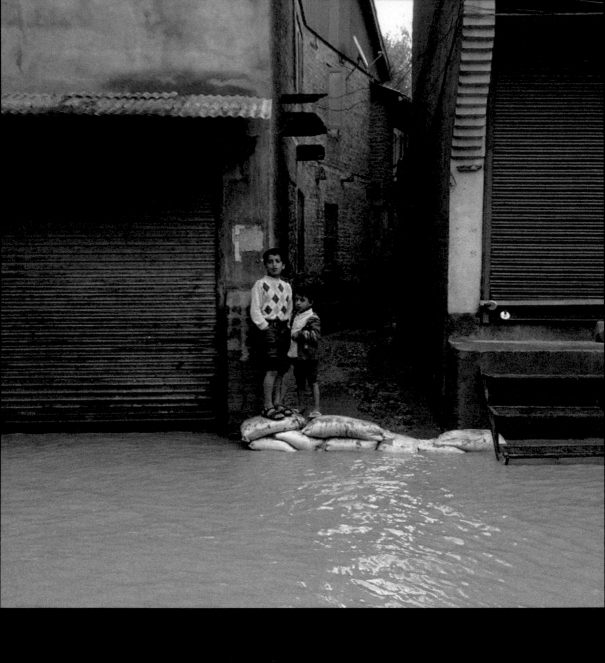

rumanhamdani
Massive floods have hit Indian-occupied Kashmir.
The devastation has been going on for a week and
finally it has subsided in most parts. 500,000 peo-
ple have abandoned their homes, some of whom
are taking shelter in various relief camps. More
than 500 are feared dead. Thousands are missing.

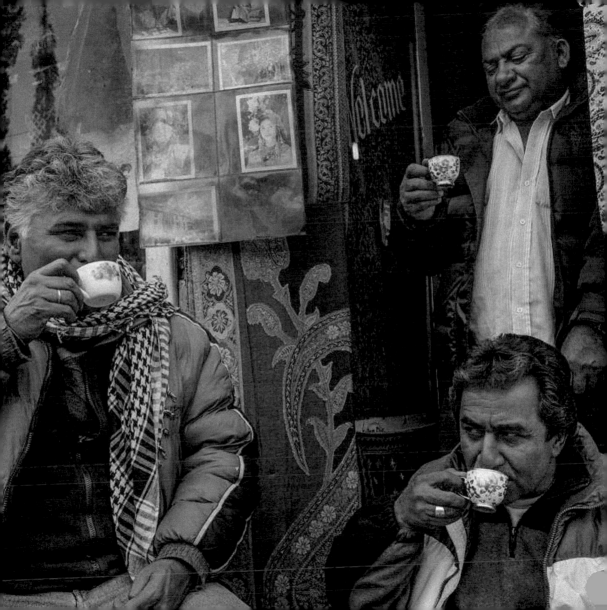

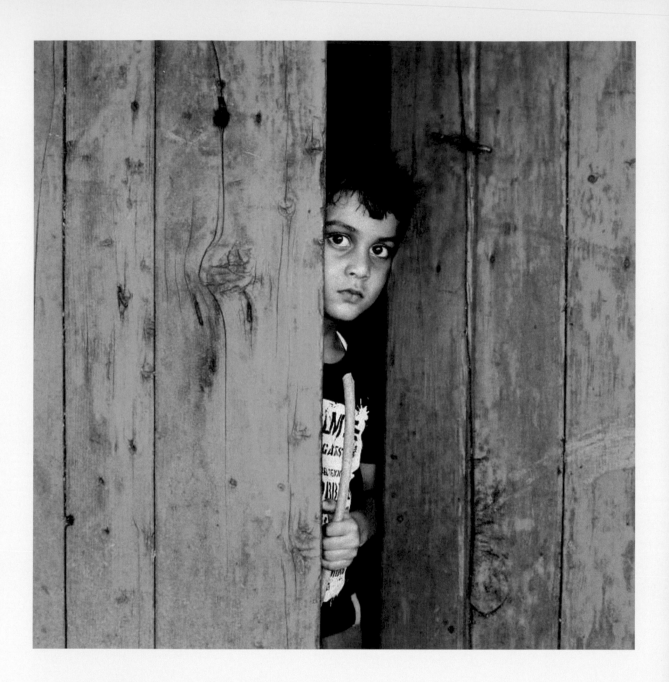

mukesh.sml
#indiapictures #_soi #_hoi #storiesofindia #indianbestgram #desi_diaries #mypixeldiary #pixelpanda_india #convexrevolution #highonstreets #mysimpleclick #indiaclicks #igramming_india #explorexstreets #_coi #streetphotographyindia

floradawson4
Dream car

cecis.r
Paris, France
• Amelie •

eddiedaws
#pozgriffwedding

caxmee
Abidjan, Côte d'Ivoire • #mamacax #wanderlust
#travelnoire #voyager #ivorycoast

eddiedaws
Xochimilco Trajineras

mmhenry
#journeyofadress with @cyndonnay

keiranlusk
Moreton Island
The Wrecks on Moreton Island, Queensland,
Australia.
#SeeAustralia #ThisIsQueensland #MoretonIsland
#Tangalooma

samvoulters

mau.cp
#tbt to better days

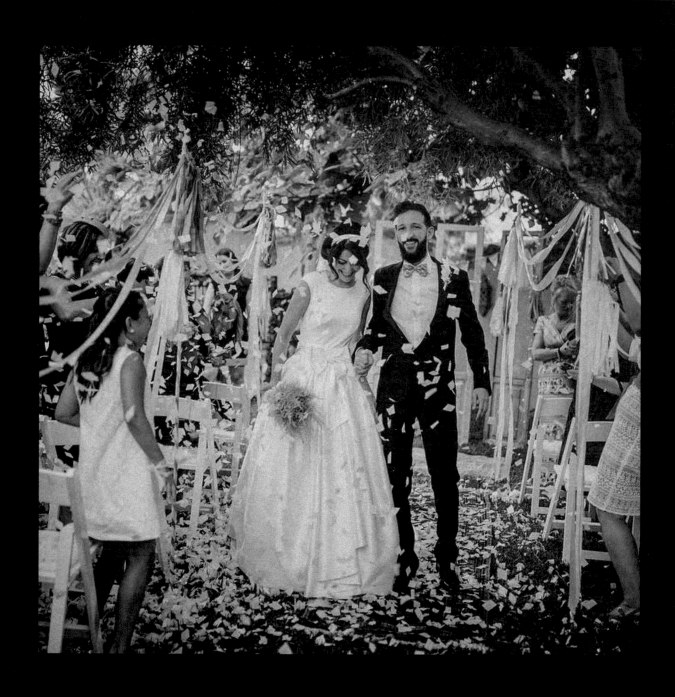

pablo_laguia
Quintas De Montecarlo
Bodas increíbles que hacen soñar, hoy en
Chihuahua ha sonado su canción y me he
acordado de ellos @paula.wateke

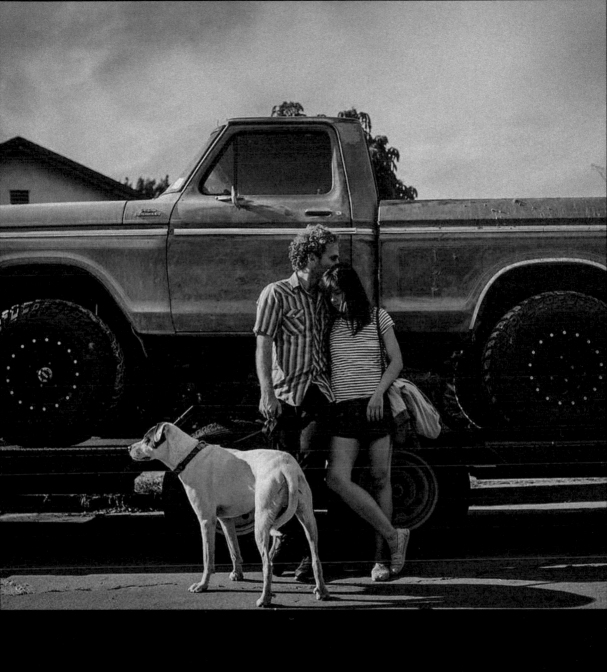

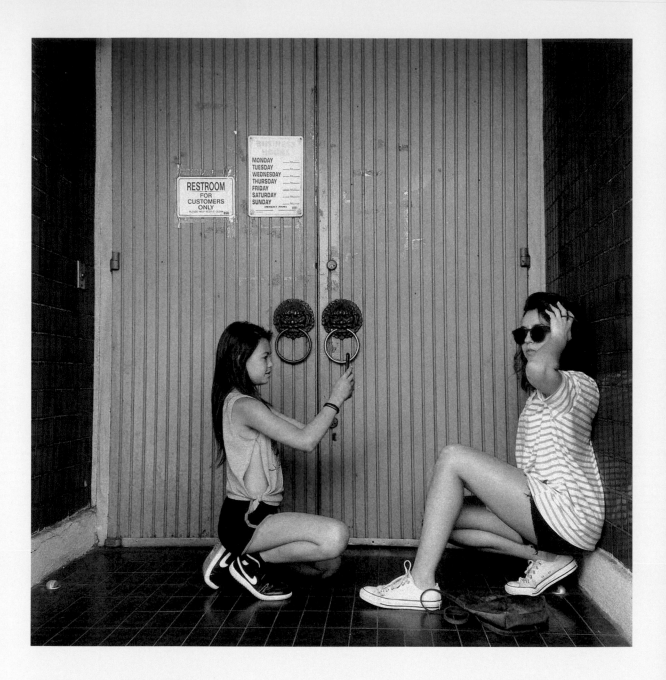

thechloeroth
My niece loves to art direct me against colorful walls. I wonder where she picked that up? Not sure I'm teaching her the right values but at least I have a little gramming partner.

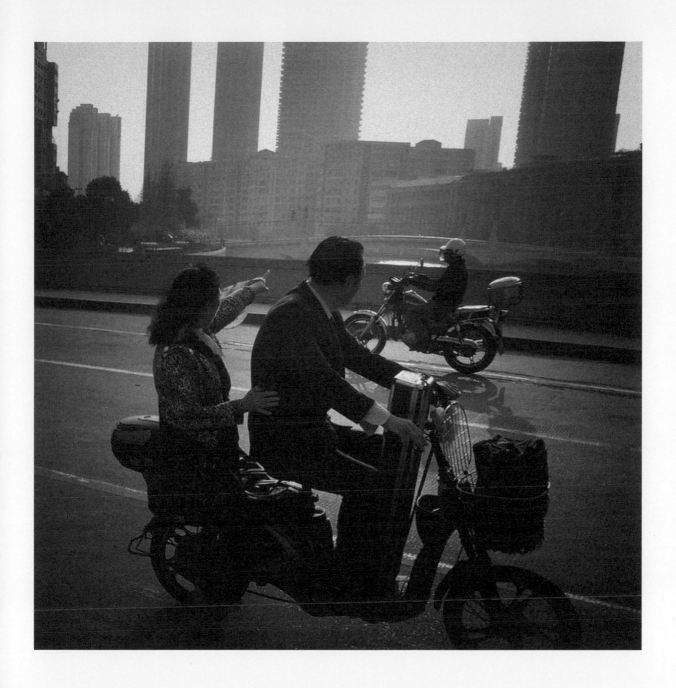

sabrinaromahn
Shanghai, China
never.stop.exploring.

oliveruberti
Yesterday I went with rangers to check on this 29-year-old mother of three named Kulling, who had been shot four times by herders last week. Save The Elephants feared her front left leg might be broken, which would greatly reduce her chance of survival. To our surprise, she was moving well enough to get water nearby and even attempted this short charge at me – very good signs! #savetheelephants

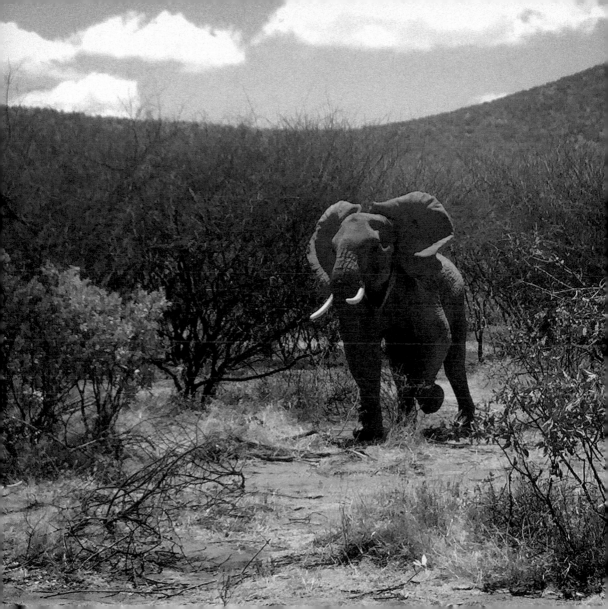

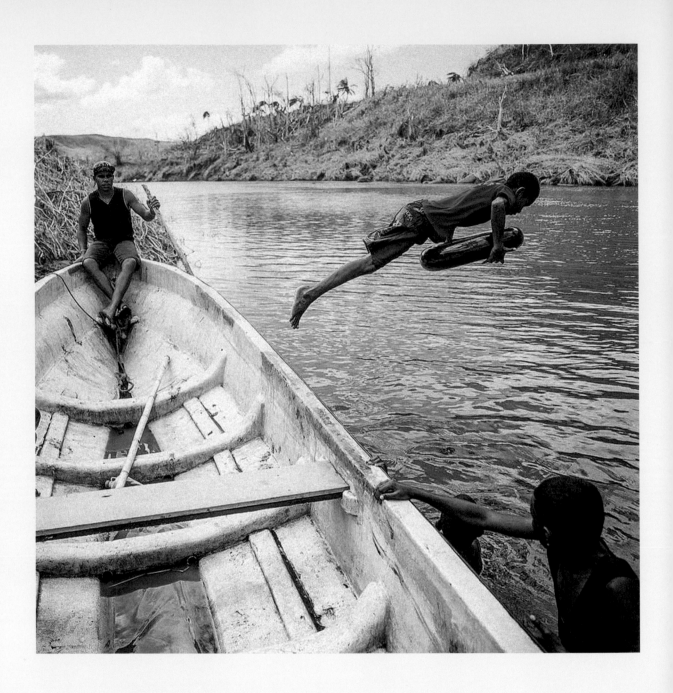

lens_pacific
Viti Levu – Fiji
#onassignment in Fiji for @unicefpacific:
A child jumps from a boat into the Rewa River
near Navitilevu village in Ra Province. Access to
Navitilevu is possible only by boat . . .

petrosphotos
#Деньвмф #navyday #традиция #tradition
#питер #petrosphotos

dakiloulou
Pretty ladies on top of empty streets and once
against it's hard to tell winter from spring #sun
#ladies #neighborhood #winterfeelslikespring
#athens #europa #home #grammasters3

eirinbugge
#angola #africa #viewsofangola #african_por-
traits #africanamazing #loves_africa #africagram
#worldunion #ig_africa #igs_africa #ig_livorno_
#wu_africa #world_union #portraitmood

h_cato
Parliament Square Westminster
Votes are in 397 to 223, British government
choose to engage in air strikes on Syria.

spispispice
Happy Easter #mezquitadecordoba

sharedwanderlust
Tokyo City
Tokyo Japan. Godzilla sighting.
#urban #urbanlife #fire #tokyo

olivialocher
Basement drum session with my Dad.

tilly2milly
What an emotional day at La Jungle, Calais with
@5ftinf and @theworldwidetribe

kylehuff
Yards Brewing Co.
Brawl
I had a few drinks with @YardsBrew's Tom Kehoe
several weeks ago + talked the history of #Yards.
You can learn more yourself by clicking the link in
@honeygrow's bio!

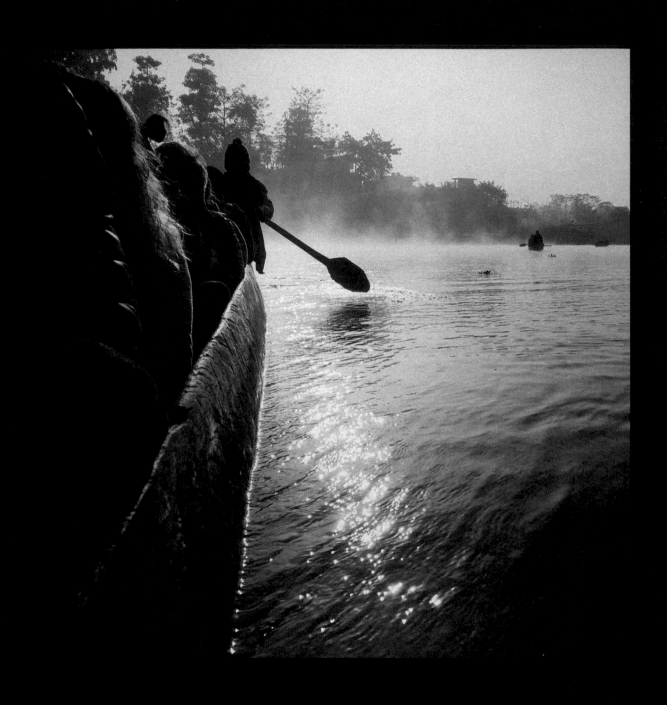

alettavanderlinden
Chitwan National Park
Last week I was still on the river in #Nepal, now I'm
listening to my alarm. From #peacefull and #calm,

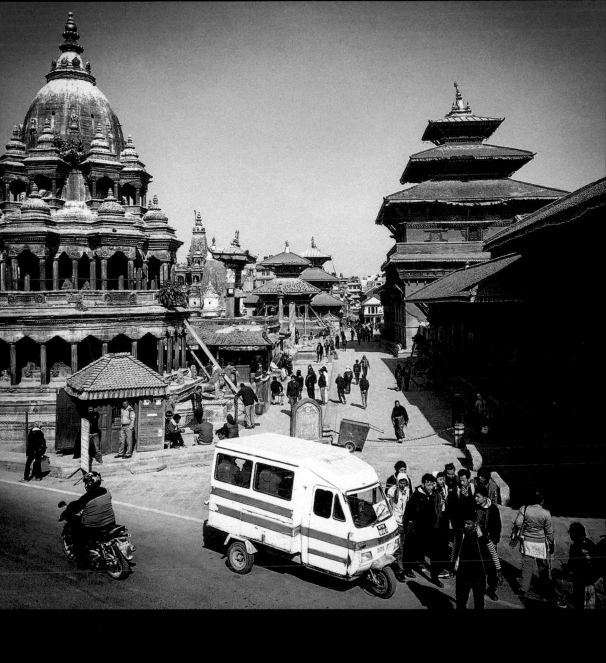

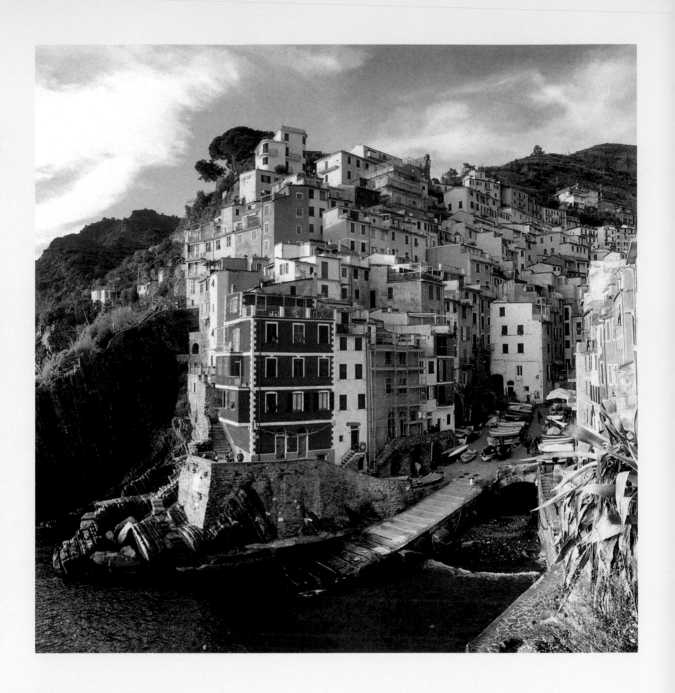

klarahorton
Cinque Terre, Italia
Riomaggiore, uno de cinque terre

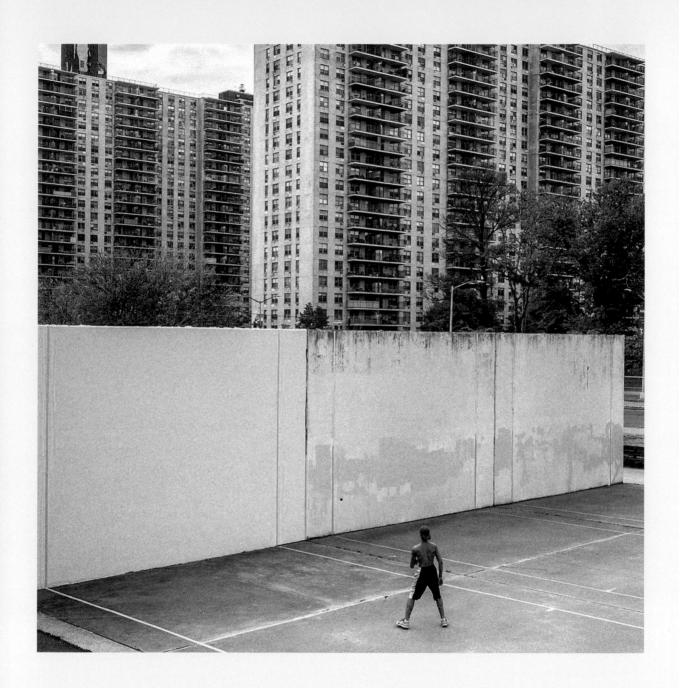

juancristobalcobo
Coney Island
Coney Island, Brooklyn, NY.

dylan_odonnell_
Abducted by ALIENS
Last night's conditions were still and
dark and perfect for photographing
this amazing galaxy M104 at the
maximum magnification my tele-
scope is capable of. 43 x 3minute
exposures in RGB were enough to
show those beautiful dust lanes.
People say it looks like Saturn, or a
UFO, or a mexican hat. What do you
think? C9.25" Edge HD, QHY12CCD.
#astrophotography #celestronrocks
#universetoday #byronbay #startalk
#ig_astrophotography #natgeospace
#space #southernhemisphere

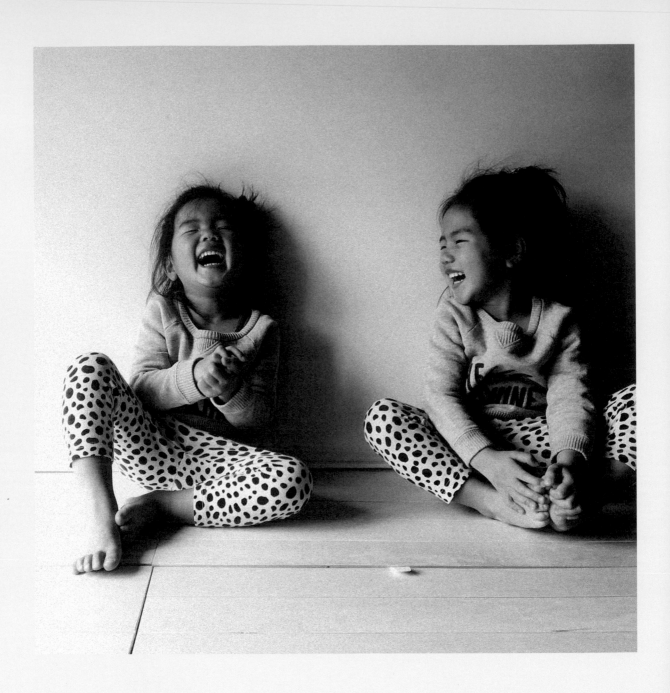

futago_no_utarita

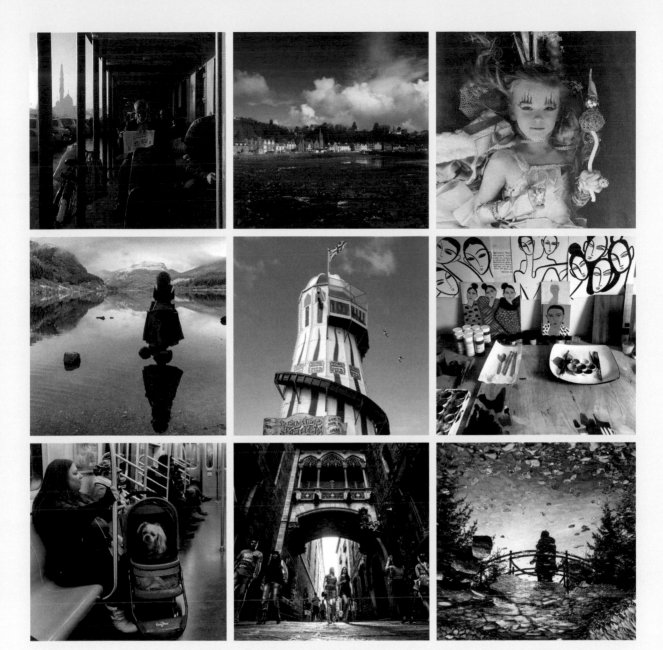

moeit_
#everydayegypt #everydayportsaid #everyday-
middleeast #everydayafrica #portsaid #followfri-
day #huntgramarabia

berriestagram
Loch Lubnaig
I met the girl from Brave . . .

markabramsonphoto
There are just certain days when everything
begins to make sense #fujix100t

locopoe
Balamory
There is no story in balamory and you really
wouldn't want to go

amberrrjones
Do you, don't you want me to love you ?

merichakan
Barri Gòtic
One of my favorite cities! #Barcelona

jinnkisss
Khabarovsk, Russia
The snow Queen Две ночи без сна, пару
лоскутков, мешочек фольги, палки,
проволоки, стекляшки, клей, немножко
фантазии и пред нами . . .

kellymariebeeman

jinnkisss
Детский парк отдыха имени Гайдара
ДДТ – Что такое осень . . . autumn in my life . . .

wesleyallen_
20• Parada Do Orgulho LGBT De São Paulo
Ameaçou chover mas não choveu,
ameaçou fazer sol e não fez. Mas por
outro lado teve muita simpatia e respeito
na Avenida Paulista hoje. :) #RespectIsOn
#paradalgbt

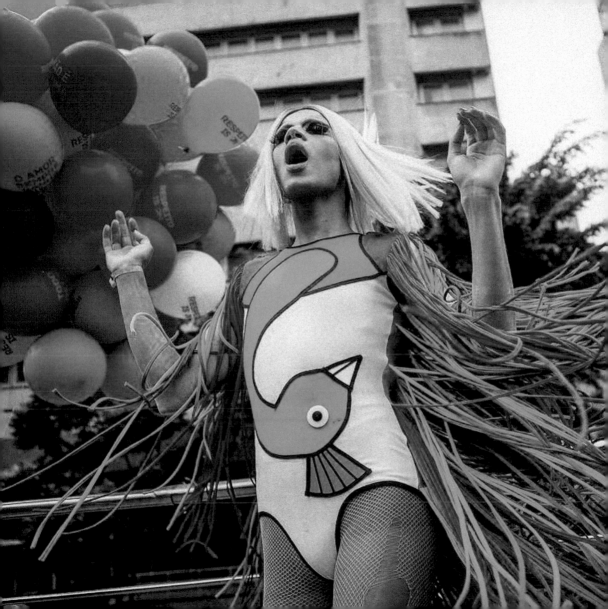

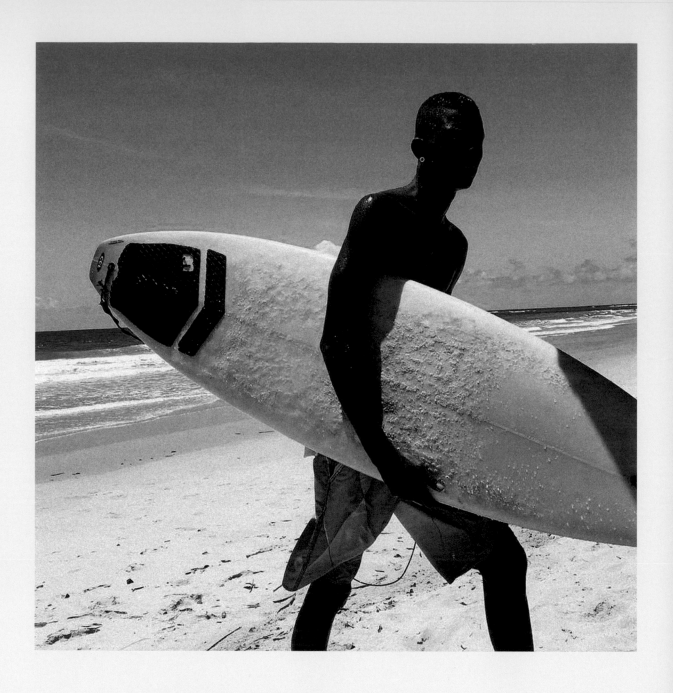

rosie_ubacher
Surfer-watching in #bahia #brazil #vsco
#igersbrasil #paradise

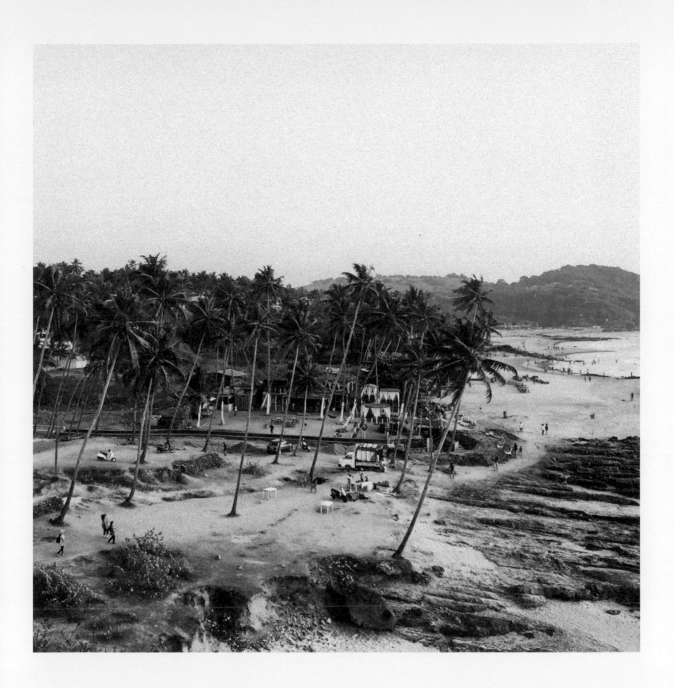

theindianhippie
Vagator Beach
#TheIndianHippie.
#igersmumbai #Backpacker #Backpacking
#Traveler #TravelTales #TravelStories
#Travelgram #TravelDiaries #TravelLife . . .

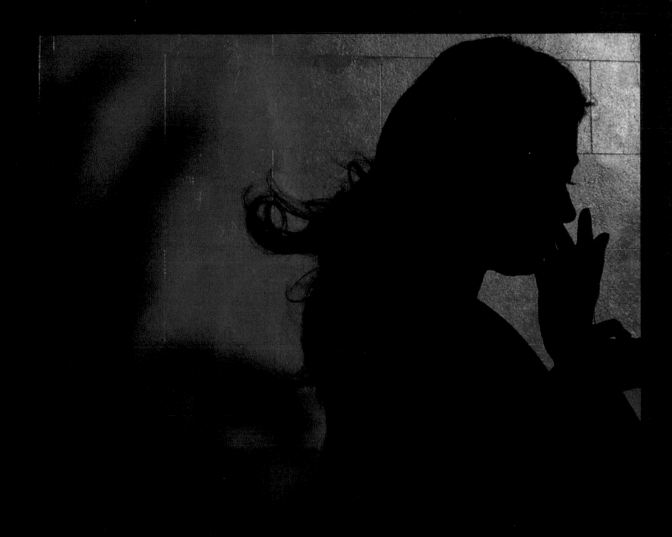

streetamatic
Washington, District of Columbia
DC Streets 164

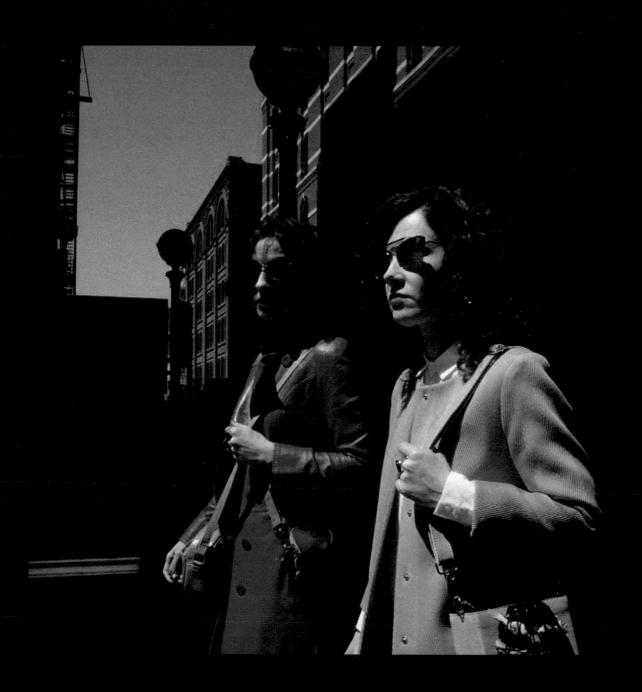

streetamatic
New York, New York
NYC Streets 150

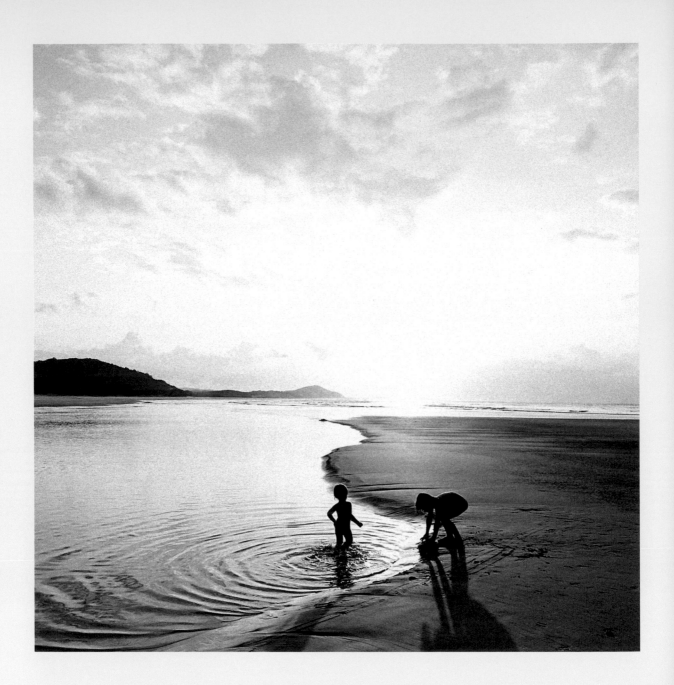

littleearthstories
today was one of those bone-tired exhausting, drama-a-minute, sanity-shattering days, where you've got to do waaay too much, with fractious children bubbling over all over the place. however, tonight I am reminded that the universe delivers small miracles when you absolutely most need them . . .

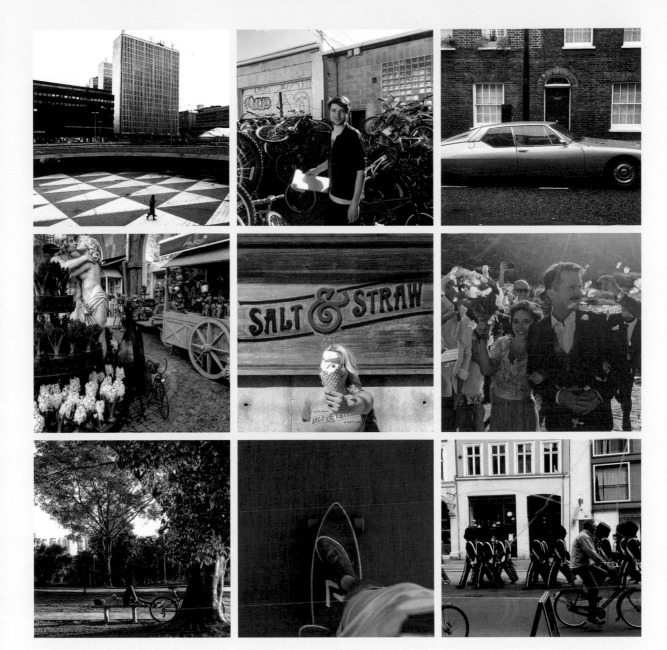

locarl
Sounds of the city #stockholm #olympusOMD

scodyg
@boisebicycleproject location scout today with @
retroscope and @willymoonshine.

sc17
London Waterloo Station
Citroen SM still looking sleek and futuristic
#Citroen #doesntfitinasquare

crystallapistil42
Opera and Ballet National Academic Theatre
Support Foundation
Vibes #livelovetheworld #thanksearth #flower-
power #livelovearmenia #yerevan

merileeloo
Salt & Straw 3345 Se Division, Portland, Or
This may or may not be one of three ice cream
cones we had today.

sydellewillowsmith
Wolfkop Camping Village
Best day of my life . THANK YOU!!!!!
@makhulu_ pic by @athenailya

jhows_
Parque do Povo
E quem se soltar da vida vai gostar e a vida vai
gostar de volta em dobro

natsmith
z-flex.

superzina
Copenhagen, Denmark
no big deal. Nothing to see!

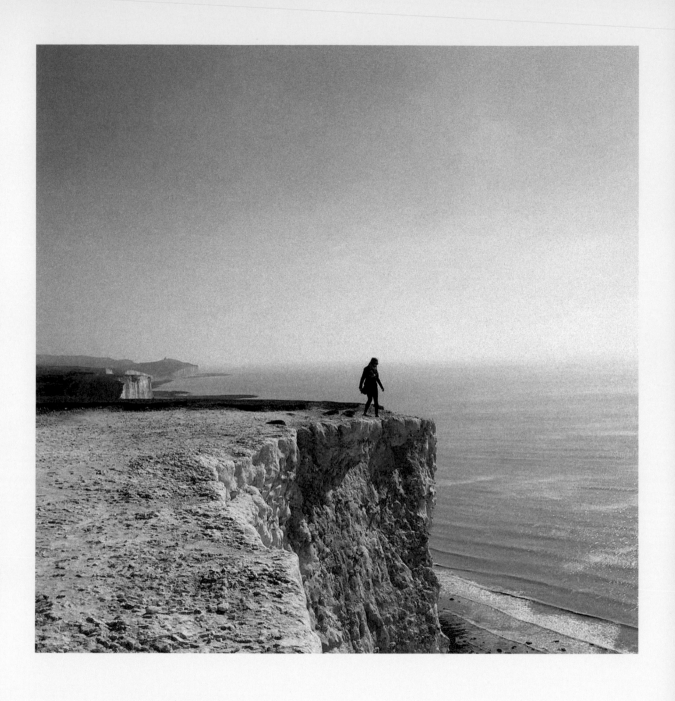

callielynn33
Look mom, no hands

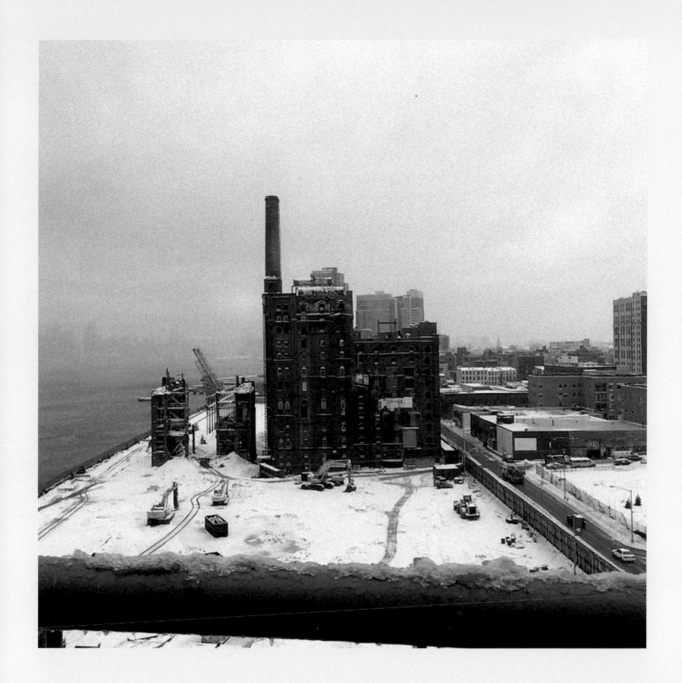

matiascorea
The Domino Sugar Factory project. It's happening.
#latesgram #domingosugar #brooklyn

paulhiltonphoto
Leuser Ecosystem
The Sumatran and Bornean Orangutans
are on the brink of extinction.
Conflict Palm Oil which is found in
almost EVERY SNACK FOOD and pack-
aged product at home, is the leading
cause of rainforest destruction which is
also the home of these beloved apes.
This vegetable oil is also driving the
Sumatran Rhino, Sumatran Elephant,
and Sumatran Tiger to their demise.
Is this really the price we should have
to pay for our SNACK FOOD?
#SaveLeuserEcosystem #CutConflict-
PalmOil #StartWith1Thing #RacingEx-
tinction #SaveOrangutans #travel #life
#happiness #instatravel #photoofthe-
day #picoftheday #instagrammers

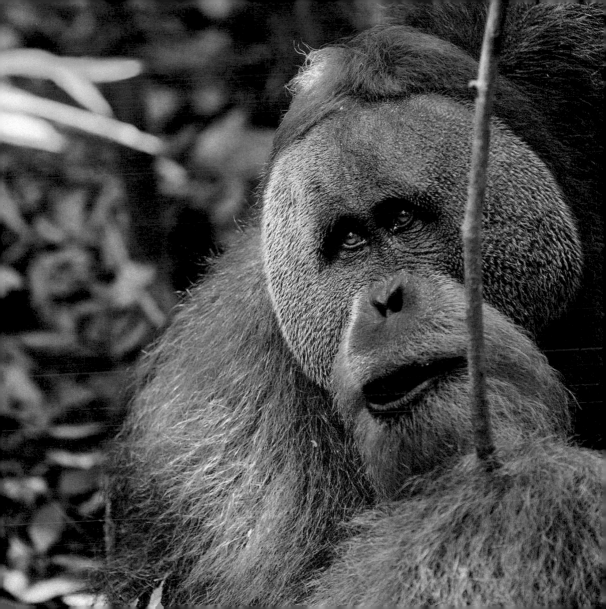

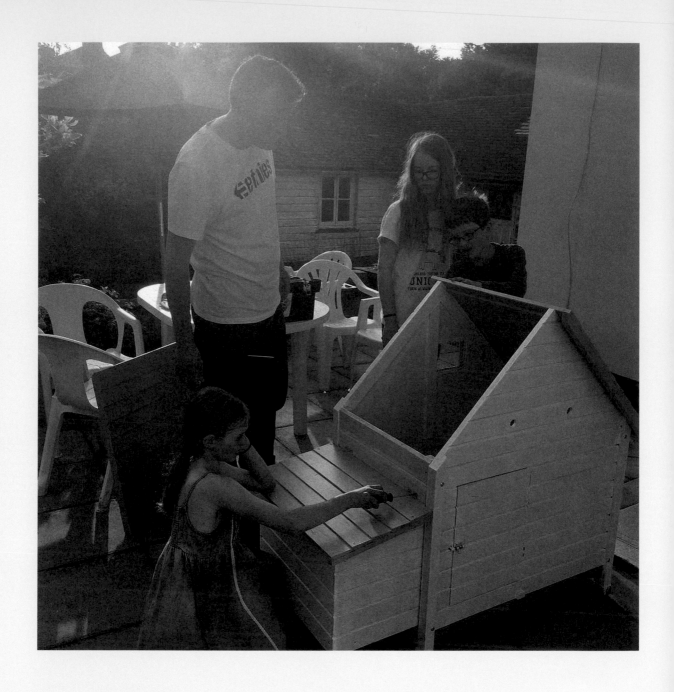

nicola_bird
Building the chicken coop. Fresh eggs means
more baking . . .

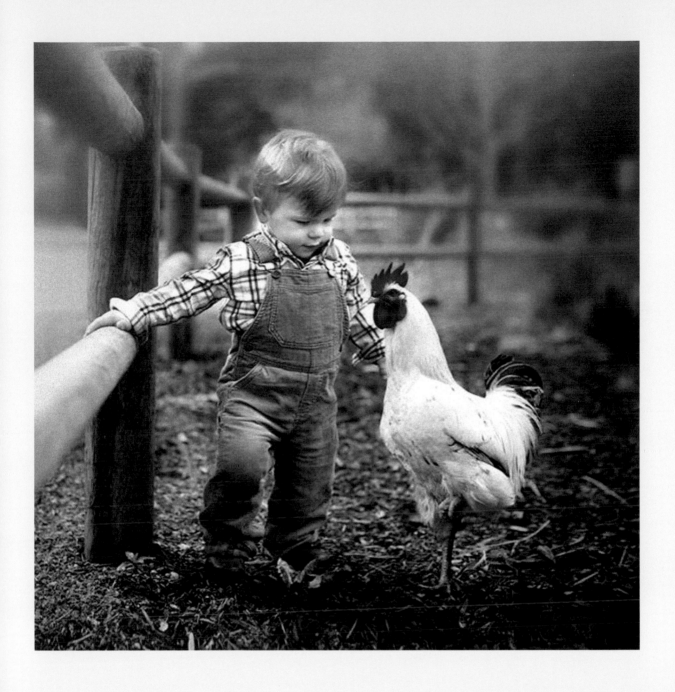

gabetomoiaga
Sunday stroll around the farm with my youngest

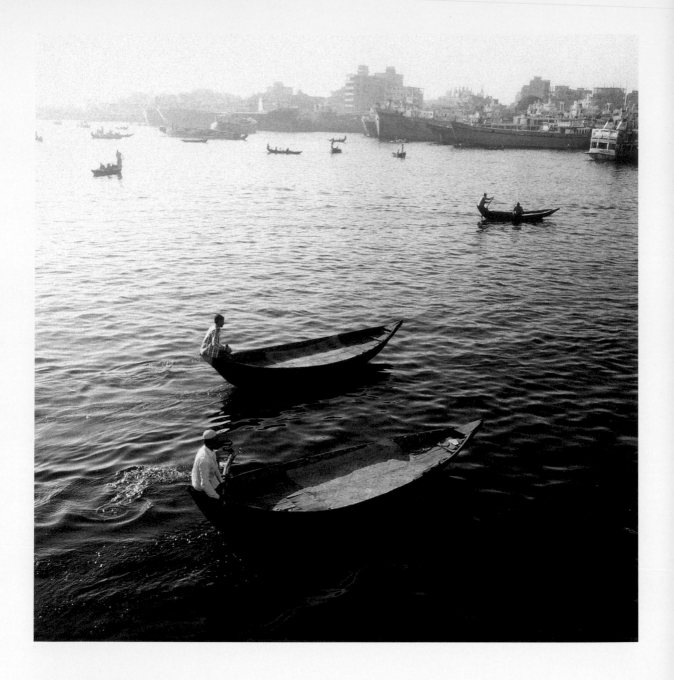

muradsfoto
Sadarghat
Borigonga River, Old Dhaka
#river #dailylife #boat #water_transport #iphone-only #iphonography #instabest #everydaybangla-desh #everydayasia #everydaydhaka #photooft-heday #documentary #hasanmurad . . .

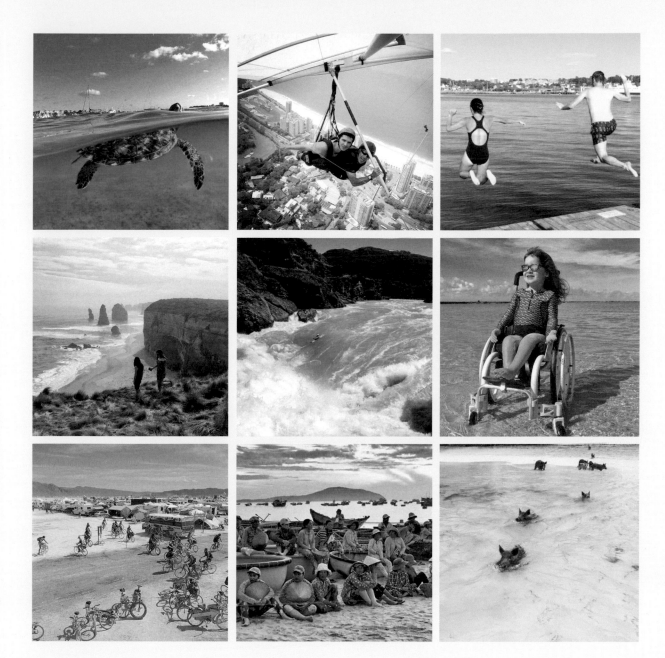

yesaccasey
Singer Island
When high tide is after work
#overunder#islandlife #seaturtle
#gopro #goproeverything #islandbum
@singerislandscenes #singerislandscenes

blackmobil
12 Apostles, Great Ocean Road
in a wonderland

spiffyfan
#burningman #burningman2014 #nofilter #bikes

mgrevtsov
Rio Hang Gliding
Well, that was fun
If you ever get the chance to do hang gliding –
don't think twice, just go for it
#lifeofadventure #neverstopexploring

iansalvat
Rio Baker . . . So huge!!
Albert Aixas
@palmequipment @daggerkayaks @double_
dutch_paddles @milyunclothes #baker #rioslibres
#chileansummer #lifestyle #pallarsriders . . .

nasonphoto
Mũi Né - Phan Thiết
Local fish vendors waits for the fishing #boats
arriving at Mũi Né village #beach, near Phan Thiết
city, southern Việt Nam in an early morning.

jestingrid
Hoppe!

juliafkogan
Praia Da Barra De São Miguel
Há alguns dias uma pessoa veio até mim e per-
guntou se a Clara tinha chance de 'se curar'. Eu
expliquei (e sei que explicarei mais milhares de
vezes, não me incomodo) que Clara não é doente.

cromachi
Great Guana Cay, Abacos, Bahamas
The Bahamas has the freshest bacon!!!
#eatlocal #pigbeach #bahamas #whole30

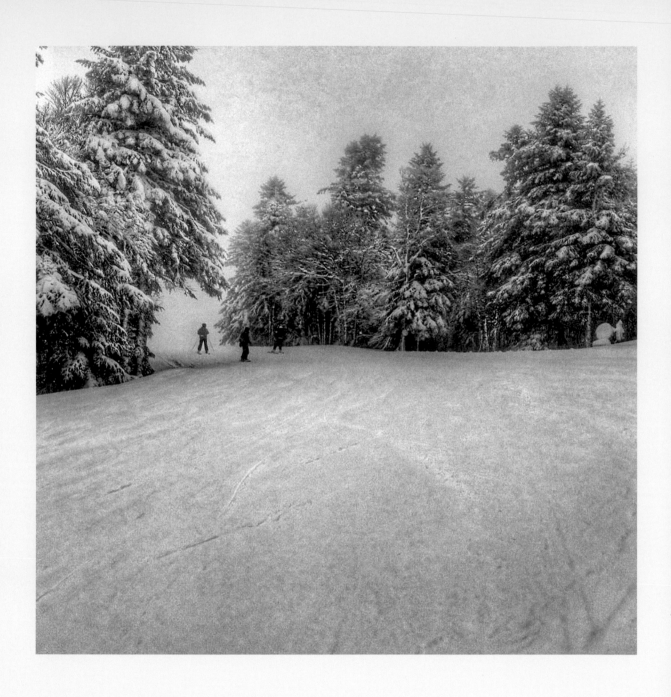

gremly
Le Lioran

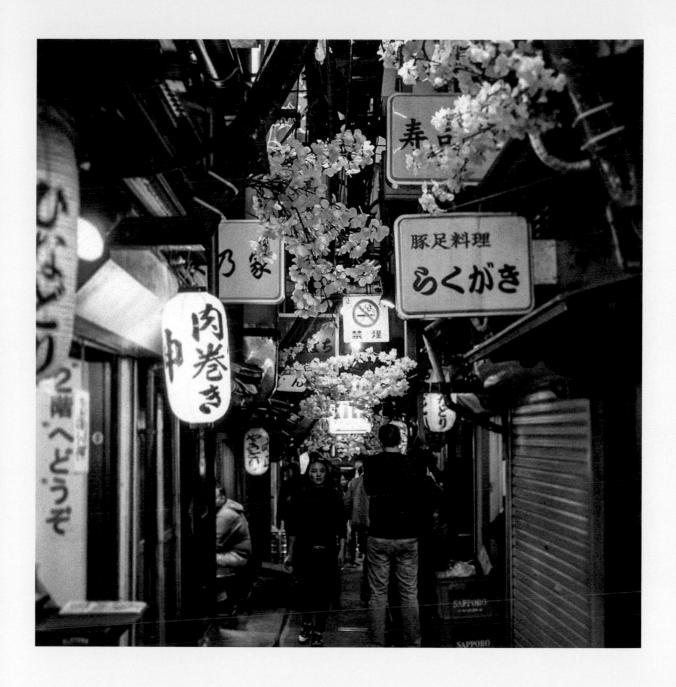

m.kulio
Shinjuku Omoide Yokocho
blade runner vibes

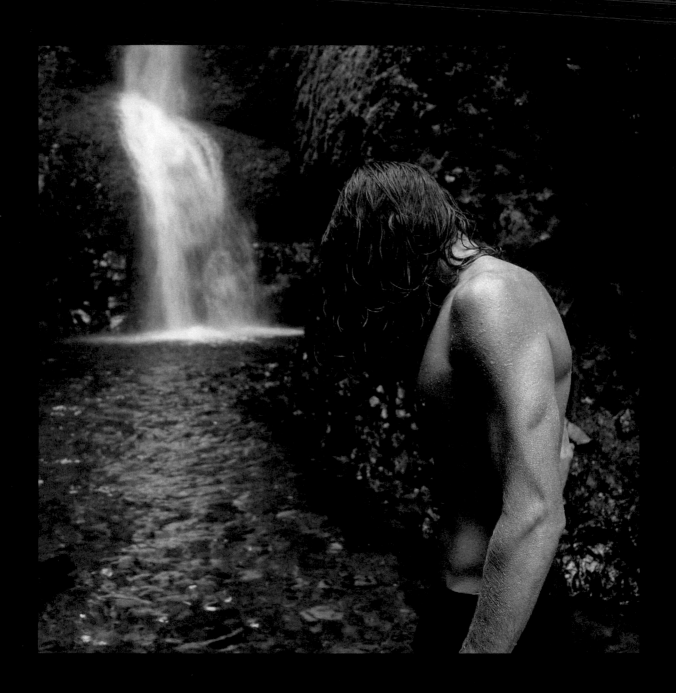

johnonelio
Oneonta Gorge
Keep it wild // #getbusylivin

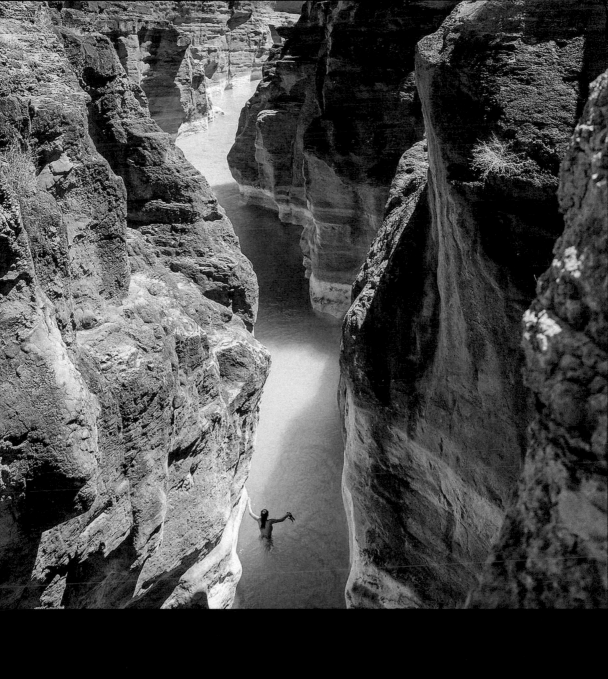

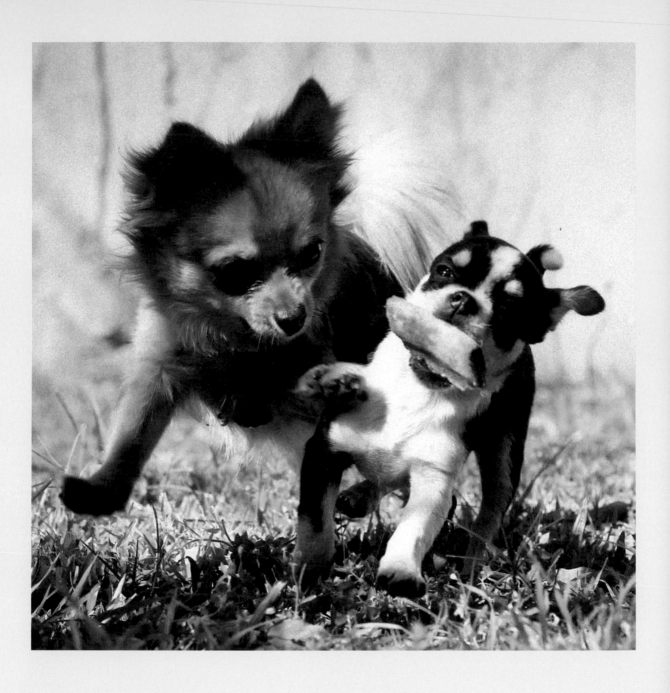

marianomane
Run forest...

huxleygriffon
Blackwall Hitch - Alexandria
#whpexpressions #huxthegriffon #everyday-
imbrusseling #dogsofinstagram #dogsofnyc
#brusselsgriffon

valentsu

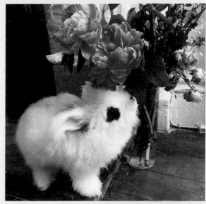

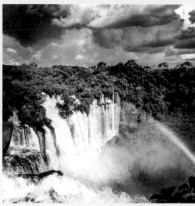

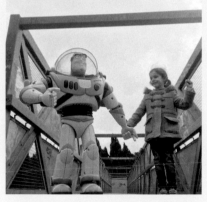

avanope
made a new friend :)))

hanthomas
Oh Em Gee, this just happened. I'm dead.
June 1st 2016 #dailyarie

cleo_thebunny
Ahhh...the sweet smell of peonies in the morning.
Happy Monday friends! And thanks @cherry-
bombemag @taittingerusa @aliciamcdole for
these beauties #cbjubilee

elizabethsmart
Missing u @vikipedia_

ricardomena72
Kalandula Falls
#angola #calandula

allydelmonte

naseke
Toy story
#WHPeyetricks @instagram #communityfirst
#primerolacomunidad #instagoodmyphoto
#igersvalencia #valenciagrafias #buzzlightyear
#igersspain #instagrames #toinfinityandbeyond

pazzopup
Paz was the ultimate gentleman for his first
#valentines day! #happyvalentinesday

salwangeorges
City of Ferndale, MI during the holidays
#puremichigan #ferndale #michigan

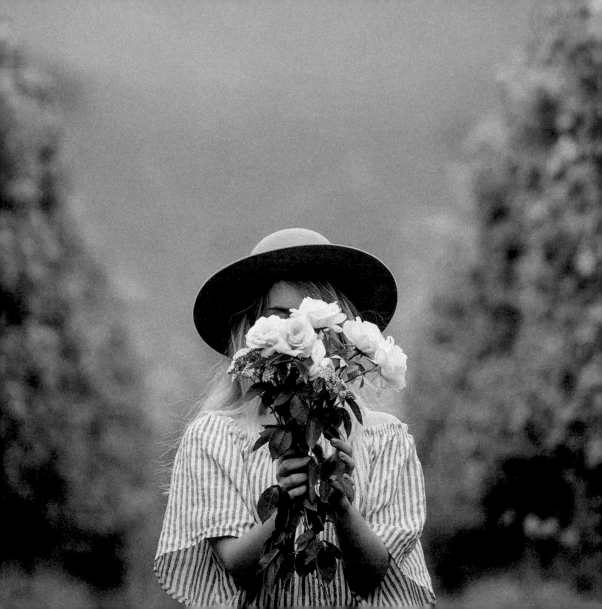

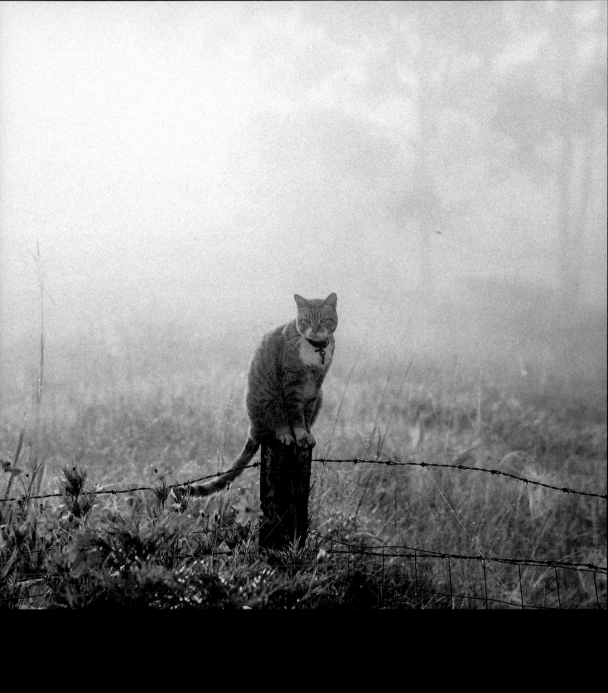

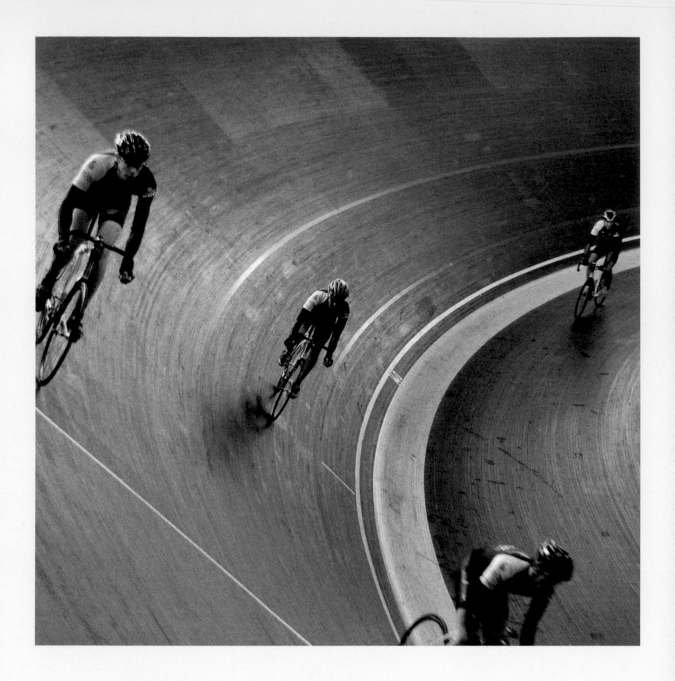

thisismybike
I penned something about my first ride on the
Eddy Merckx Velodrome in the photo previous.
Or read the blog. Safe to say, I will find my way
back to the steep curves ASAP.

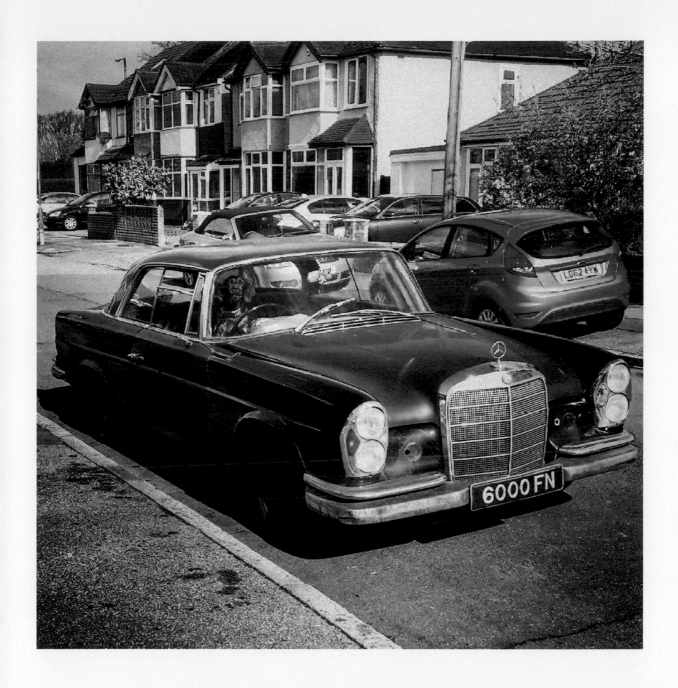

the.tinker.taylor
Houunslow
Kerb-Crawler Alert #edgyvibezz #vintage-
mercedes #HoundSlow #dogsincars

francesmehardie
Alice's
'People, even more than things, have
to be restored, renewed, revived,
reclaimed and redeemed; never throw
anyone out.' Audrey Hepburn

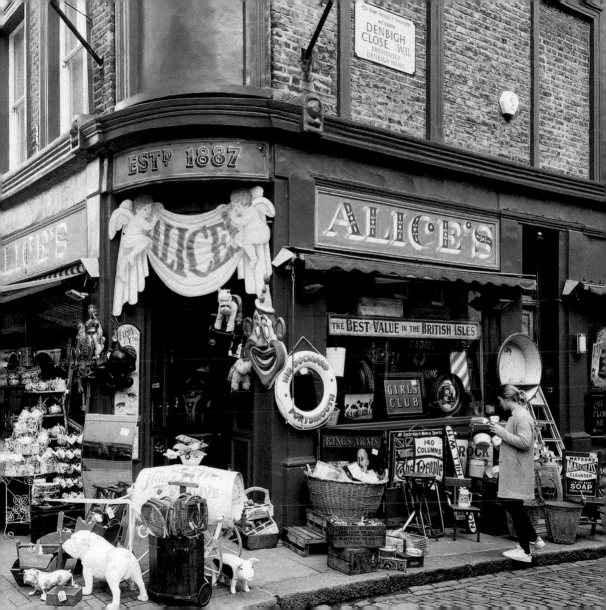

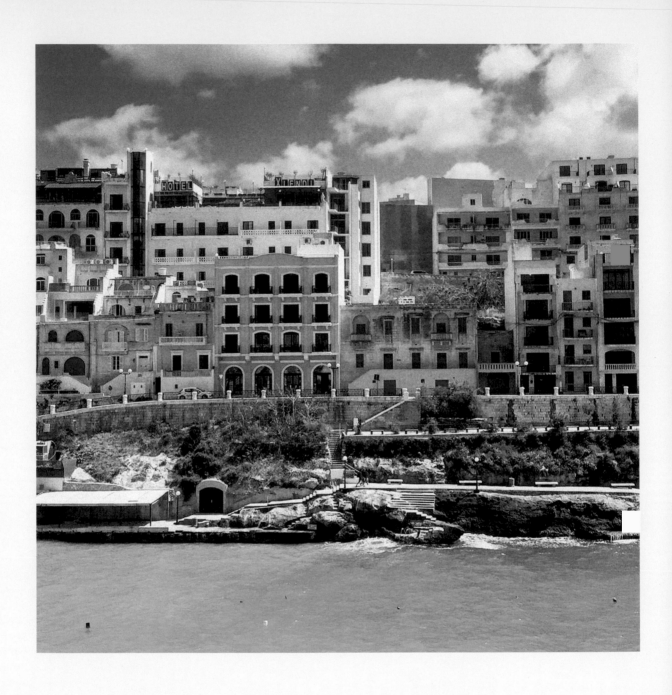

jmeulemans
Xlendi Bay Gozo
Chillest little town in all of #gozo

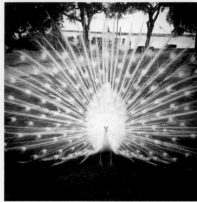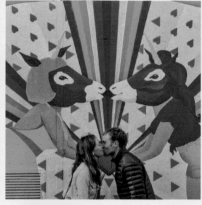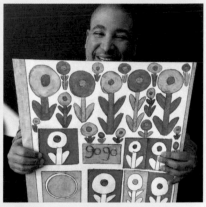

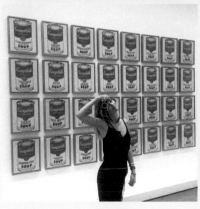

mells324b21
Staglieno
#cimitero #monumentale #cimiteromonumentale
#staglieno #genova #joydivision #hands #cimit-
eri_monumentali_ #graveyard #graveyard_dead
#tombstone #cemetery_shots . . .

apesmixtape
Beautiful peacock outside of my cabin #peacock
#camping #cabins #lakewhitney #arrowheadre-
sort #nature #beautiful #sundayfunday

maliabeth
MoMA The Museum of Modern Art
Taken' pictures of @michael__maxwell taken'
pictures of me in front of some Warhol pictures.
#moma #andywarhol #warhol #artist #adventure
#dreamland #model #tomato . . .

sophiacosmo
@montanaleviblanco for his beautiful costumes
last night in O, Earth! Everyone should go see this
show! Please remember us when you are famous,
babyboy

travellingduff
So excited to be getting married tomorrow to my
best friend and my around-the-world adventure
partner @joeyclawrence

jim_stoddart
Brick Lane
#BrickLane #TruemanBerwery #Spitalfields
#piano #pink #dress #pinkdress #market

barbenvakil
Williamsburg NYC
Let's start working

landgallery
Spring is here NYC #Jamesrosa

becstocks
In a regular street in Hampstead. Every home
needs a garden ornament.

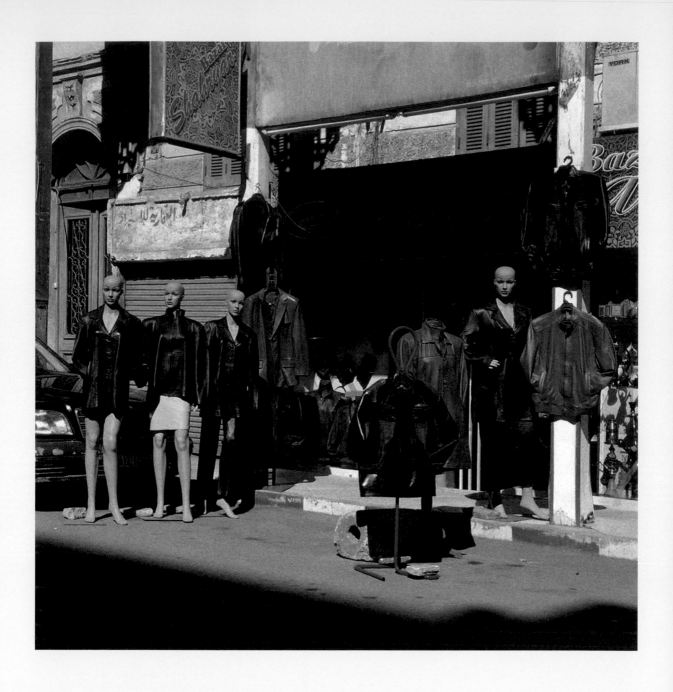

moeit_
ارورش بنات في بورسعيد

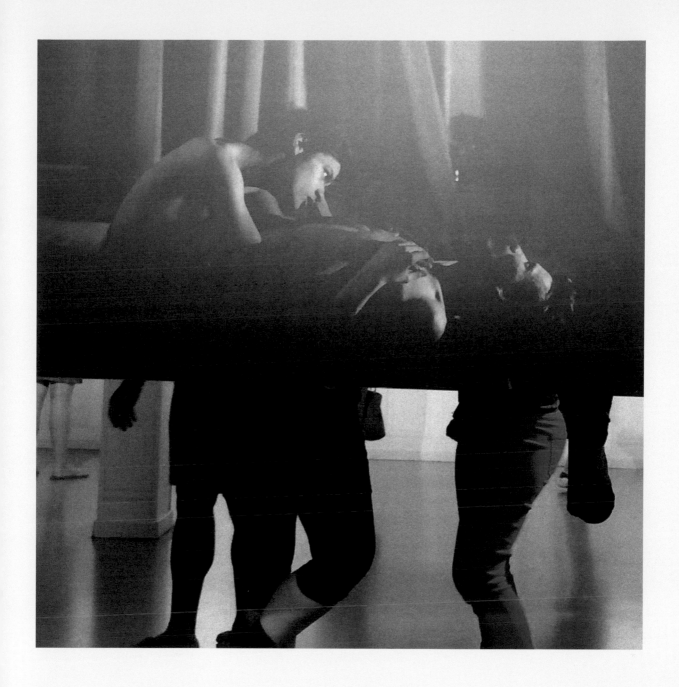

jamesrosen
#worldpress

caxmee

Repost from @instagram – happy to be part of this #RunwayForAll series #mamacax

'#RunwayForAll means any teenager feels represented when they open a magazine or watch a fashion show,' says Mama Cax (@caxmee. Mama grew up in Haiti, lives in New York City and never aspired to be a model — 'not only because there were very few dark models on magazine covers but also because I grew up with very little knowledge of the fashion industry,' she says. 'Eight years ago, after getting my leg amputated, the idea of being a model was even more far-fetched.' Today, Mama is modeling and doing other things that she was told there was no audience for, like sharing tips for traveling as a black female amputee. 'The majority of humans do not look like the main-stream idea of beauty,' she says.

'One of the greatest barriers is not belonging. Through modeling I hope to show that beauty does not always wear a size zero and beauty does not always walk on two limbs.'

Every day this week, we'll be sharing the story of a model who is redefining industry standards and making sure there's room on the #RunwayForAll. Photo of @caxmee by @simonhuemaen

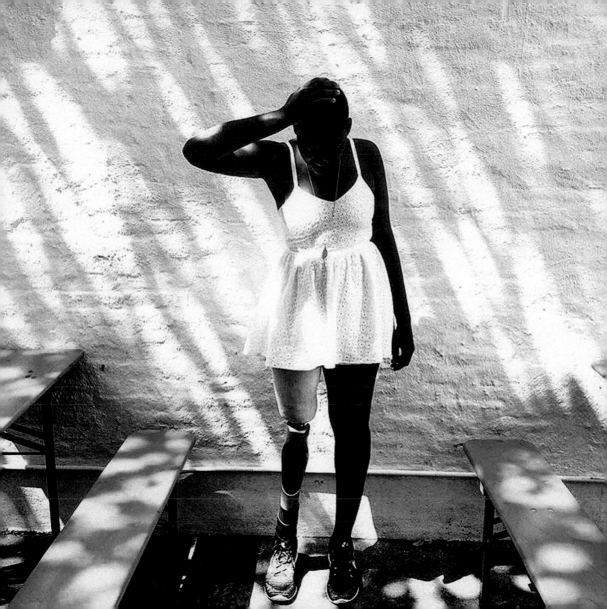

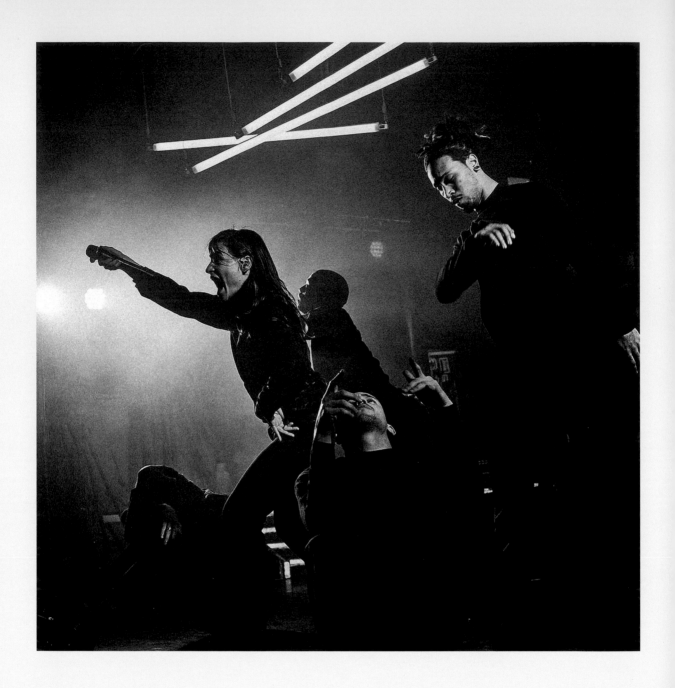

amandafordycephoto
KOKO London
#christineandthequeens
#kokolondon

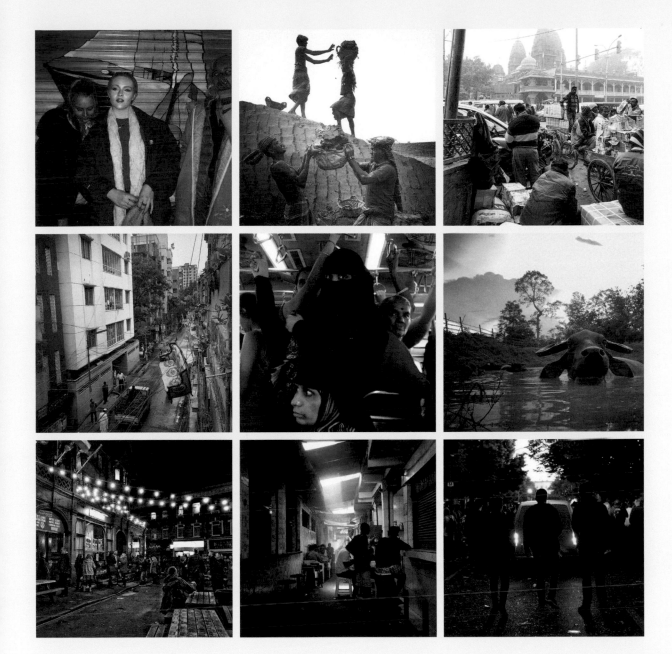

evamcalpine
Bonnington Cafe
Veggie night

ismailferdous
Isla Manpura
Local people building polders to protect land
from river erosion #climatechange #Bangladesh
#latergram #iphoneonly #Teamwork

h_cato
Old Delhi

ismailferdous
Dhaka, Bangladesh
When a whole couch gets stuck in the wires of
#Dhaka city. #iphoneonly

anushree_fadnavis
An everyday scene in the ladies compartment
of the Mumbai local train #traindiaries #trains
#Mumbai #mumbaidiaries #everydayeverywhere
#everydayasia #everydayindia #everydaymumbai

phukradung
หมู่ ๘ บ้านโนนสวรรค์
อาบน้ำจากก่อนนอน

onlyamomenthoney
Night Light

deni_perez
De novo a feira mais linda do Brasil, do mundo
e até da Bahia. São Joaquim #sãojoaquim #fei-
radesãojoaquim #salvador #bahia #Brasil #brazil
#deniseperez_bahia #deniseperez

_foveola
Berlin, Germany
lasting memories | summer 2015

elyasami
Деревня Универсиады
Энтони Берджесс "Заводной
апельсин"
Маленькими шагами идем к
цели, но о #книжный_марафон
не забываем. Итак, эту книгу
я читала очень долго. Я знала,
что в ходе повествования будут
мерзкие вещи, но все же хотелось
прочитать именно из-за языка,
на котором говорит рубежное
поколение malltshipalltshikov и
kisok "надсатых". Можно ли спасти
мир от зла, лишая человека воли
совершать дурацкие поступки?
Книга является ответом на этот
вопрос. Каждый человек должен
обладать свободой выбора, а не
быть "заводным апельсином" в
руках правительства.
Достоинства: оригинальный
язык, актуальная проблема
агрессивности молодежи.
Недостатки: чрезмерное описание
мордобоев и насилия.
Шибко философская вещь и
"всякий такой kal". Надо глубоко
копать и долгое время пребывать
в раздумьях.
Перечитывать бы не стала, но
прочитать советую.

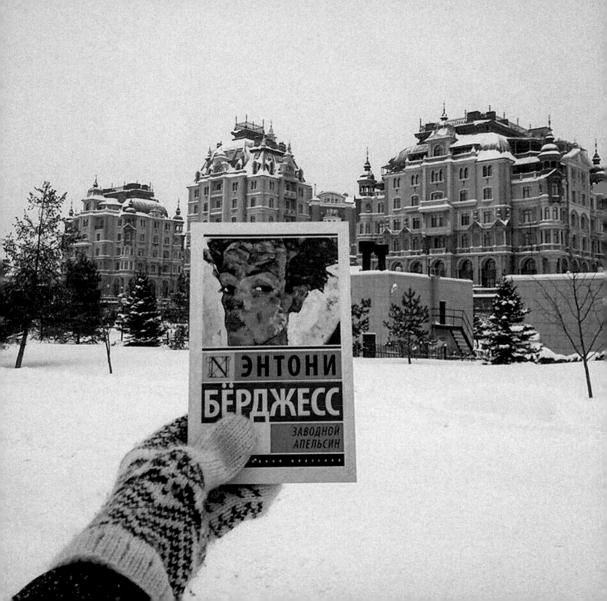

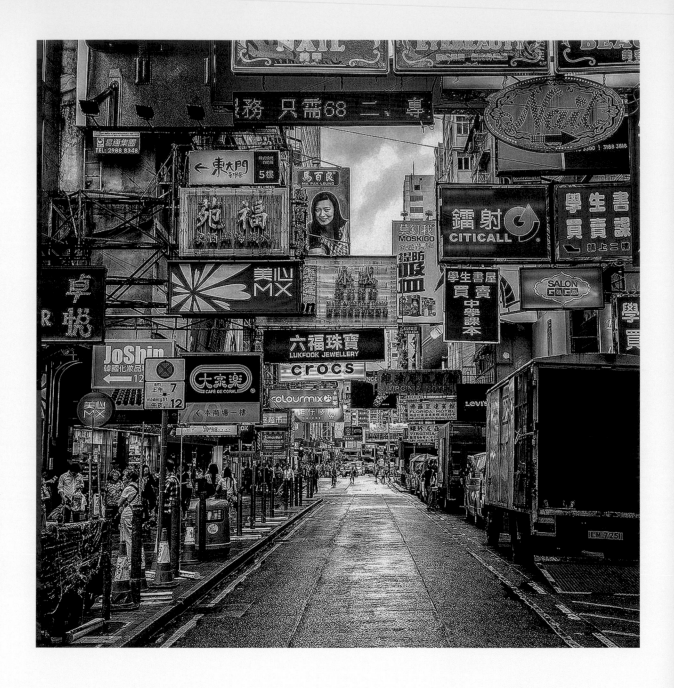

tokio_kid
Mongkok,Hongkong

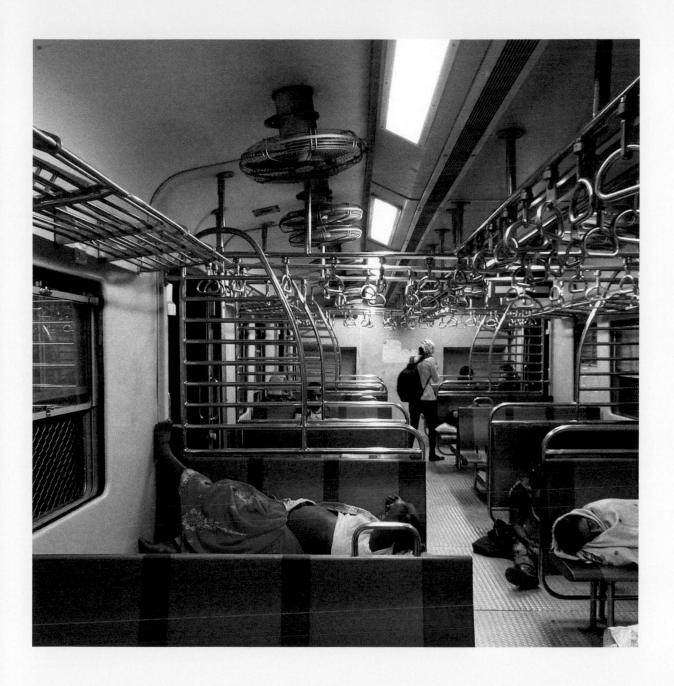

anushree_fadnavis
Another night in the train while travelling back
from work. #traindiaries

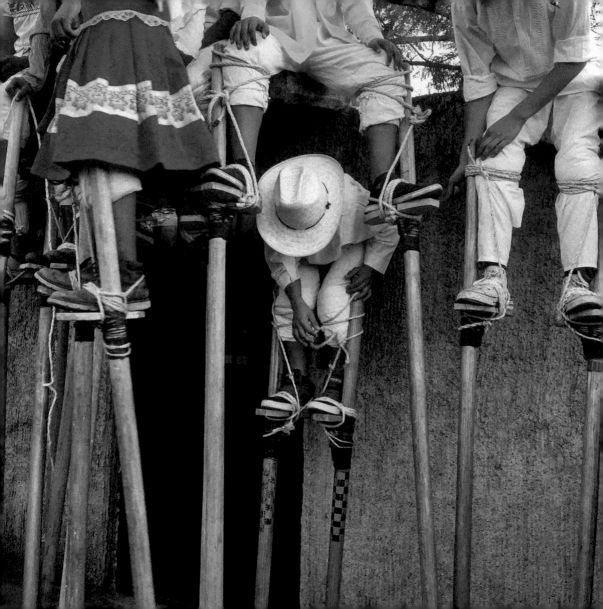

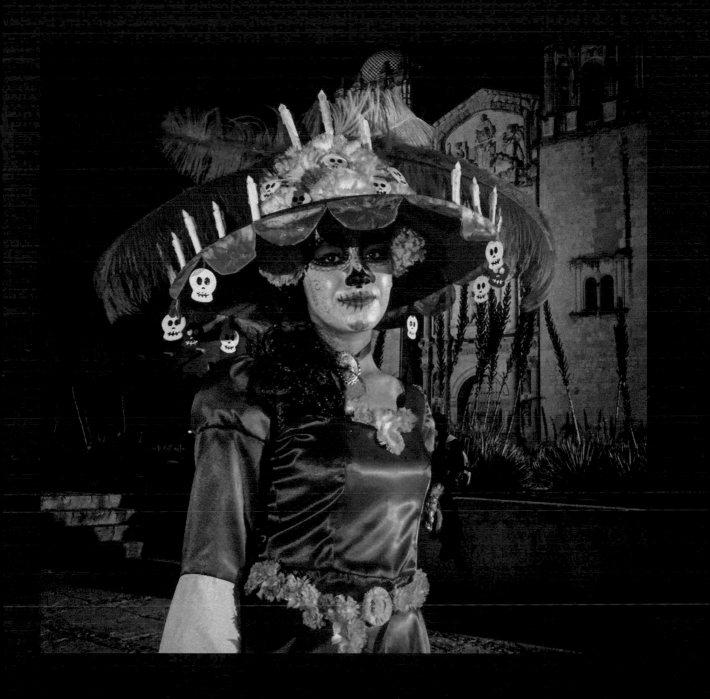

fcoronado
Cd. Oaxaca, Oaxaca
Como cada año, la muerte tilica y flaca hace su
arribo a la Ciudad de Oaxaca.

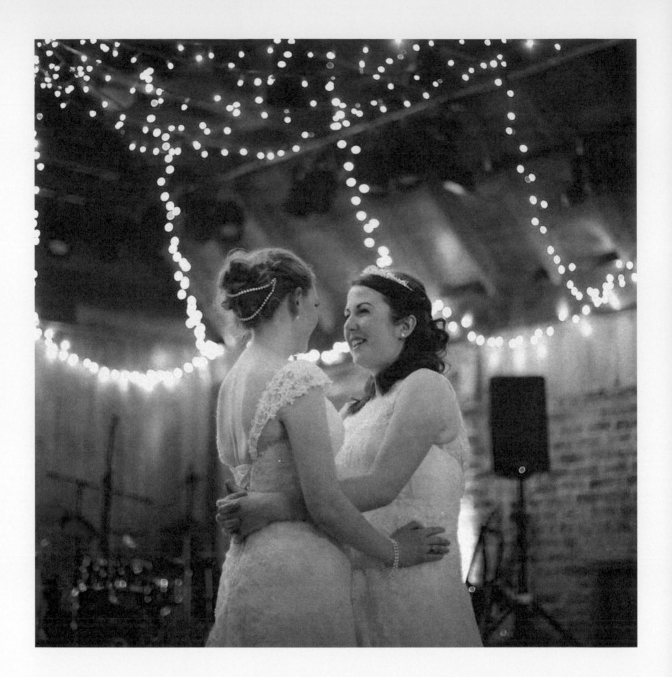

mcneilrachel
First dance – new blog post of Louise & Sarah's
wedding is up! .

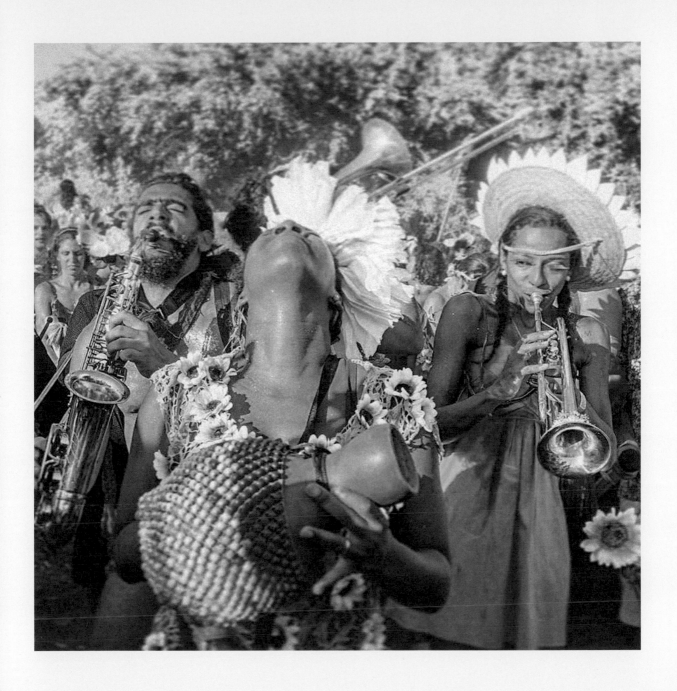

tatiruediger
Jardins Do Mam
. . . e a tristeza sempre tem a esperança . . .
Vincius de Moraes

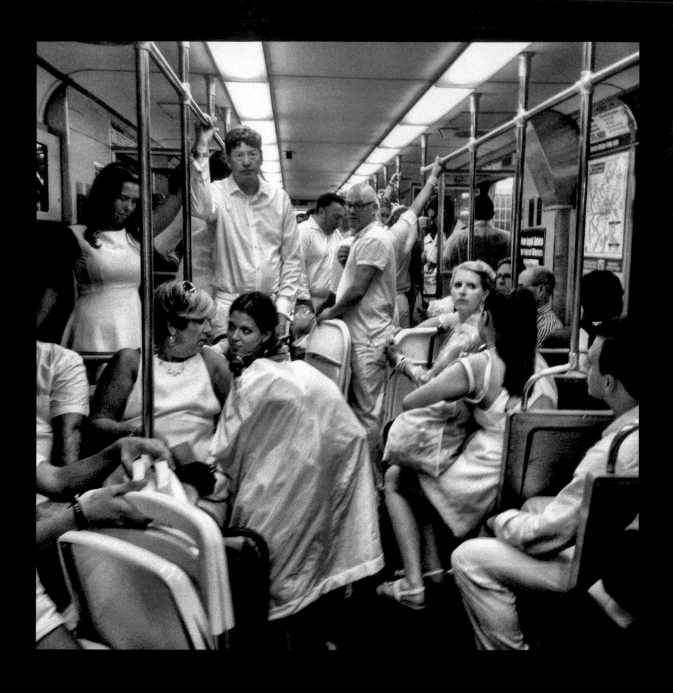

chuckseye
Broad St Subway
Subway en Blanc. Our transportation to the secret
locale of Diner en Blanc.

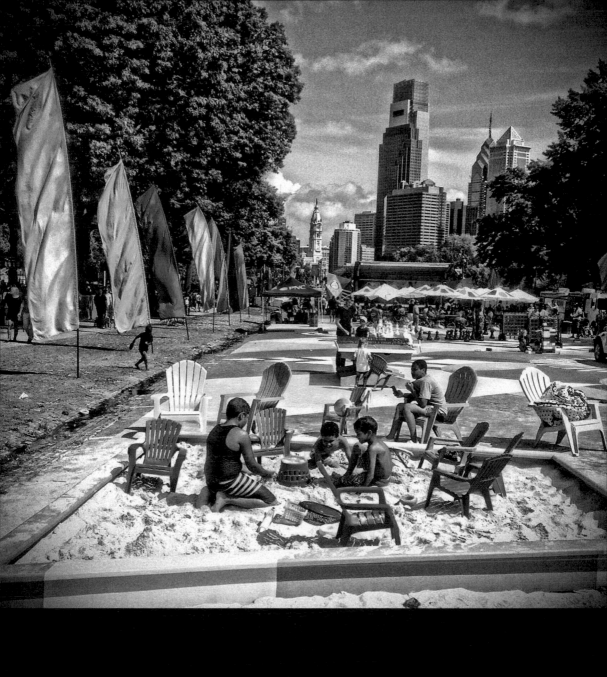

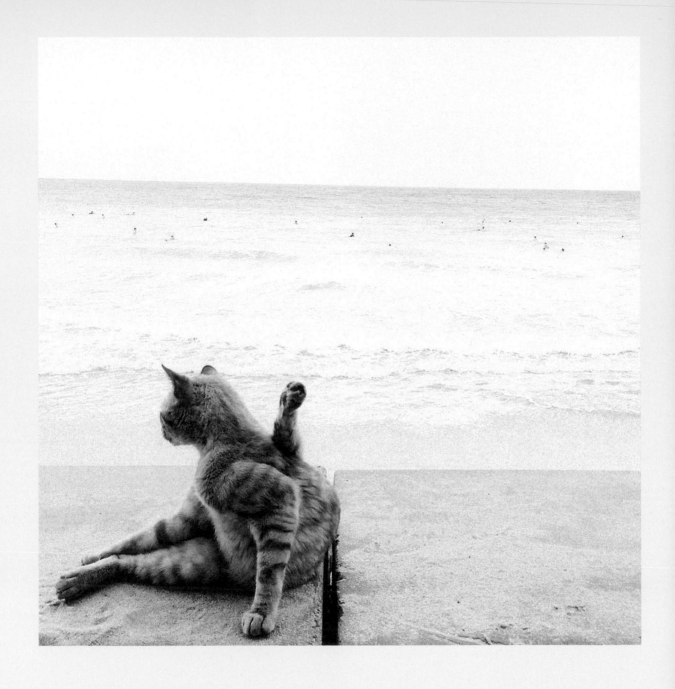

vinicius_eneas
Barraca 21, Praia De Ponta Negra – Natal
If I had a Tail.

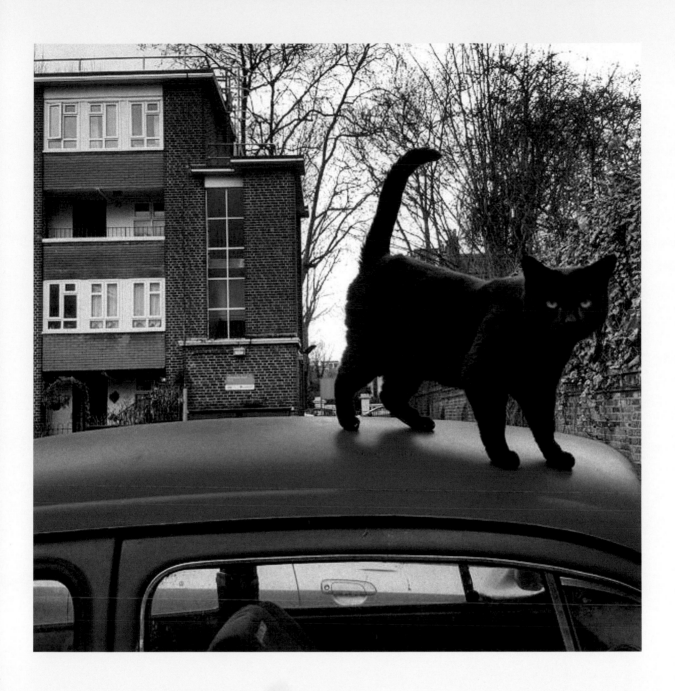

amberrrjones
Purr-motor

mgrevtsov
Sambódromo da Marquês de
Sapucaí – RJ

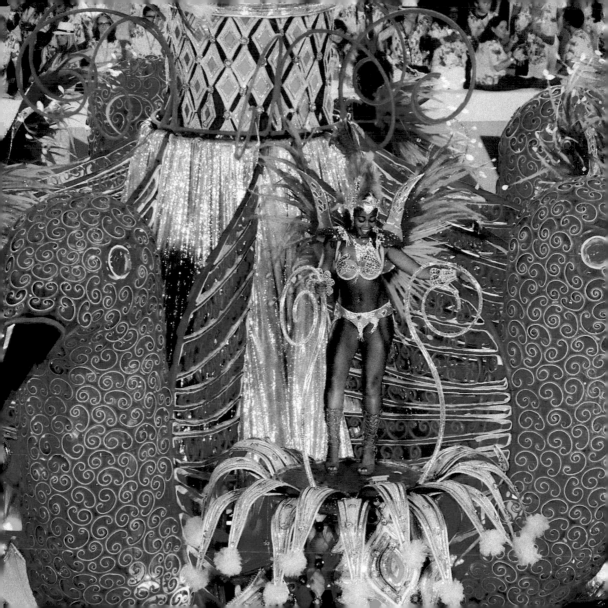

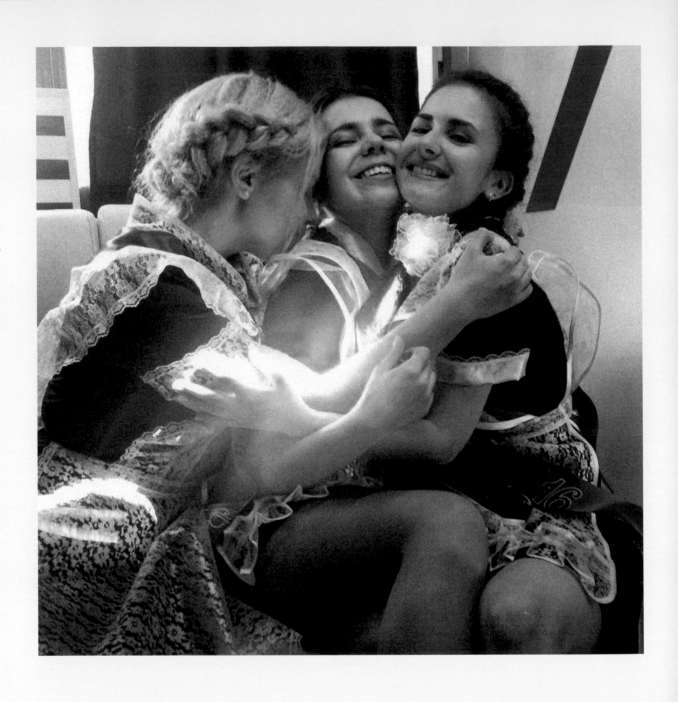

purshervil
НАВЕРНО, ЭТО ОДИН ИЗ ЛУЧШИХ И САМЫХ
ЯРКИХ ДНЕЙ В ЖИЗНИ! Я
была уверена, что, как только на линейке
заиграет советская песня о школе и начнут
говорить речь, я сразу же расплачусь . . .

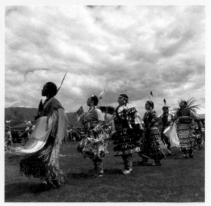
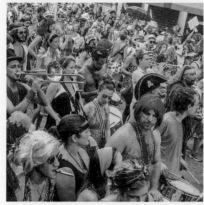
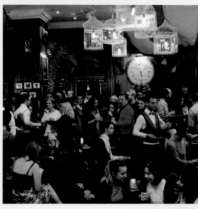
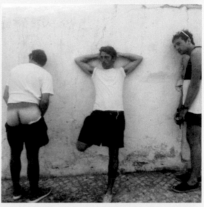
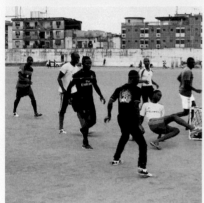
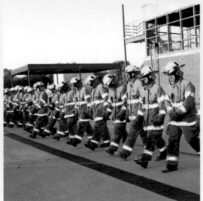
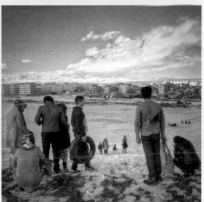

bonzojones
Finishing Line Of The Virgin London Marathon

anasrshd
Knaresborough
Hope you guys had fun with my never-ending
humour. Haha. See you another time.
@amad_razak #potd #ootd #travel #friends . . .

spiffyfan
Malibu Bluffs Park
#nofilter #chumashday #Chumash

tatiruediger
Cordão Do Boi Tolo
Somos muitos

rolfemarkham
Mr Fogg's Residence
Radium One drinks at Mr Fogg's Residence. #iab

yandelli
'Here come the girls' #actcasual @joeyandell
@dingleyandell @erd27

arristide
Every minute in Africa, an UEFA Champions
League game is being played. The beautiful game.
Future #Drogba and #YayaToure out on the field.
#Africa #Football #JogaBonito #Soccer . . .

striving2beraw
3 years ago today, we were caring for our 11-day-
old son. My husband was home from either shift
or on leave. We both were watching the news as a
Dallas Fire-Rescue call turned south & a firefighter
lost his life . . .

fardin.nazari
Snowy day 01
#Abhar #Zanjan #Iran
#lphotography #instagram #documentaryphoto
#documentaryphotography #dailylife #Documen-
tary #People #streetphotography . . .

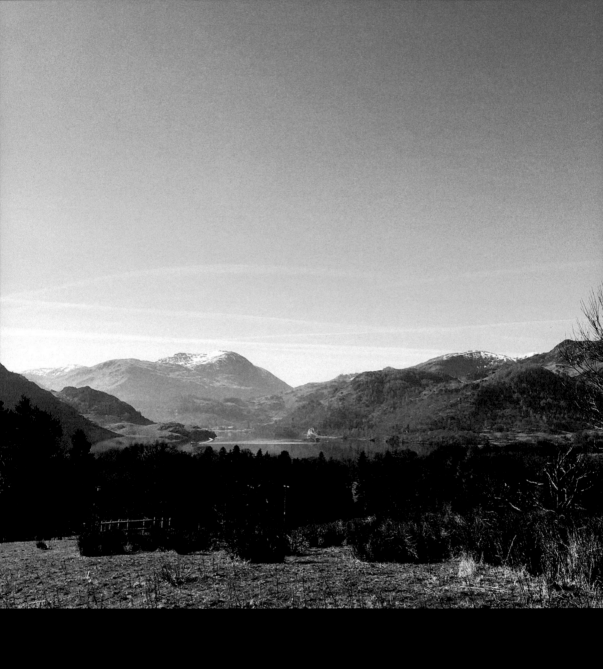

ameliahodgson1
Ullswater. The Lake District.
Sunny day #sunny #Monday #farming #ullswater
#lakedistrict #cumbria #pretty

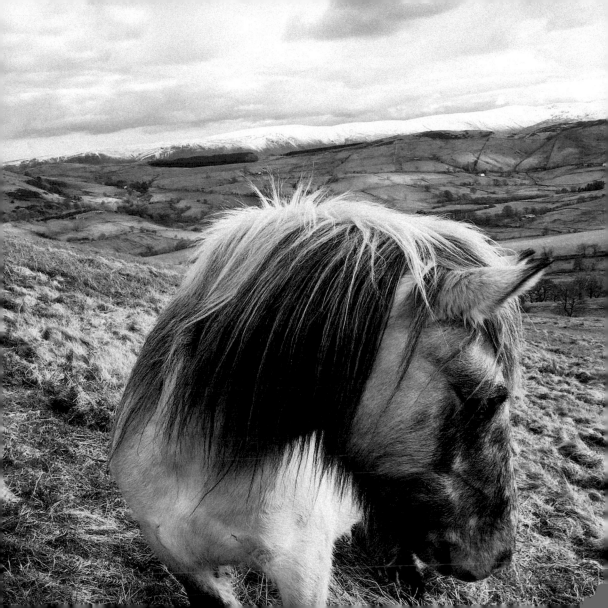

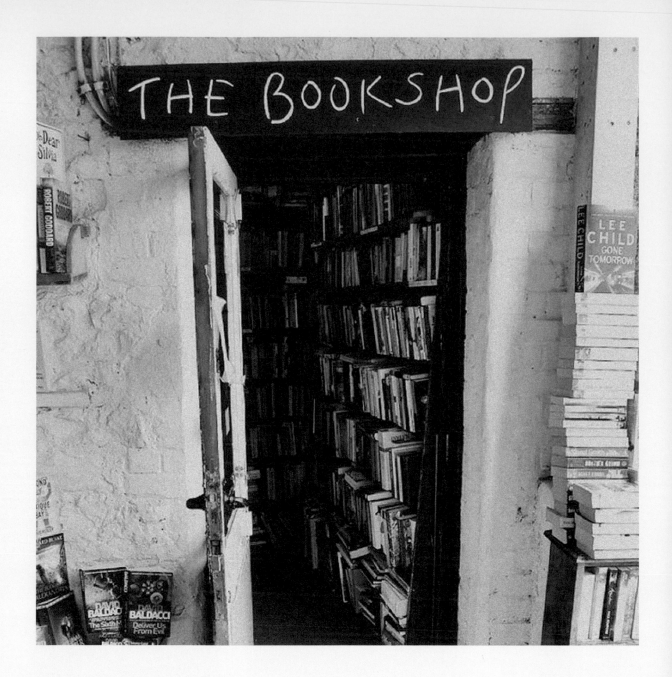

allydelmonte

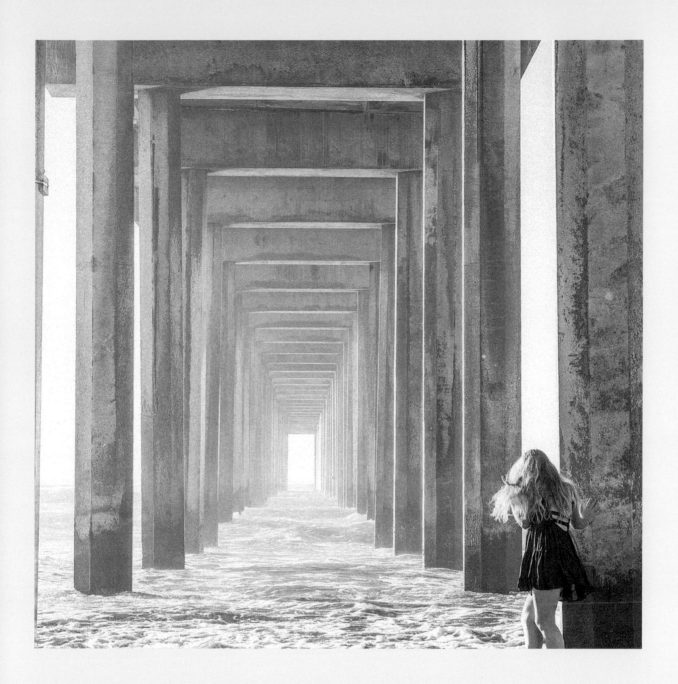

stevesweatpants
Los Angeles, California
Shedding one tear for all the love to everyone
in LA who came out to the first stop on our
#NextMilestone tour with @honda

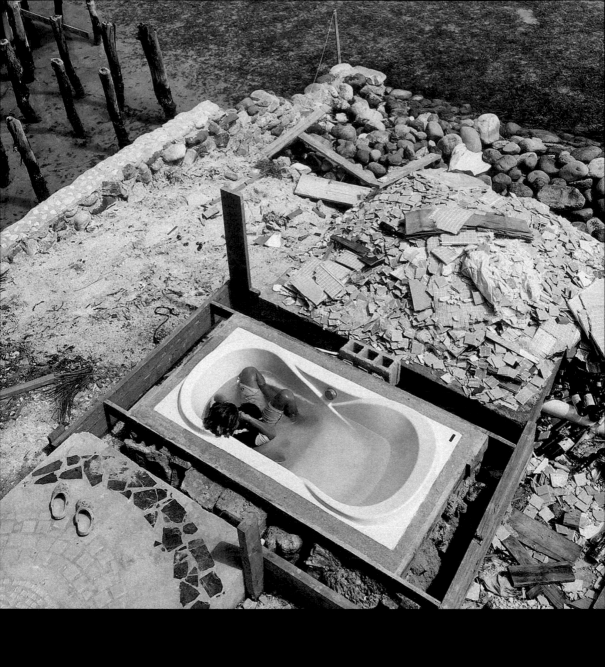

pketron
Pigeon Cay, Utila, Honduras
When your house by the sea is under construction
and you're in need of a makeshift wading pool.

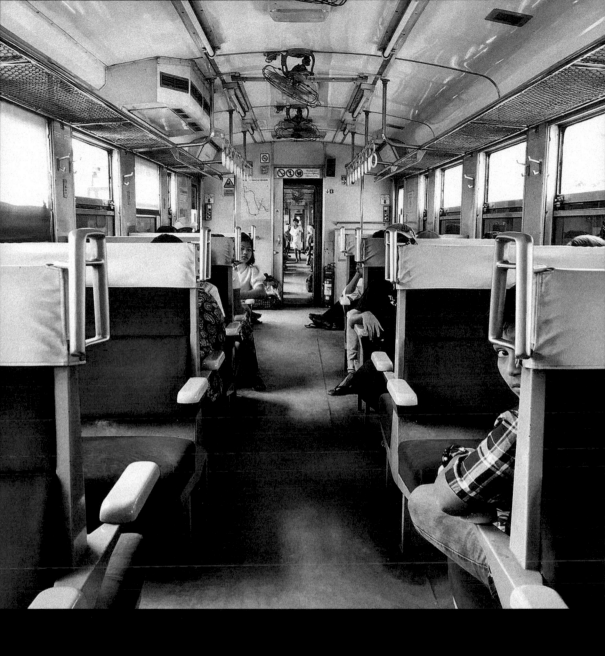

pketron

Yangon Circle Line
Time seems to stand still in a place like Yangon.
This was taken last week, but could easily be

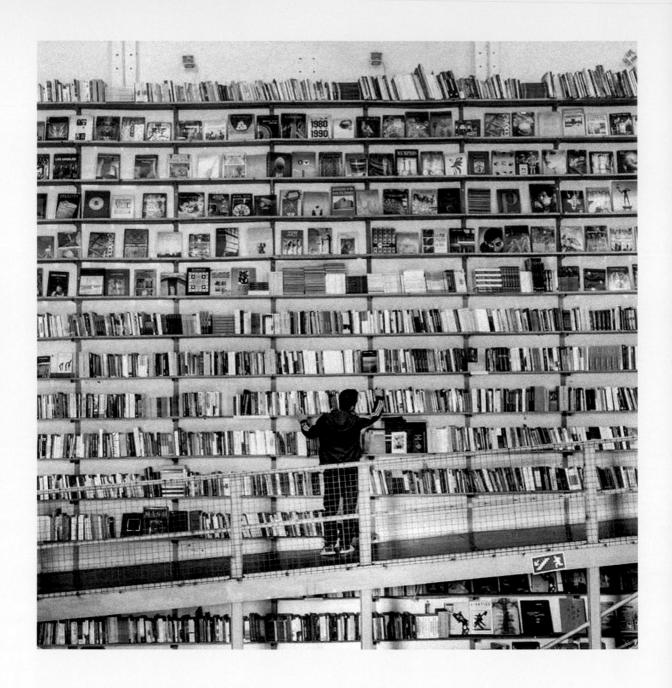

cimek
Lisbon, Portugal
need something to read?

 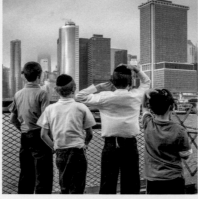 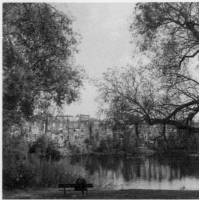

 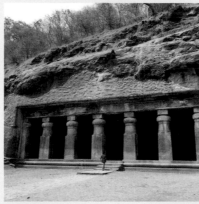

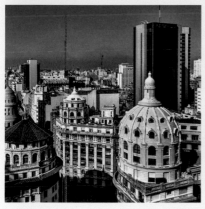 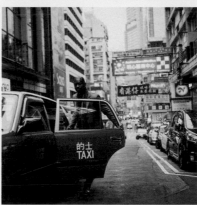 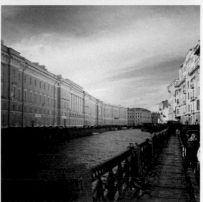

carlosthegypsy
It's always beautiful after the rain. #Sunset
#AfterTheRain #Clouds #Roofs

klsmeanders
View today. Spring blizzard.#springblizzard
#coloradospring#brrr#brightoncolorado
#snowymorning#blowingsnow

pao_lamaga
Mirador Galeria Güemes
Tocar el cielo con las manos y el corazón

juancristobalcobo
Staten Island Ferry
On the ferry #statenislandferry #statenisland
#hassidicjews #helloicp

theindianhippie
Elephanta Island Caves
#ElephantaCaves

alenpalander
Hong Kong
@edwardkb has a mean whistle.

nigelpaulin
Hampstead Heath
Tranquility runneth over. Oasis of Peace.
#mychurch #nature #love #meditate #tranquility
#peace #stillness #reflection #naturelovers #just-
goshoot #livefolk . . .

shameem_ehsan
Rain drops keep falling on my head..... #rain
#raining #rainyday #rainydays #water #clouds
#happy #happiness #smile #cloudy #lifestyle
#everydaydhaka #street #streetphotography
#photooftheday #instagood #gloomy . . .

lina_liss

minamohit
Port of Piraeus
Refugees send a happy wave as
they get accepted to relocate to
#Skaramagas, a different camp in
Athens but with better facilities.
These people have lived in tents out
in the open for weeks and months.
The EU borders still remain closed.
#portpiraeus #greece #athens
#refugeecrisis #humanize #betterlife
#humanrights #photojournalism

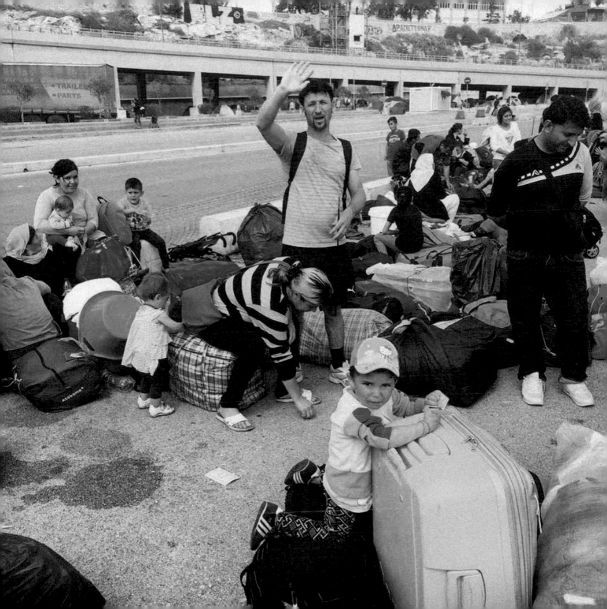

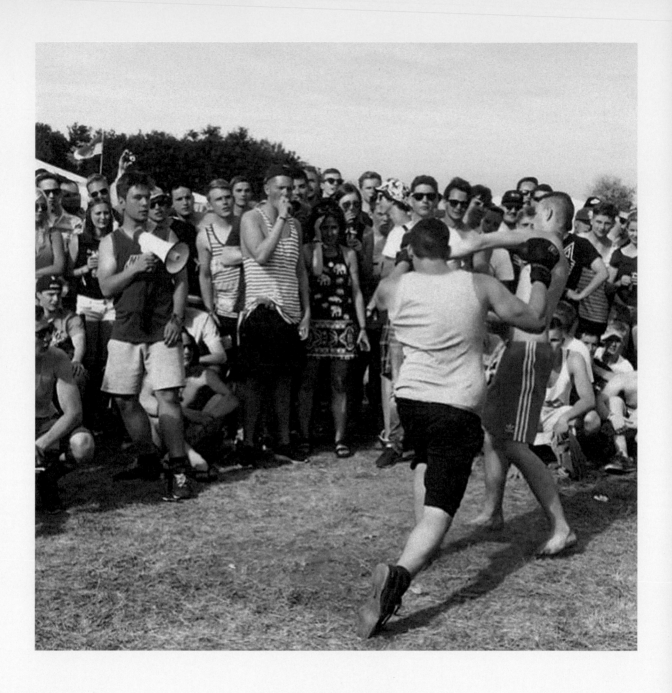

maxgehl
splash! Festival
#fightclub #splash18 #kippenmann

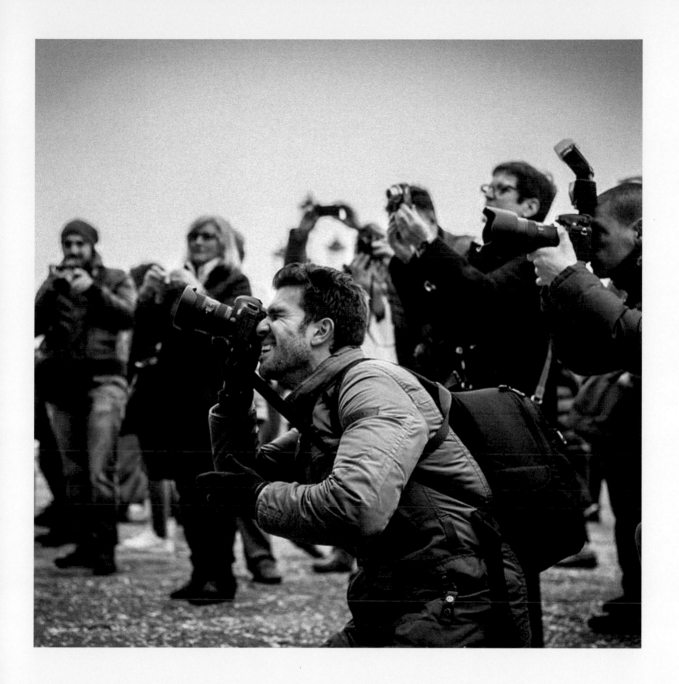

lorenzosalvatori
Assalti fotografici
#venice #venezia #carnevalevenezia2016
#streetphotography #streetphoto

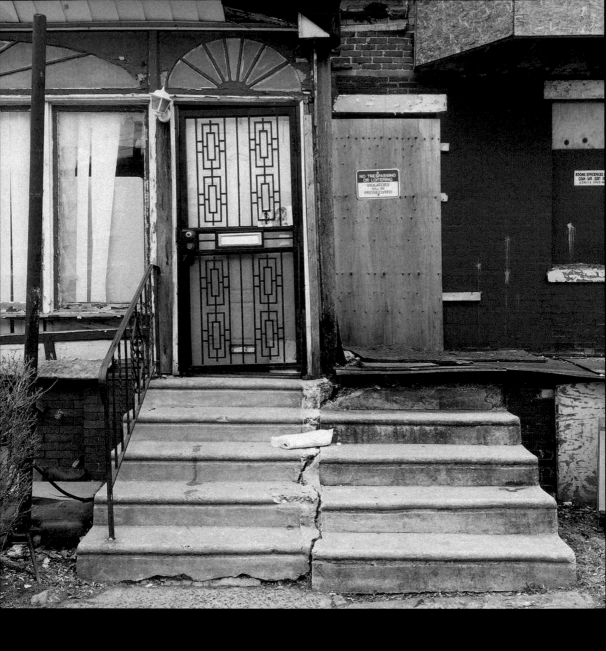

billycress
#igers_philly #philadelphia #whyilovephilly
#phillyhomeportrait #VSCOcam #explore215
#westphilly #kingsessing

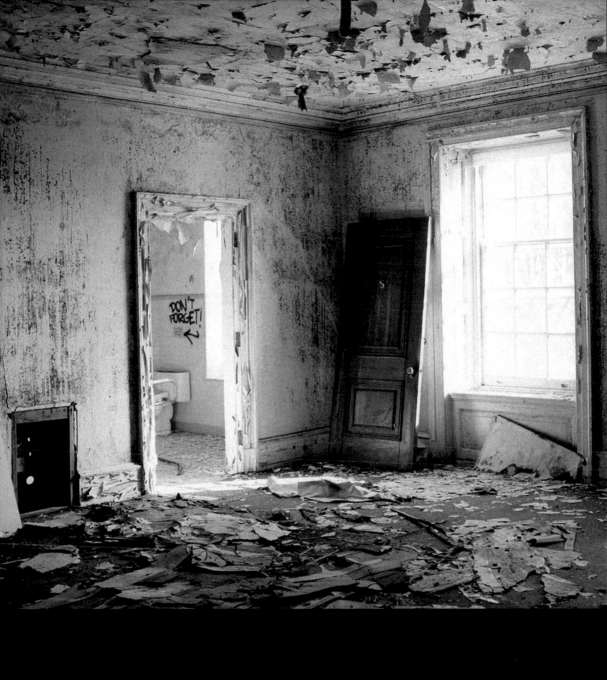

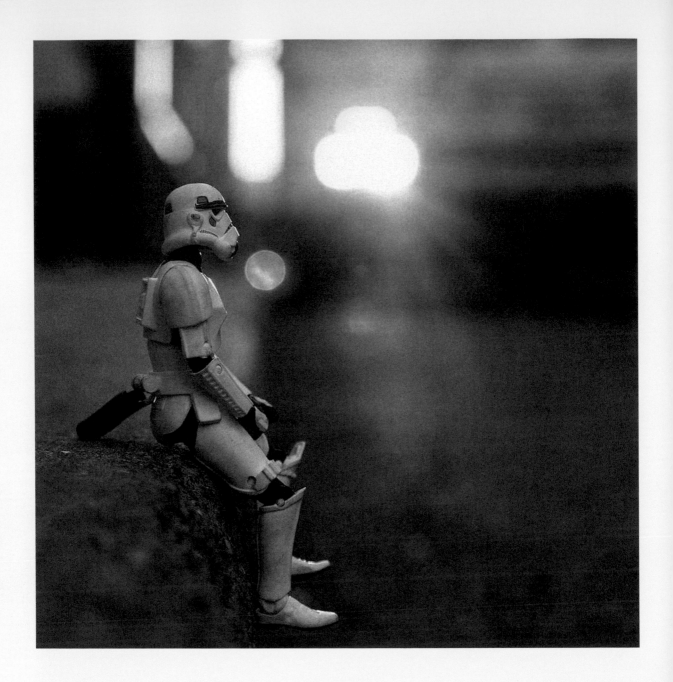

tigerladyyy
Just a curbside prophet.
#stormtrooper #starwarsfigures #starwars
#toyphotography #toysofinstagram #toyslagram
#atadreadnoughts #toyfun #nerd #canon_photos
#canon6d #detroit #motorcityshooters
#igersdetroit #adventuretime #detroit . . .

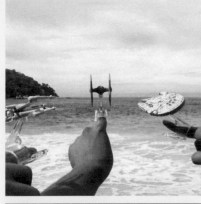

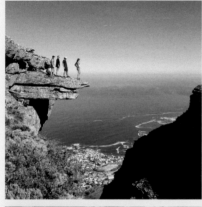
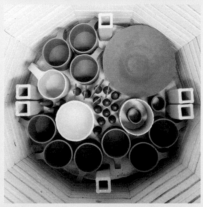
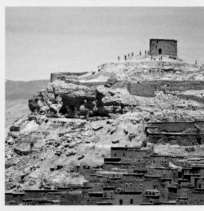
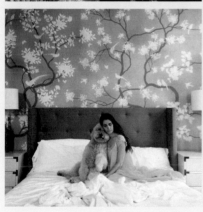
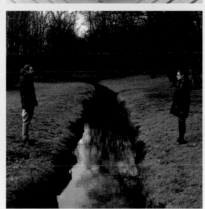
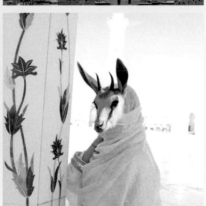

gomezlovera
Colimilla, Jalisco
The brothers
#brothers #family #starwars #tiefighter #xwing #milleniumfalcon #toys #beach #sea #seaside #mexico #travel #blue #mexico #mexigers . . .

travellingduff
Table Mountain
This morning's pancake-making spot with @erinsprong @tatjanabuisson @andrew_arnott

carolyn_mara
my morning | with Rufus. I didn't have to bring the boys to school today thanks to carpool so I stayed in bed a bit longer than usual and cuddled with my breathing teddy bear!

dylan_odonnell_
Oh man! How's this for a nice ground strike over Byron Bay tonight? My memory card filled up and I ran back in the house, smashed some stuff accidentally, flew outside and scared one of my neighbours crouching in the dark like a lunatic . . .

bdb_ny
Documenting my last bisque load of 2015
#bdbkilnloads #ceramics

pixie.zi
Park GrabiszyĐski
#lovers #ditch #park #romance #love #lawn #water #mood #selfie #narzeczony #narzeczona #miło #rów #wiosna #canon #canonpolska #vsco #vscocam #przegladinstagrama

paolounchained
Dippin' Dots
#winterstormjonas #winter #blizzard #snowstorm #newyorkcity #snow #jonas #whiteout • #january #weather #NYC #streetphotography . . .

gracemlau
#throwbackthursday #throwback #tbt #morocco #desert #travel #traveling #travelgram #travelling #africa #nature #wanderlust

aliashollygolightly
Today I took a special guest to the white mosque . . .
#my_365_fantasy #my_365 #nothingisordinary #hashtagfloosie #sunnypicchallenge

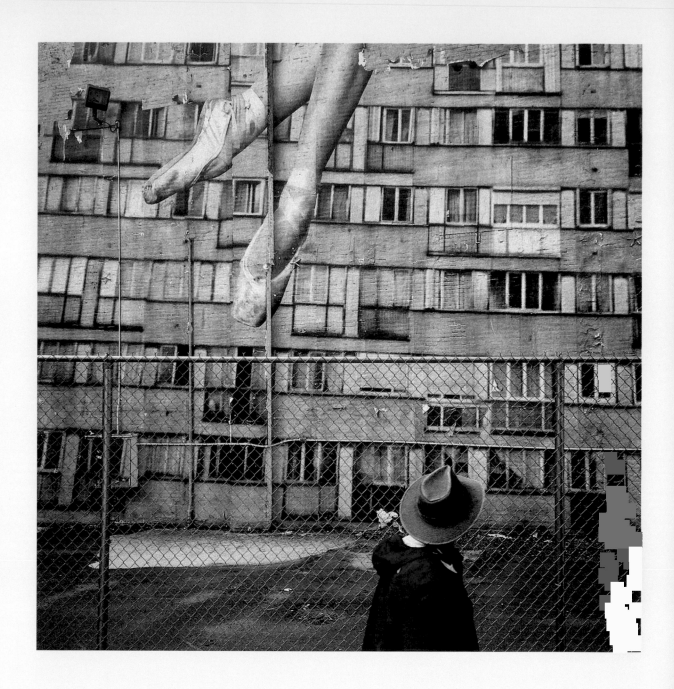

arthurbondar
New York, New York
New York City is always full of the spirit of danc-
ing. If you are there just relax and move in the
rhythm of the city.
Photo by @arthurbondar #viiphoto . . .

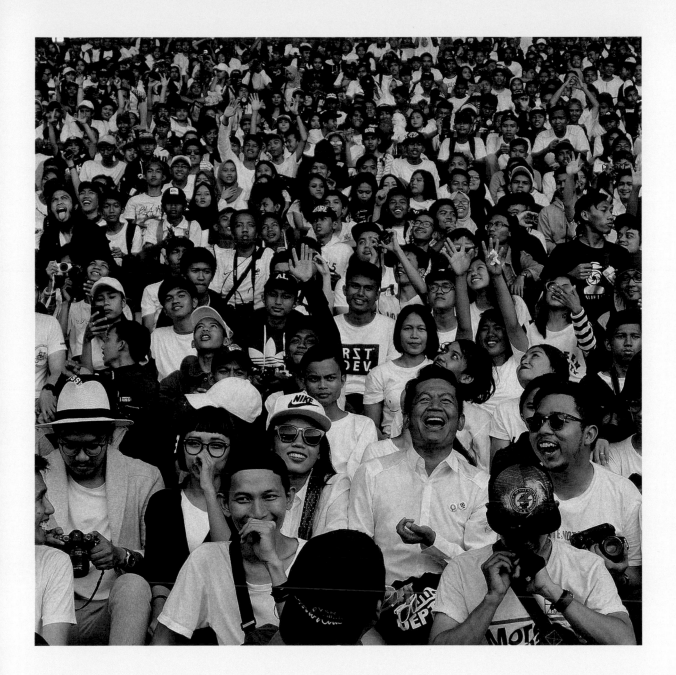

boylagi
Gelora Bung Karno (Senayan-Jakarta-Indonesia)
When you know you are an instagrammer . . .
world wide instameet is the moment when you
feel 'that moment' of being an Instagram user . . .
#WWIM13 #LifeOnEarthWWIM13

paulhiltonphoto
Yemen
'If YOU want to awaken all of humani-
ty, then awaken all of yourself.
If YOU want to eliminate the suffering
in the world, then eliminate all that is
dark and negative in yourself.
Truly, the greatest gift you have
to give is that of YOUR OWN
SELF-TRANSFORMATION.'
- Lao Tzu

The rape of our Oceans is happening
at an unprecedented scale WORLD-
WIDE (not just in Asia). It is up to each
one of us to reverse this destruction.
Step up in any way you can. You can
make a difference wherever you are
in the world.

#SHARKS #SaveOurOceans
#SaveSharks #Oceans #ThinkBlue
#StartWith1Thing #RacingExtinction

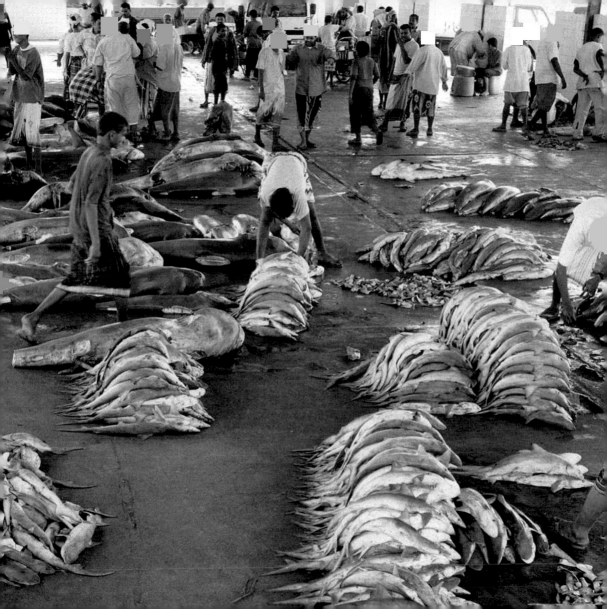

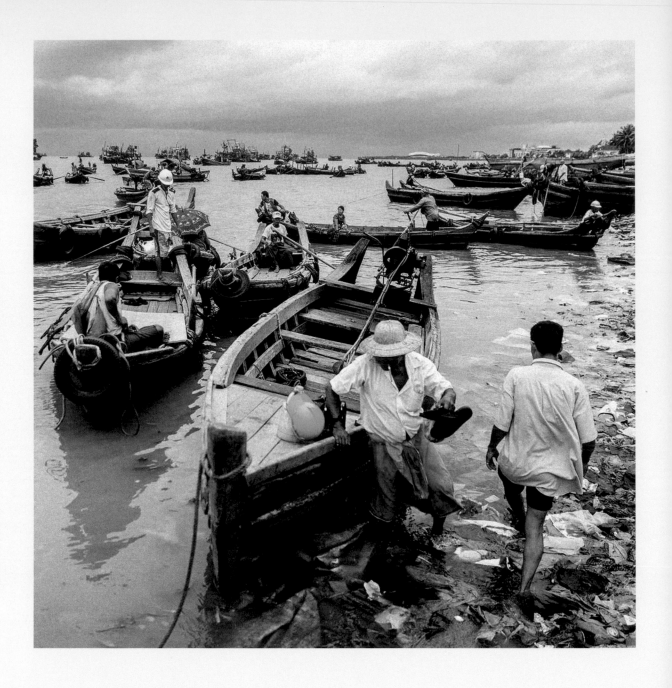

remichapeaublanc
#LaoSurLaMontagne day 47.
We will leave Myanmar sooner than planned, to
come back in Bangkok tomorrow. Wrong season
and some medical reasons... I'm sorry Myanmar,
I will be back another time, I promise you.

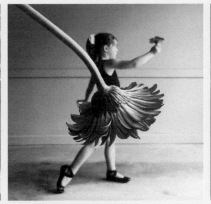
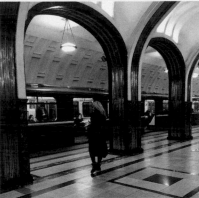
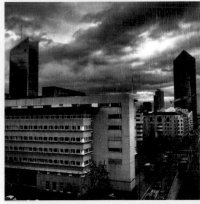
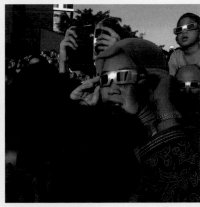

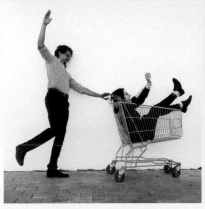
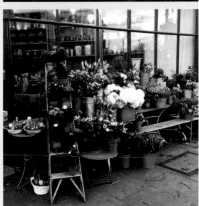
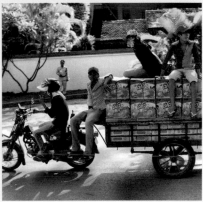

devteros
Haus der Kunst
On their way to Oktoberfest. #wwim12_munich

echtoby
Nouveau Palais De Justice- Lyon
Rainy Dusk #dusk #skyscraper #lyon #cbd #sky-
line #archilovers #rainyday #lyoncity #lyon__only
#onlylyon #monlyon #lyoncity #igerslyon
#ontheroof #rooftoper #rooftop_prj

lmmima
Love in the time of consumerism, putting price
tags on people and other stories 2/3.

mlnordan
flower skirts (Sorry for the photo spam. I just had
too much fun doing these!) #WHPeyetricks

peksicahyo
Solar Eclipse sightseeing. #snapjakarta #eclipse
#indonesia #1000kata #peksicahyo #instasunda

crazycatladyldn
Nikki Tibbles Wild at Heart
More flowers to brighten up a miserable day.

purshervil
Bolotnaya Square
Дорогая моя, ты сегодня сидишь
В этом сонном, разбитом экспрессе, а за
окнами - слякоть.
И так странно, так холодно...ты молчишь . . .

sandy_huffaker
Well, I guess that's one way to do it.
#puttputt #golf #streetphotography #cheater

agungparameswara
Siem Reap
Day-4. Street scene when i went to the Loft.
#fujifilm #x100T #7daysincambodia #travel

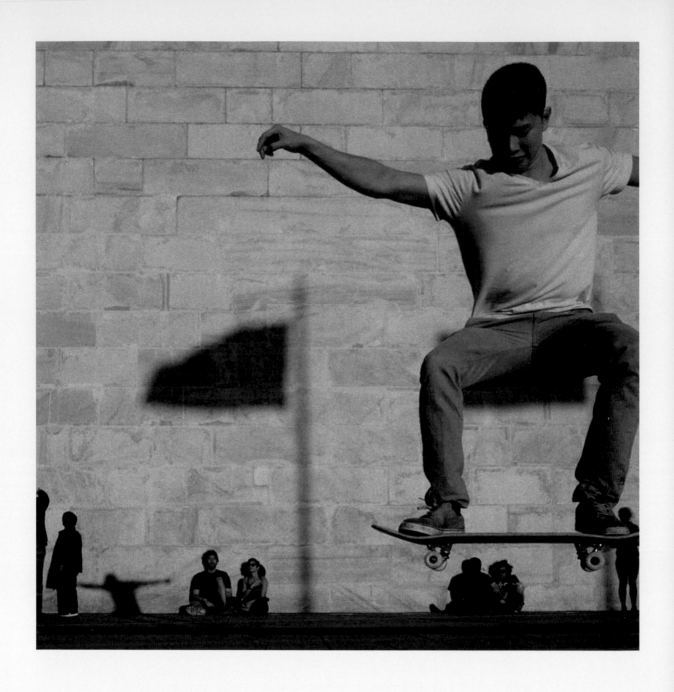

streetamatic
Washington, District of Columbia
DC Streets 133

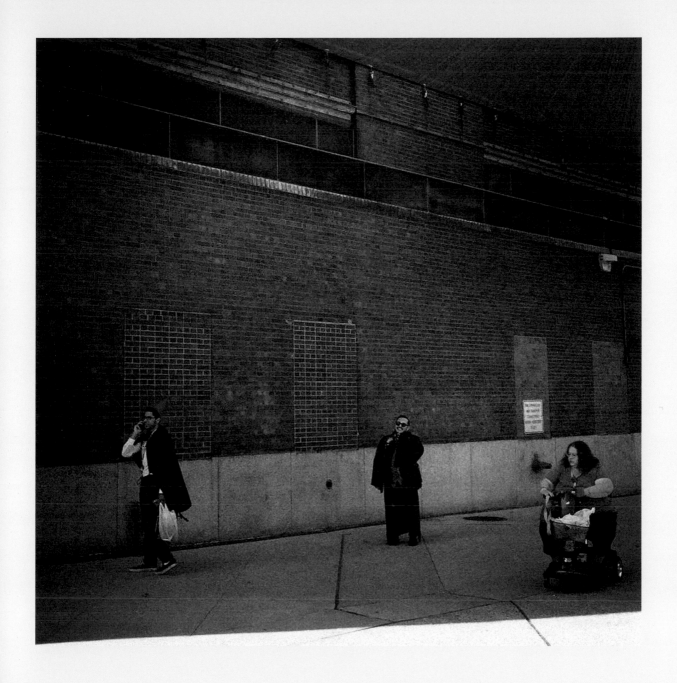

shelserkin
Magi
#nyc #streetphotography #mobilephotography
#hipstamatic

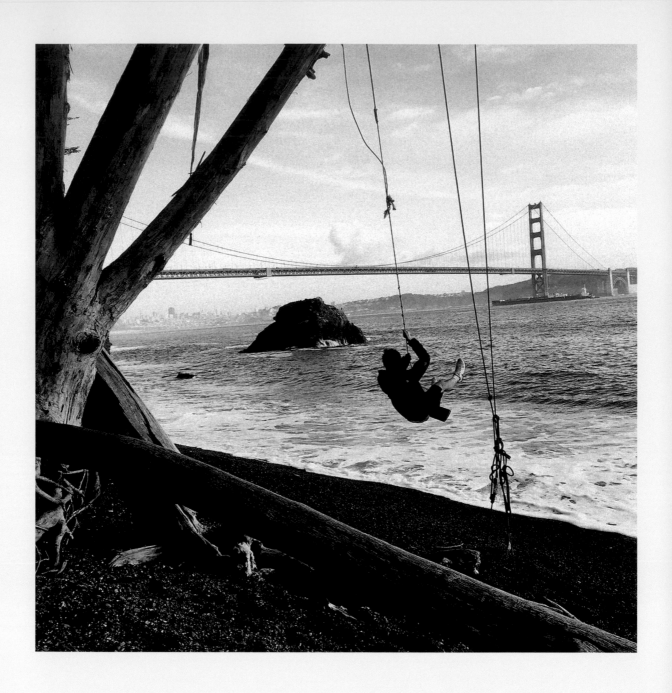

cromachi
Kirby Cove, Marin Headlands, CA
A picture of me celebrating the birth of
Baby Yeezus #SaintWest

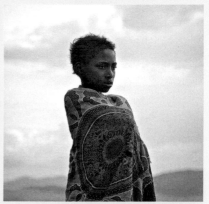
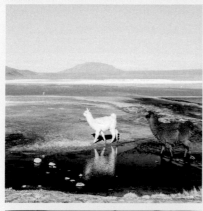
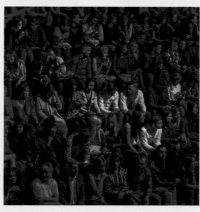
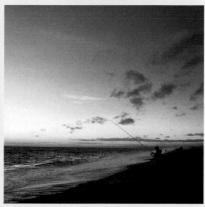
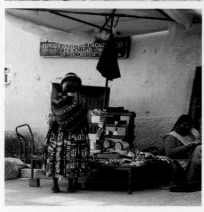
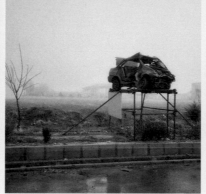
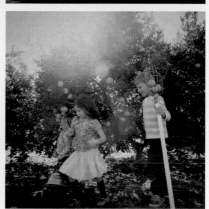

ellgue
#everydayeverywhere #everydayeasterneurope #streetphotography #everydaycrimea #1415mobilephotographers

kympham
Bolivia
Off-roaded with the crew, jumped in emerald puddles, made some new furry friends. Just another day in Bolivia. Just another day in my business.

hannalonnroos
Coroico
Just an ordinary day.

sandy_huffaker
Beach football game during visit to Trevor Hoffmans beach house in Del Mar. #PGAAC #pgAllAmerican @nikebaseball #brach #football #sandiego

ryan.koopmans
Moscow, Russia
Face In The Crowd #moscow #russia #mbfwrussia

fardin.nazari
Today landscapes 02
#landscape #landscapephotography #landscapephotos #lphotography #instagram #lphotography #iphone6 #landscape_lovers #landscape_collection #landscapes

eirinbugge
#angola #africa #viewsofangola #african_portraits #africanamazing #loves_africa #africagram #worldunion #ig_africa #igs_africa #ig_livorno_ #wu_africa #world_union #portraitmood

locopoe
Chesil Beach

kinzieriehm
The Showcase of Citrus
Winter is citrus season in Florida & the kids are out of school, so we decided to go orange picking yesterday. We don't have our own tree anymore so we went to the U pick place . . .

daphnetolis
Avtobuska Stanica Gevgelija
The pavement in #Gevgelija train
station was for many hours the
playing ground and the sleeping
ground for hundreds of refugees.
#Greece #Macedonia #refugeecrisis
#migrants #refugees

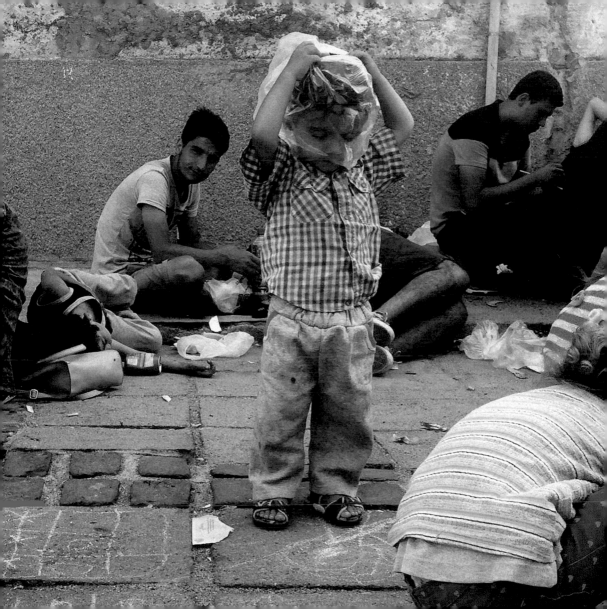

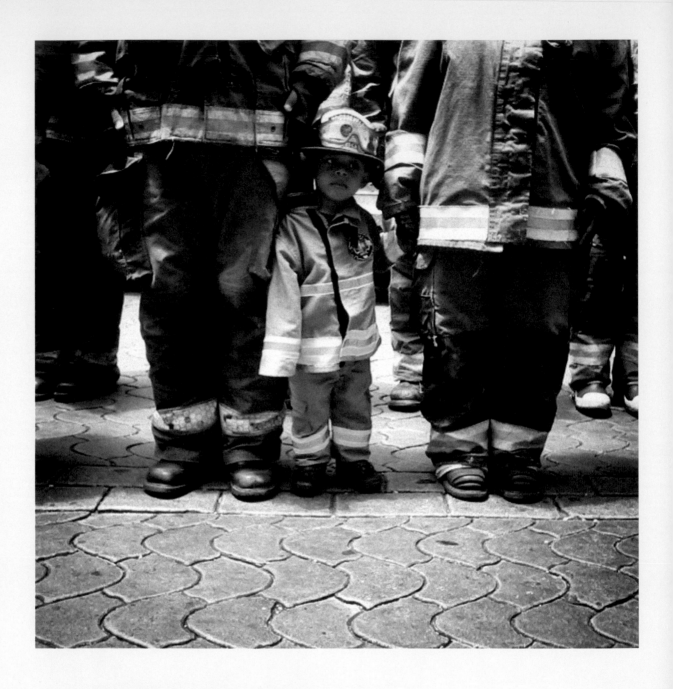

alisson_mieless
Definitivamente se robó todo el show! :)
#bomberos #Gye #EjerciciodeAgua
@bomberosgye

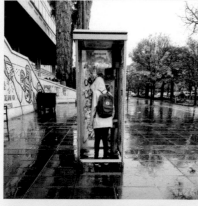
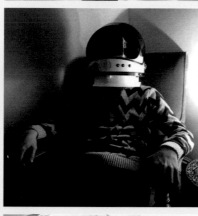
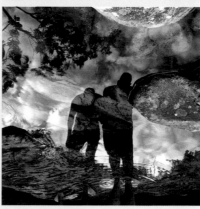
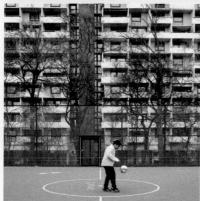

danrooms
One for @mjessett #icecream #bedford #CF

chiquidar
Parque Italo Americano
| De vez en cuando vemos el mundo al revés |

littleenglishunschool
What's this?

clementinaltube
de las aventuras del cono de tránsito /repost/

bonzojones
Teddy in VR heaven

chiquidar
El agua también es un espejo | Water is also a mirror

benjamarkoword
Go outside and play.
#vscocam #wwim11stgt #wwim11stgt
#instameetstr #weown0711

edsel
#Haikuesday
Friday night lovers
breathed whiskey on each other in radio glow.
#philipandersonedsel #Captionsbywriters

greenpenlondon
Pilot Inn
#theoldandthenew on River View #greenwich-peninsula #themoore #northgreenwich

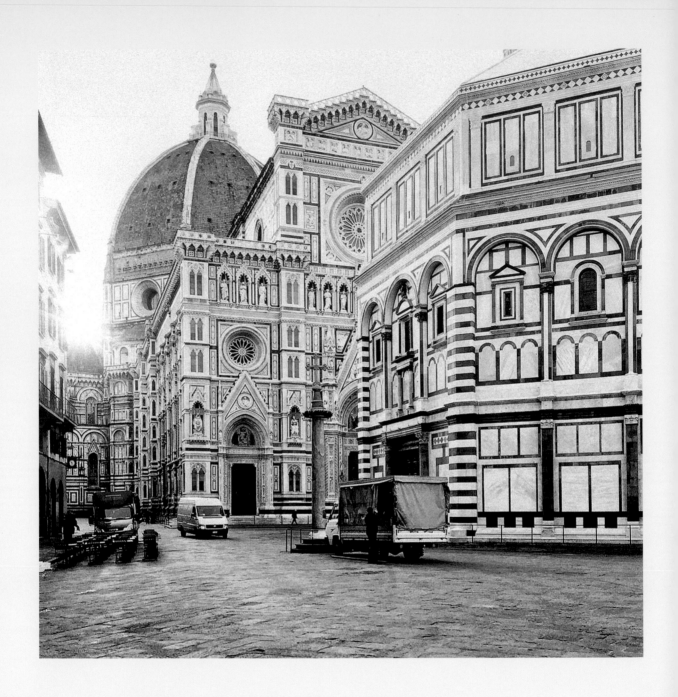

andreanoni_15
Piazza del Duomo
In Florence there are a lot of great reasons to get
up early in the morning, this is one!

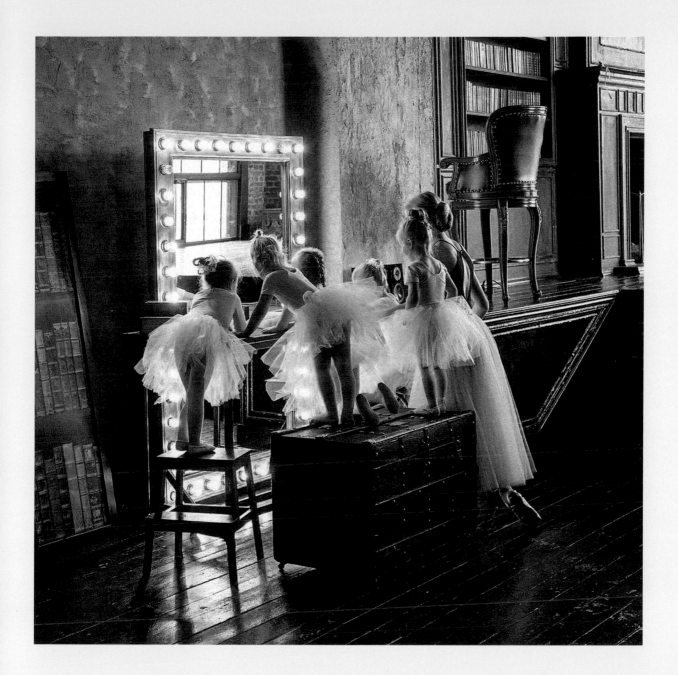

lenarakorneeva
#Буднибалеринылизы #Балет #ballet
Воробушки учатся и слушают рассказ
балерины о том как и чем правильно
закалывать волосы...

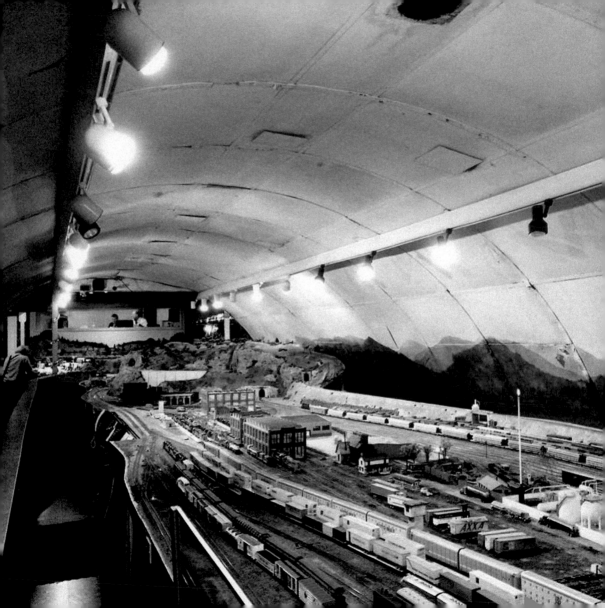

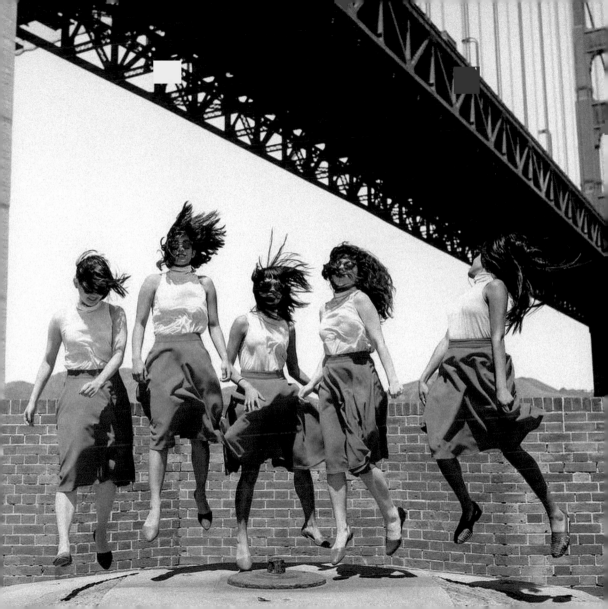

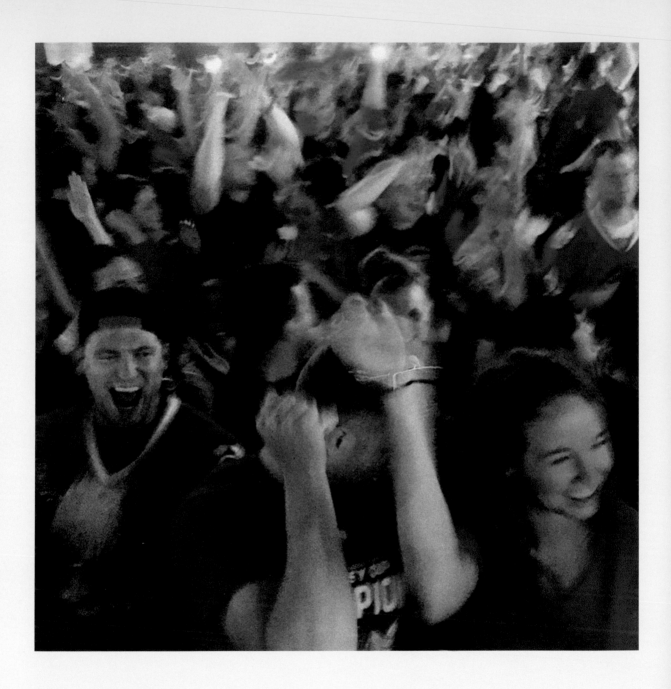

oliveruberti
Joe's on Weed St.
Grandma went home from the hospital, @sophi-
akruz came home from Africa, and the Stanley
Cup came home to Chicago. A night to celebrate!
Go Hawks!!! @nhlblackhawks #Blackhawks

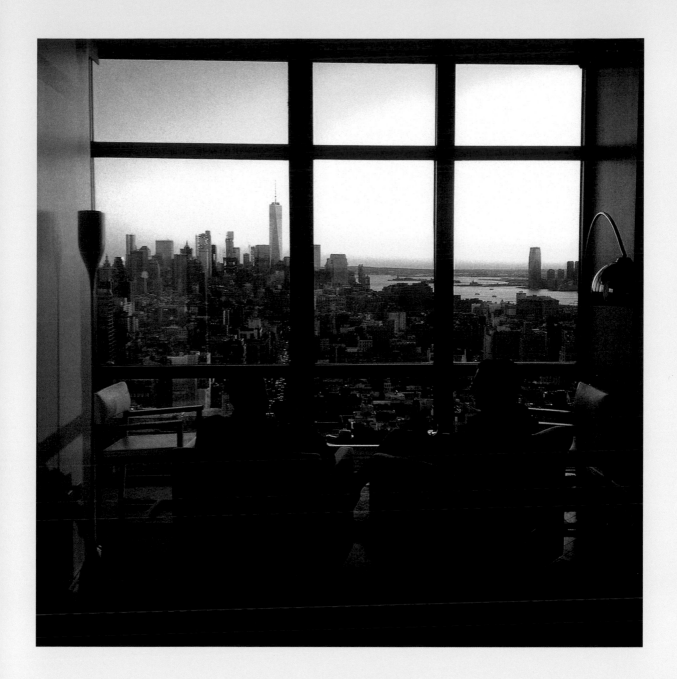

hermoseando
Another stunning sunset in Manhattan. #sunset
#everydayusa #dreams #friendship #cityland-
scape #myfeatureshoot #reportagespotlight
#manhattan #kurieleando

agungparameswara
Gianyar
Community watch two crickets fight
each others on bamboo tubes called
Bumbung during the traditional cricket
fighting tournament in Gianyar. Most
people have seen the cockfighting
popular among the locals.
A little-known but no less ardent
hobby among Bali's farming communi-
ty is cricket fighting, or mejangkrikan.
The insects face off inside bamboo
tubes known as bumbung, and bets
are placed on the bouts, which
typically last two minutes.
Despite the influx of high-tech video
games and flashy electronic-based
entertainment, the age-old tradition
of cricket fighting remains alive and
kicking among Balinese men.
#balineselife_ap #instagram
#agungparameswara #everydayasia
#balineselife #instanusantara

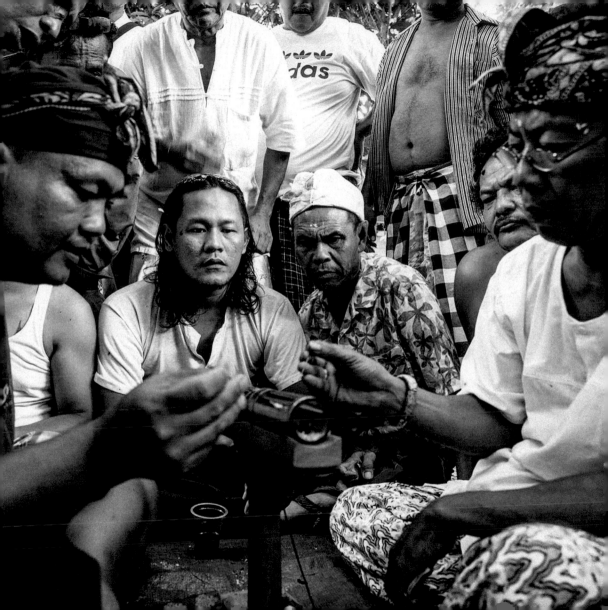

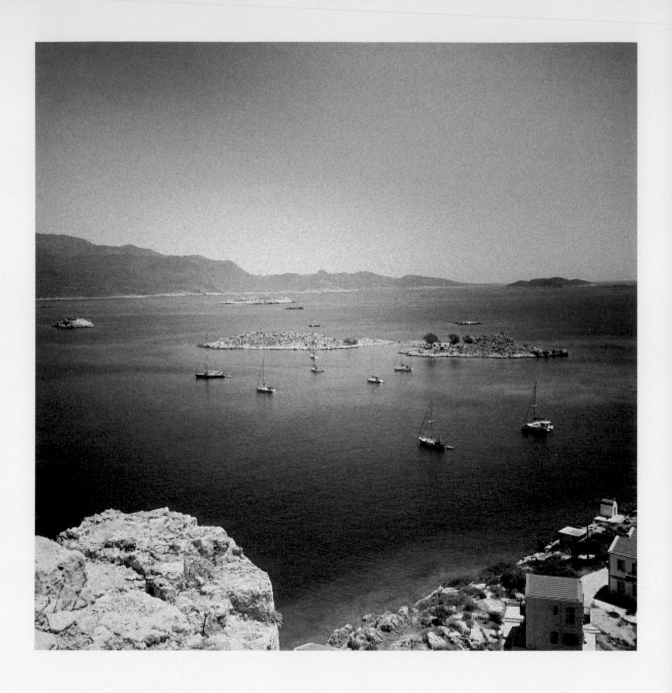

harika47
Meis Adasi
#greece #whataview

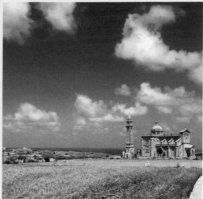
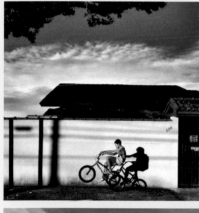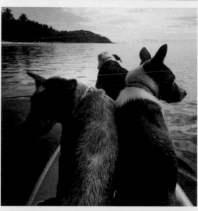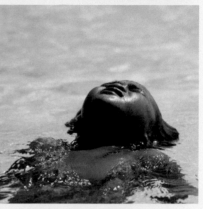
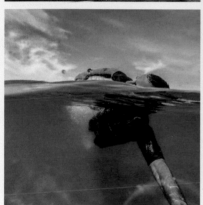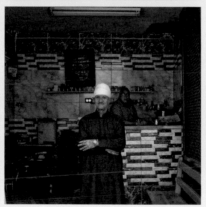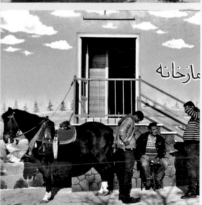

mlnordan
#WHPemojisinthewild

rosie_ubacher
#semiyak #bali

jmeulemans
Ta' Pinu
Mediterranean middle-of-nowhere countryside
#nofilter #gozo #malta #travel

sandra_pagano
Monte-Carlo, Monaco
Fazendo o que ele mais gosta
#saojosedoscampos #autumn #bike
#whpexpressions #brasildesafiebarreiras

supdogoz
Sitting down on the job #dogsurfing #dogs
#lifeofadventure #tablelands #beachlife
#dogsofinstagram #dogsup #queensland
#lovinglife #sup #standuppaddle #australia . . .

beau.thomas.travel
#philippines #palawan

inigoagote
Donostia-San Sebastián, Spain
w/ @borjagainzarain

nourikam
The look of contentment | Less is more
#Thisisegypt

sadeghpix
Iran,
Mashhad # #everydayiran #everydayasia #every-
daymiddleeast #everydayeverywhere #roozdaily
#roozdaily_theme #ReportageSpotlight #natgeo
#natgeocreative #instagram

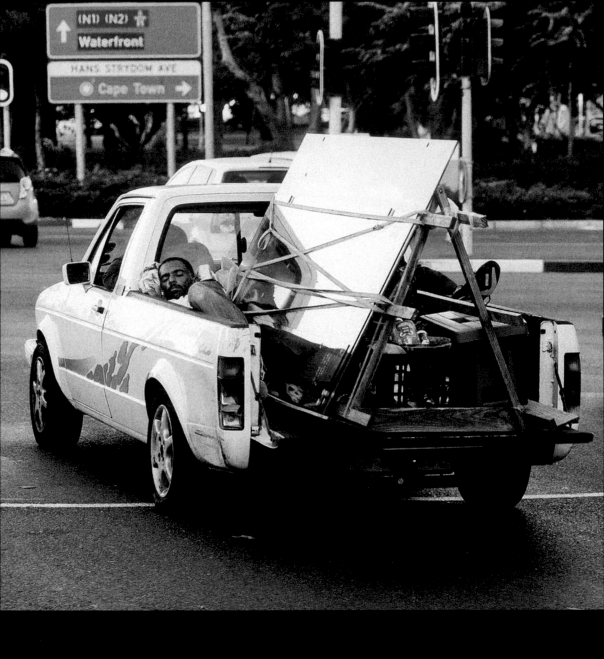

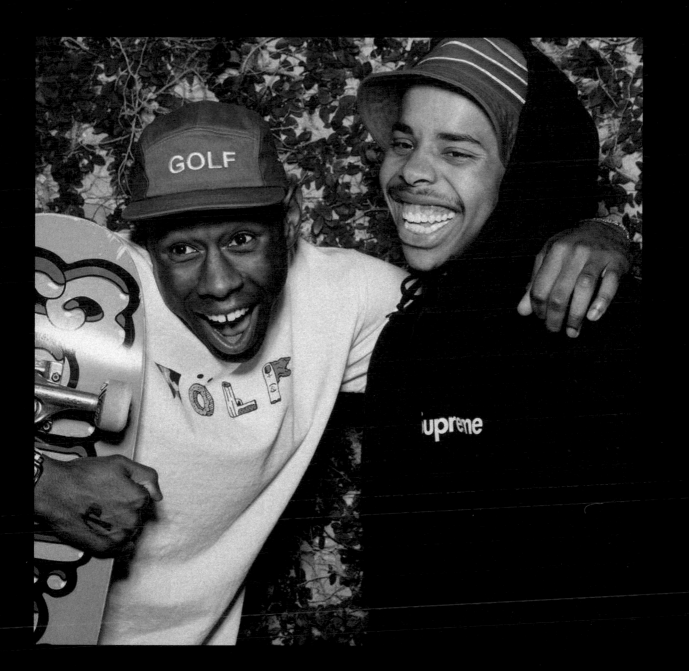

jeremydeputat
The #Texas Golf Wang Gang. FRIDAY IS THE
OPENING AT INNER STATE GALLERY. HOPE TO
SEE EVERYONE THERE!!! #TrustTheShooter

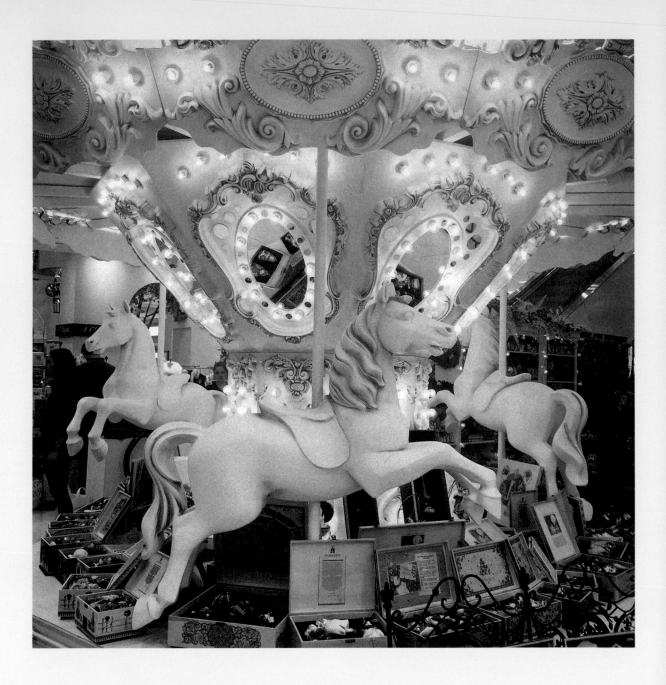

aedelweiss
DLT Department Store St. Petersburg
The time of the year when unicorns become
slightly more real, at least in department stores

#fairytalesinthemaking #christmasmood

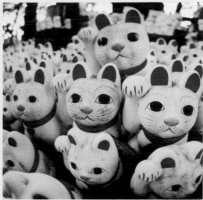

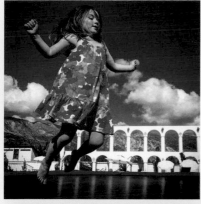

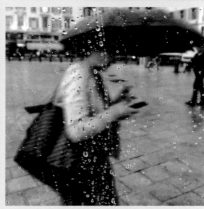

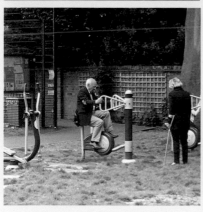
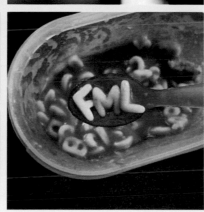

erbilkececi
CERMODERN - Cer Modern Sanatlar Merkezi
L O V E L Y @instagram #destinationearth
#bestvacations #discoverearth #earthofficial
#bestplacestogo #beautifuldestinations
#wonderful_places #fantastic_earth . . .

patriciocrooker
Violet flying. #WHPsplitsecond #instagram
#bolivia #jump #fly #girl

rajinmehta
Holland Park – The Royal Borough of Kensington
and Chelsea
When I grow up I want to be like this guy, 83 and
dressed like a G whilst flexing. #whoneedslululemon #nodaysoff #gymbuddy

melanappe
Fournier Street
Want•to•be•your•other•half
#doors #doorsaroundtheworld #london #londonlife #london_only #travelgram #doorsonly
#visualsgang #graphic #pantone #symmetry

nataliekeigher
H.I.L.A.R.I.O.U.S. Pedicures are never going to be
the same again. @west4tattoo you guys ROCK
#ChristopherForever #ConceptToe
@lianamacpherson #NewYork

apesmixtape
Just one of those days, Don't take it personal.
Just one of those #TLC days. #FML
#donttakeitpersonal #imsotired #sleepy
#momlife #thegoodlife #foodporn #foodart

elchadsantos
Gotokuji Temple
Estoy pensando en abrir un blog . . . #neko
#manekineko #setagaya #tokyo #japan
#huffpostgram #mashpics #instagramjapan
#natgeo #natgeotravel #tokyocameraclub . . .

romdilon
Marseille, France
Rainy day #marseille

sydellewillowsmith
Muswell Hill, North London
My anthropologist uncle Adam Kuper pulling his
darling grandkids Evie and Phoebe around his
garden this morning #londontown #familytime
#followthesun

karla_schwede_bw
Cup Cookie – I wish you all a wonderful
weekend! #gramoftheday #thewee-
koninstagram #diewocheaufinstagram
#adogslife #a_dogsworld #canon
#canonphotos #canonmomente
#comeandsee #photowall #prince-
ly_shotz #jj_indetail #whippetsofins-
tagram #whippetlove #whippetlovers
#dogsofinstagram #dogstagram

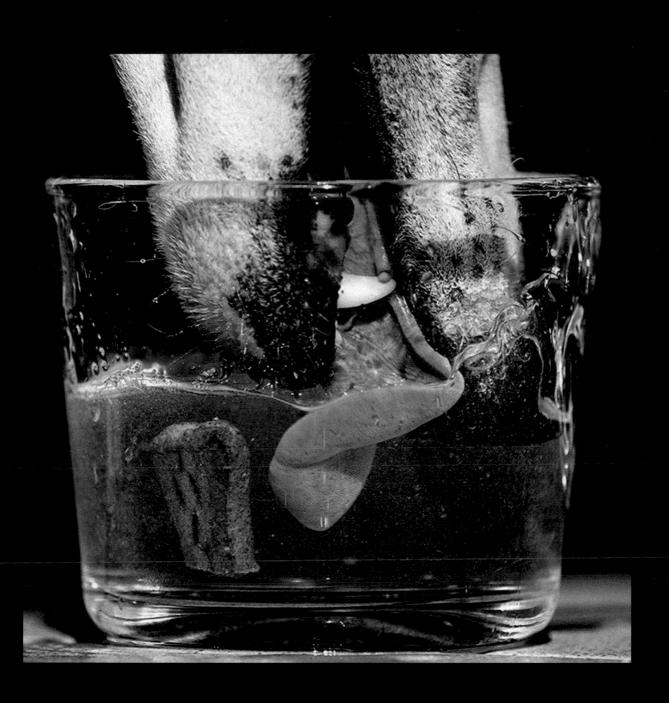

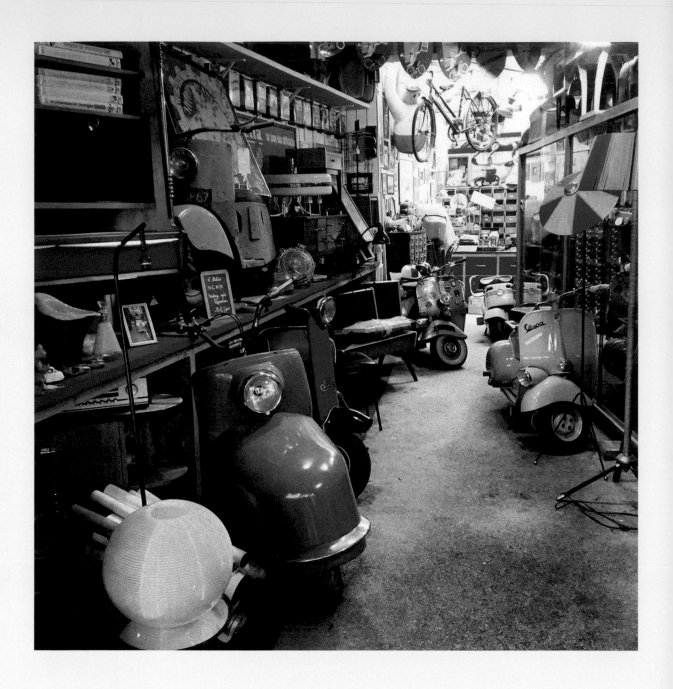

leretronaute
Rue Faidherbe
#scooter #garage #vespa #atelier #workshop
#engineshop #repairshop #moto #motorcycle
#motorbike #bicycle #vintage #shop #vintage-
shop #boutique #vintagestore #lesanneesscooter
#paris #france #brocante #antique #bricabrac

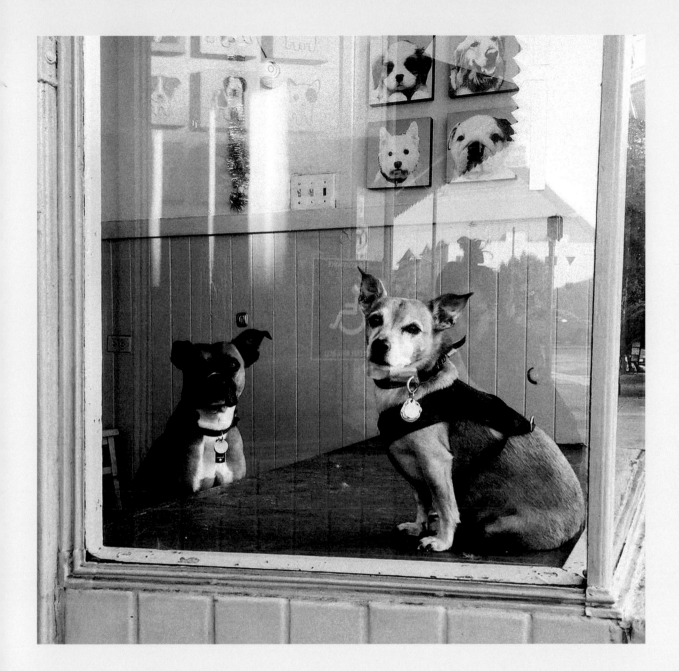

thechloeroth
"Everybody staring cuz we're rocking big jewelry."
– Gucci Mane. (In case you're a new follower, I
have a series called #ILiveNextToADogGroomer
and it's just my neighbors and rap lyrics. That's all.
Goodnight.)

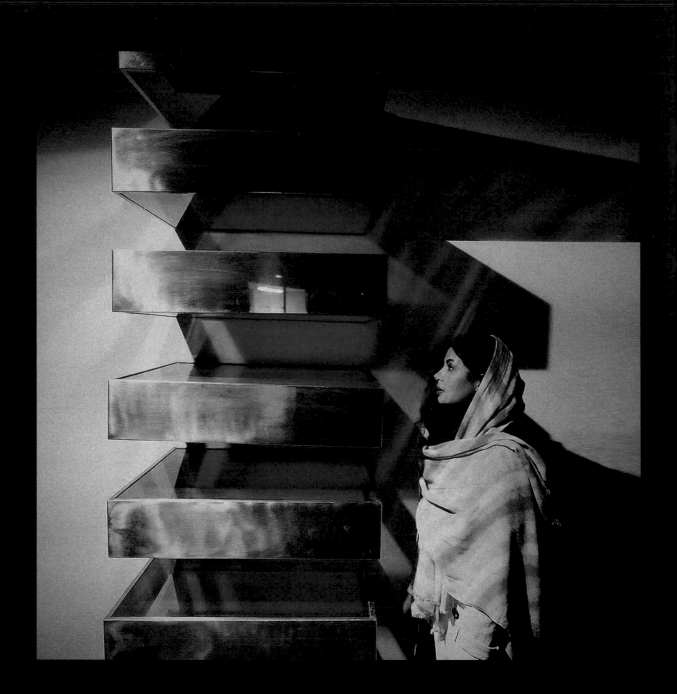

godyar
Tehran Museum of Contemporary Art
All the beauty of life is made up of light & shadow.
همه زیبایی‌های زندگی از تضاد نور و سایه ساخت شد.
#whplightandshadow #iwascreateitforWHP

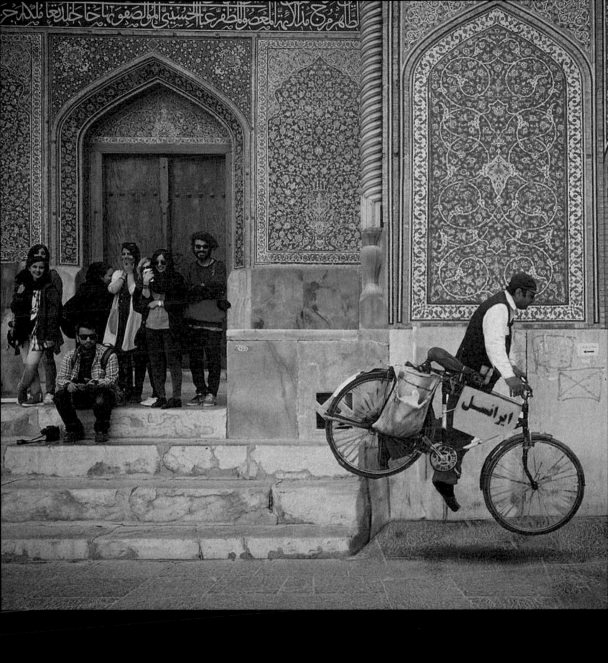

godyar

در ادامه پست قبلی #هاسپرزا میخواهم از صدفه مرای سلا
جدید برایتون بگم.
در سال و دون و پنج دوست مراد بیشتر سفر کنگ و جاهایی مک
نتوسنتم بیپیم میرب و ورب و گاکسی کنگ ابو اشخاص میخلتف
بیشتر آشنا شب.خوب میدونم که نزیهای گوب اطنوروی
بیپی بیشتر آشنا شب.خوب میدونم که نزیهای گوب اطنوروی
بیپی میگمیون در و بدل میشم و این خودش بمترین راه . . .

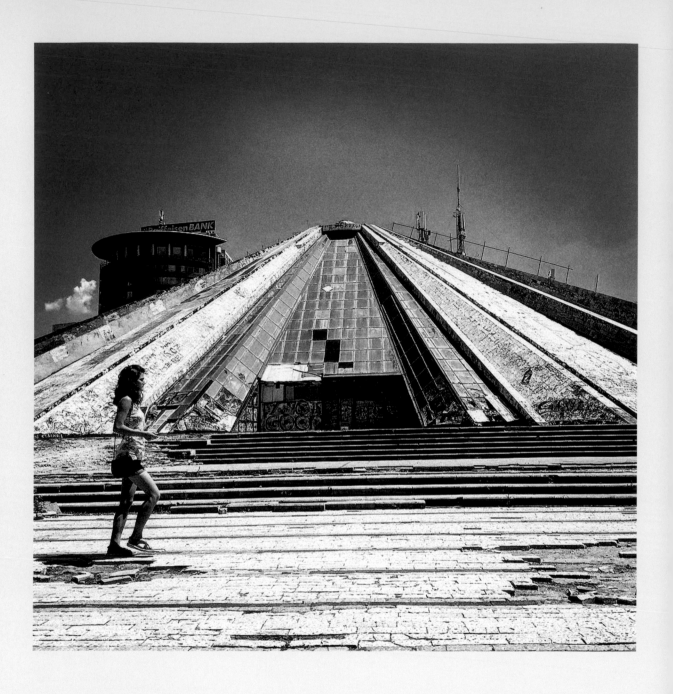

markmaffei1
Pyramid of Tirana
Interesting city

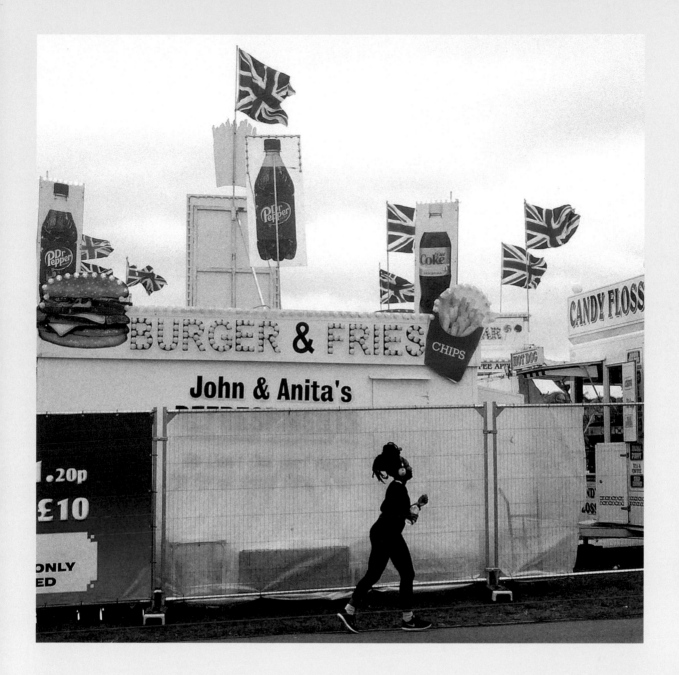

becstocks
Burgess Park
Bank holiday in Burgess Park. Yay the coming of
the fun fair

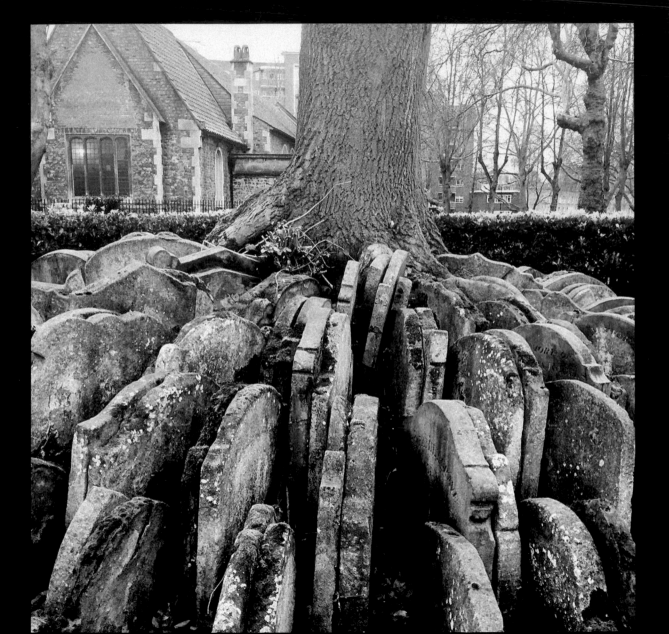

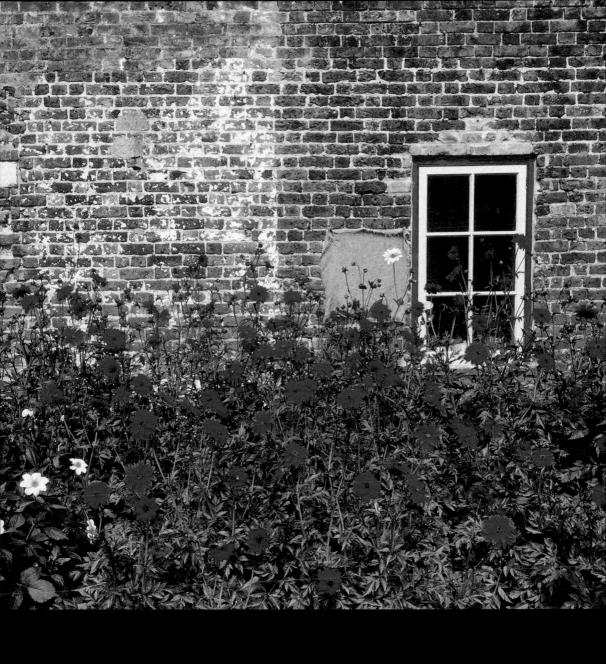

jenniferschussler
Fulham Palace
Had a lovely walk around Fulham Palace today.
Love living near these places #londonlife
#FulhamPalace #garden #walledgarden
#flowers #summer

i_bibliotaph
Nineteenth-century books

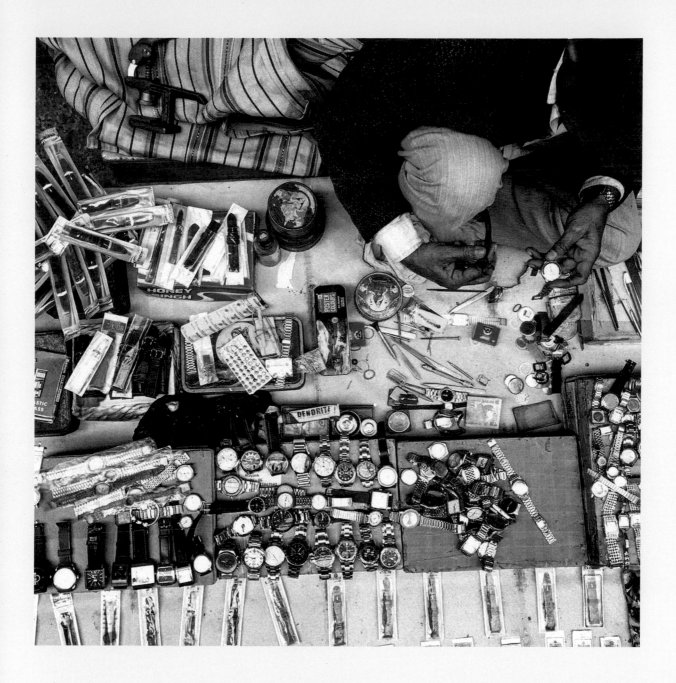

ashishchopra
Chandni Chowk, Delhi 6
W A T C H M A N
#india_gram #indiapictures #indiatravelgram
#_oye #_soi #_soidelhi #delhigram #delhighted
#delhi_igers #sodelhi #saadidilli #dfordelhi #dildi-
lli #dillipics #ourdelhi #lonelyplanetindia . . .

dylan_odonnell_
Twas the night before Christmas, when all through the house, not a creature was stirring, because they'd all been DESTROYED BY THIS HIGH POWERED FRIKKEN LASER TREE I MADE! Merry Christmas everyone! Santa bought me this vintage Celestron 102-HD refractor at the base of the laser tree! He bought it from Ice in Space forums and dropped it off early to avoid potential eye damage. Have a geeky Christmas and a nerdy New Year! 5 X 15s f11 ISO 100, canon 70D.
#celestronrocks #lasertree #christmas
#lasers #iceinspace #canonaustralia

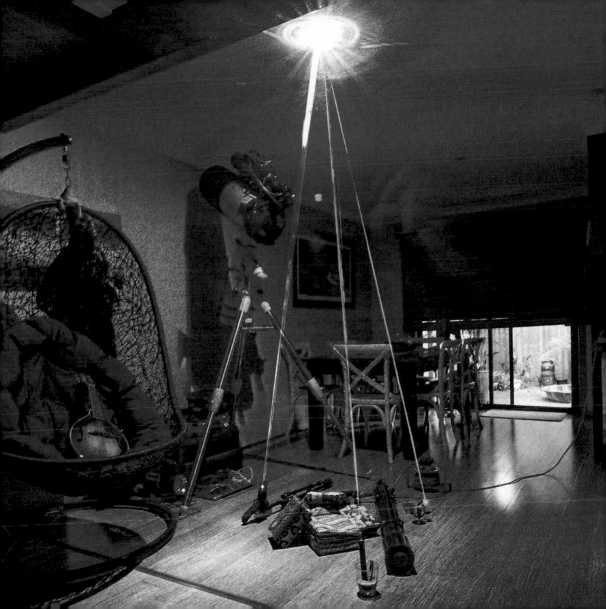

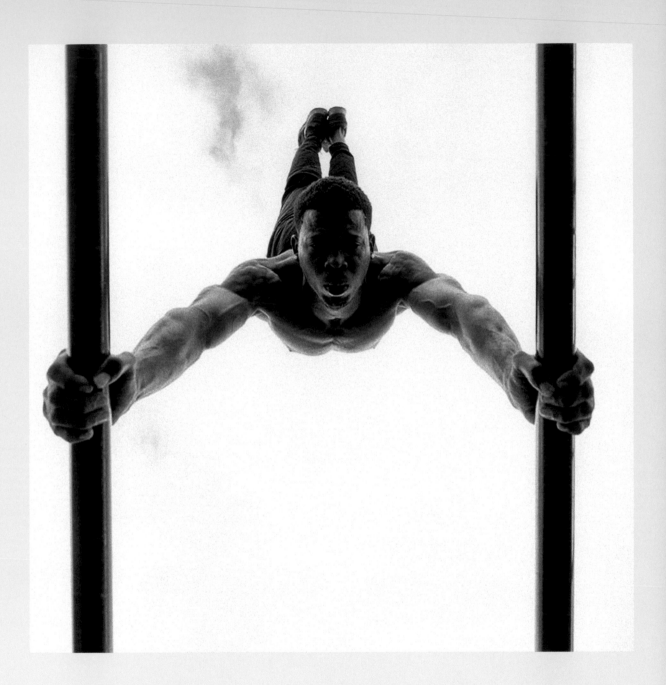

peter_zwolinski
#whpresolutions2016 to get a firm grasp on
consistency (in general) I feel as if my work has no
consistent feel to it nor do I post consistently. 2016
is the year where you'll see tons of new work by
me. Happy new year

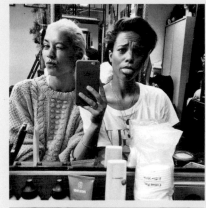
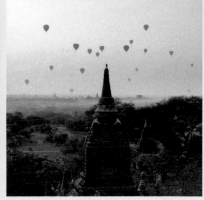
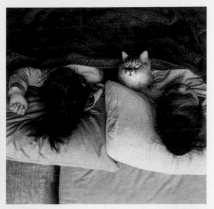
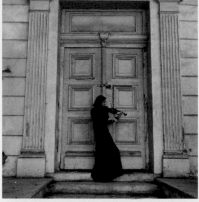
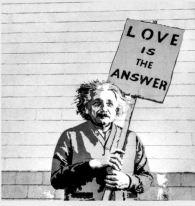
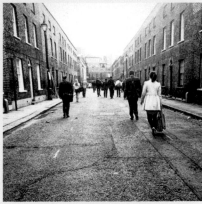

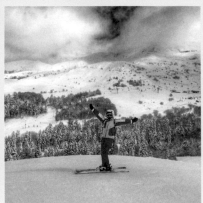
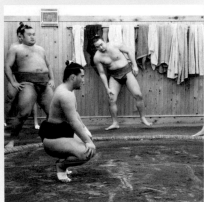

nicole_huisman
mogeen
Fun times with my babe @chloechante at @demakeupschool #saycheese #backstage

hamedwasief
Foad Street داؤف غراش
Violin magic
#vsco #vscocam #vscogood #instagood #instadaily #morning #street #sister #violin #music #playing #old #buildings #architecture . . .

sdadich
Wired
Two cancelled @british_airways flights later, I still managed to (virtually) make it to London for @magculture #modmag15—with very special guest @billy_sorrentino! Jeremy and team . . .

steph_cordes
Bagan, Myanmar
Balloons over Bagan part 2 #speechless

marlatelierista
Union Market DC
#followyourheart #spraypaint #graffiti #streetart #publicart #text #love #unionmarket #washing-tondc #letgirlslearn #message #wisdom #publicart #artandactivism #nevergiveup . . .

gremly
Le Lioran

futago_no_utarita
Thank you friend @violaondariva my cat is like their mom

sc17
Waterloo, London
#whpmydailyroute #commuters #London #zombies

beau.thomas.travel
#sumo #japon #tokyo

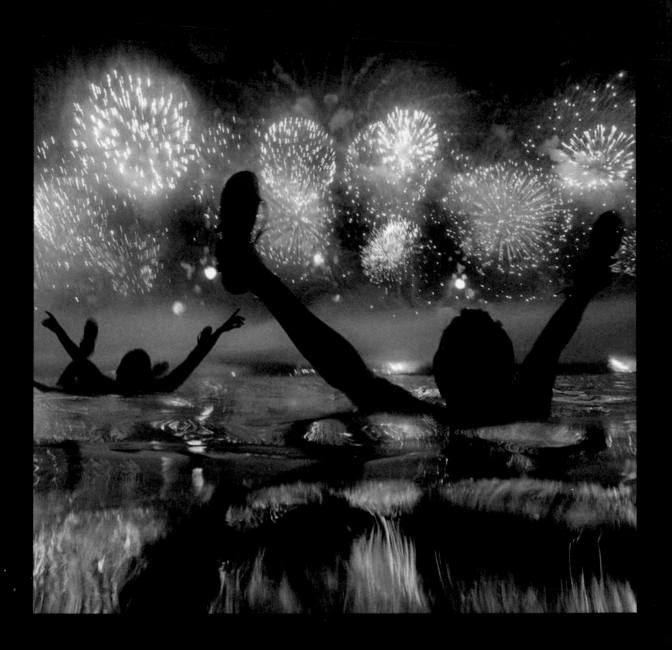

christophesimonafp
Copacabana Beach, Rio de Janeiro
Happy new year 2016 from Copacabana beach
in Rio de Janeiro

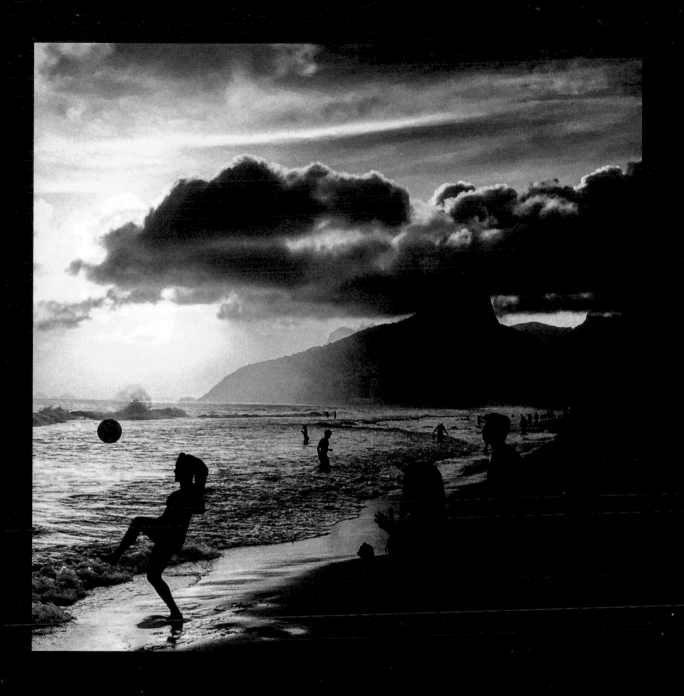

christophesimonafp
Football na baraca 54 in ipanema beach
Rio de Janeiro

With special thanks to our friends at Instagram.

And with gratitude to the many talented members of the Instagram community featured in the book:

_dersash
_foveola
juliafox
_lumberjake__
a_heidari20
a_ontheroad
aedelweiss
agungparameswara
alenpalander
alessioalbi
alettavanderlinden
alexandrelahaye
alexfawks
ali.shms
ali_berrada
aliashollygolightly
alisson_mieless
allydelmonte
amandafordycephoto
amberrrjones
ameliahodgson1
anasrshd
ancient_hearts
andreanoni_15
andrewlichtenstein
angrylittlenotion
anushree_fadnavis
apesmixtape
arayan_photography
arkadripta1 /
 katha_collective
arristide
arthurbondar
artist_cp
ashishchopra
ashwellmatthew
asokaremadja
atchoumfan
aupresdetoi
avanope
awoxsa
b.e.s.s.a.r.i.o.n
banerjee.anurag
barbenvakil
bdb_ny
beau.thomas.travel
becstocks
benjamarkoword
berriestagram
bethanytoews
billycress
birdcloudusa
 and Nathan Edge
blackmobil
bonzojones
boylagi
bro_ker326
brooklynarchitect
callielynn33

camilla_engman
carlosthegypsy
carolina_ferrer_
carolyn_mara
caxmee
cecis.r
cherkis
chiaraluxardo
chiquidar
chris_mueller
christophesimonafp
chuckseye
churrito
cimek
claudiavdbroek
clementinaltube
cleo_thebunny
cncndn
corasacher
crazycatladyldn
cremedelacremeba
cromachi
crystallapistil42
dailyaima
dakiloulou
danrooms
daphnetolis
darosulakauri
deni_perez
denissewolf
devteros
diana_lars
dianazeynebalhindaw
dianewithonen
djasonnam
dorina_wayfarer
dylan_odonnell_
echtoby
eddiedaws
edsel
eirinbugge
elchadsantos
Eleazar 'Caps' Briceno
elenakrizhevskaya
elizabethsmart
ellgue
elyasami
emrhbg
erbilkececi
esteeveeen
evamcalpine
f64s125
fardin.nazari
fcoronado
Filippa Edberg-Manuel
floradawson4
followkk
fotolucida
francesmehardie

futago_no_utarita
gabetomoiaga
godyar
gomezlovera
gracemlau
greenislandstudios
greenpenlondon
gremly
h_cato
halesnew
hamedwasief
hanifshoaei
hannalonnroos
hanthomas
harika47
haytay1010
helloemilie - Emilie
Ristevski
hellokmueller
hellosearah
hermoseando
hobopeeba
huxleygriffon
i_bibliotaph
iamnicolem_
iansalvat
iantehphotography
ijlal2278
inigoagote
iphoneishootipost
iqbalbabon
irawolfmusic
iringo.demeter
ismailferdous
jacobjonasthecompany
jacquifink
jamesrosen
jaydabliu
jeffmindell
jenniferschussler
jeremydeputat
jestingrid
jhows_
jinnkisss
jitskenap
jmeulemans
johnonelio
jotasphotography
jsph
juancristobalcobo
juliafkogan
justinestoddart
kailightner / matthe-
whulet
kajeh
kararosenlund
karla_schwede_bw
keiranlusk
kellymariebeeman

kevindliles
kierandodds
kingofmongols
kinzieriehm
klarahorton
klsmeanders
kurtarrigo
kylehuff
kympham
la_mayte
landgallery
lauragoodall
lenarakorneeva
lens_pacific
leretronaute
lina_liss
littleearthstories
littleenglishunschool
littleredapple
liz_appa
lmmima
locarl
locopoe
lonnypugh
lookdoyousee
lorenzosalvatori
lowfatroubo
luccico
luciazolea
m.kulio
m_mateos
maliabeth
marianomane
markabramsonphoto
markmaffei1
markosian
marlatelierista
maryloo_berlin
matiascorea
mau.cp
maxgehl
mcneilrachel
melanappe
mells324b21
merichakan
merileeloo
mermaideleh /
 photographer:
 outlierimagery
mgrevtsov
mich.dee
mimi.wade
mimi_brune
mimiochun
minamohit
mishavallejo
mishkusk
miyukiadachi
mlnordan

mmhenry
moeit_
monicatorne
mukesh.sml
muradsfoto
nampix
naseke
nasonphoto
nastaran__fp
nataliekeigher
natsmith
nesam.keshavarz
nicola_bird
nicole_huisman
nigelpaulin
nikonandy
nourikam
nyc.globetrotter
oggsie
oliveruberti
olivialocher
onlyamomenthoney
ozin.17
pablo_laguia
pao_lamaga
paolounchained
paperaxxe
partha14
patriciocrooker
paulhiltonphoto
paulinhohop
pazzopup
peksicahyo
peter_zwolinski
petrosphotos
photoaskew
phukradung
piergiuliocaivano
pixie.zi
pketron
purshervil
raaaqlkm
rahmanism
rajinmehta
remichapeaublanc
reycanlasjr
ricardomena72
richcrowder
riteshuttamchandani
rolfemarkham
romdilon
rosie_ubacher
royaloperahouse
rumanhamdani
runaholic.mx
ryan.koopmans
sabrinaromahn
sadeghheydarifard
sadeghpix

salwangeorges
samishome –
 Samantha Wong
samvoulters
sandra_pagano
sandy_carson
sandy_huffaker
saunakspace
sc17
scodyg
sdadich
seojups
sevilita
shameem_ehsan
sharedwanderlust
shelserkin
shoonastanes
sierrablaircoyl
simona.ghizzoni
sohailsingh
sopheesmiles
sophiacosmo
spiffyfan
spispispice
steph_cordes
stevesweatpants
streetamatic
striving2beraw
supdogoz
superzina
sydellewillowsmith
taomeitao
tatiruediger
the.tinker.taylor
thechloeroth
theerissara
theindianhippie
thesmartview
thisismybike
tigerladyyy
tilly2milly
tinypies
tokio_kid
tonipascualcuenca
tonyinseattle
travellingcars
travellingduff
valentsu
vinicius_eneas
voodoolx
wesleyallen_
workingwanderer
yandelli
yesaccasey
youseful.dk
zarialynn
zenography
zishaanakbarlatif
zoebuckman

Penguin Random House UK

PARTICULAR BOOKS
UK | USA | Canada | Ireland | Australia
India | New Zealand | South Africa
Particular Books is part of the Penguin
Random House group of companies
whose addresses can be found at
global.penguinrandomhouse.com

First published 2016
001
Foreword copyright © Jim Stoddart, 2016
The moral right of the author of the foreword
has been asserted
Image selection by Jim Stoddart.
Cover photograph © Krisanne Johnson
Printed in Italy by Graphicom srl
A CIP catalogue record for this book is
available from the British Library
ISBN: 978–1–846–14909–2